The Western Horizon

TheWestern

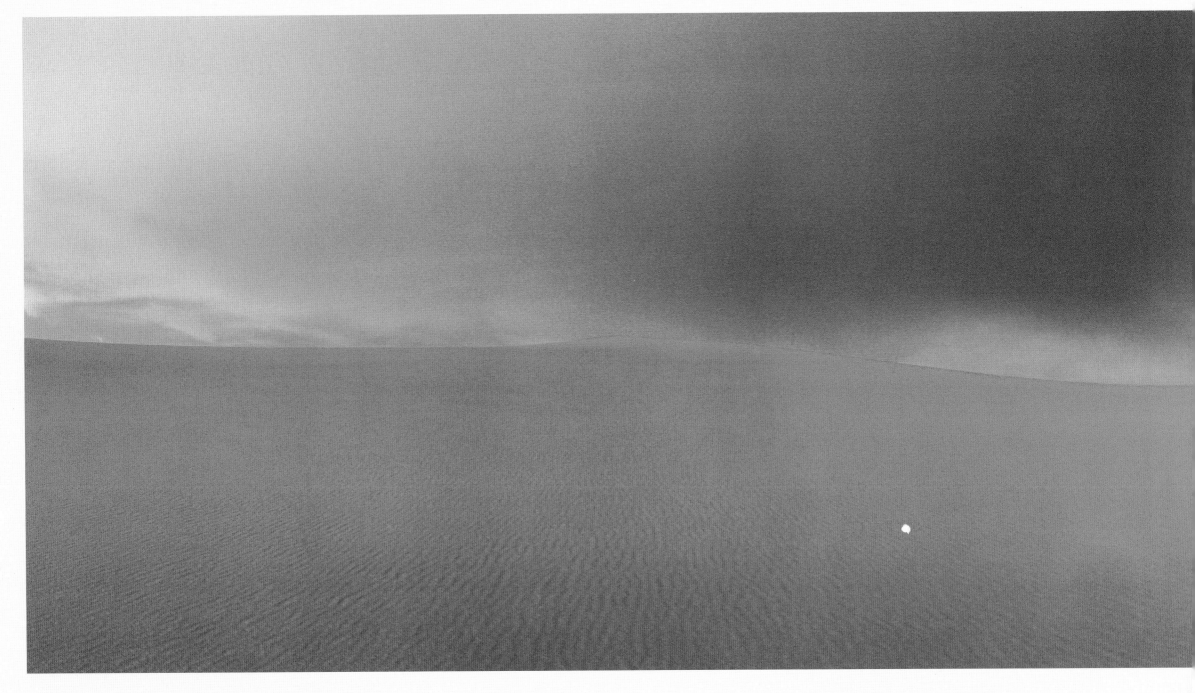

Horizon

Photographs by
Macduff Everton

Commentaries
and sketches by
Mary Heebner

Introduction by
Edmund Morris

Harry N. Abrams, Inc., Publishers

Contents

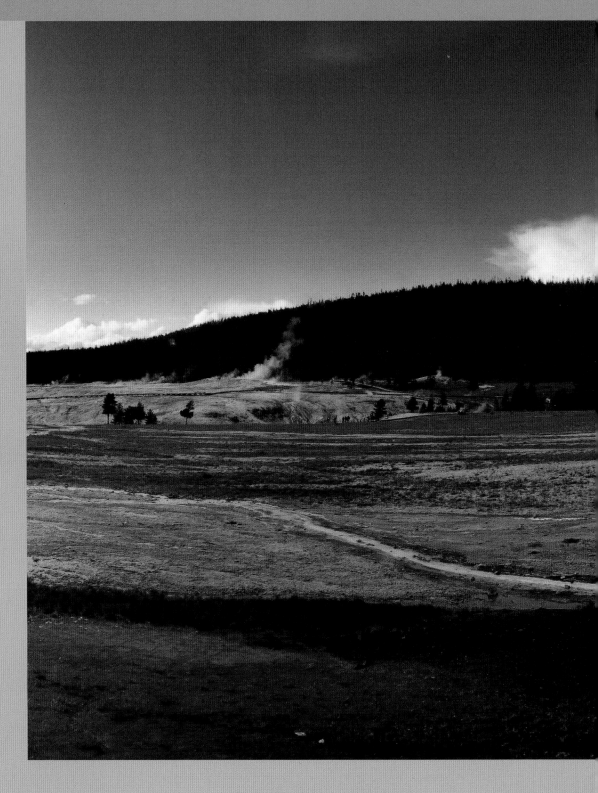

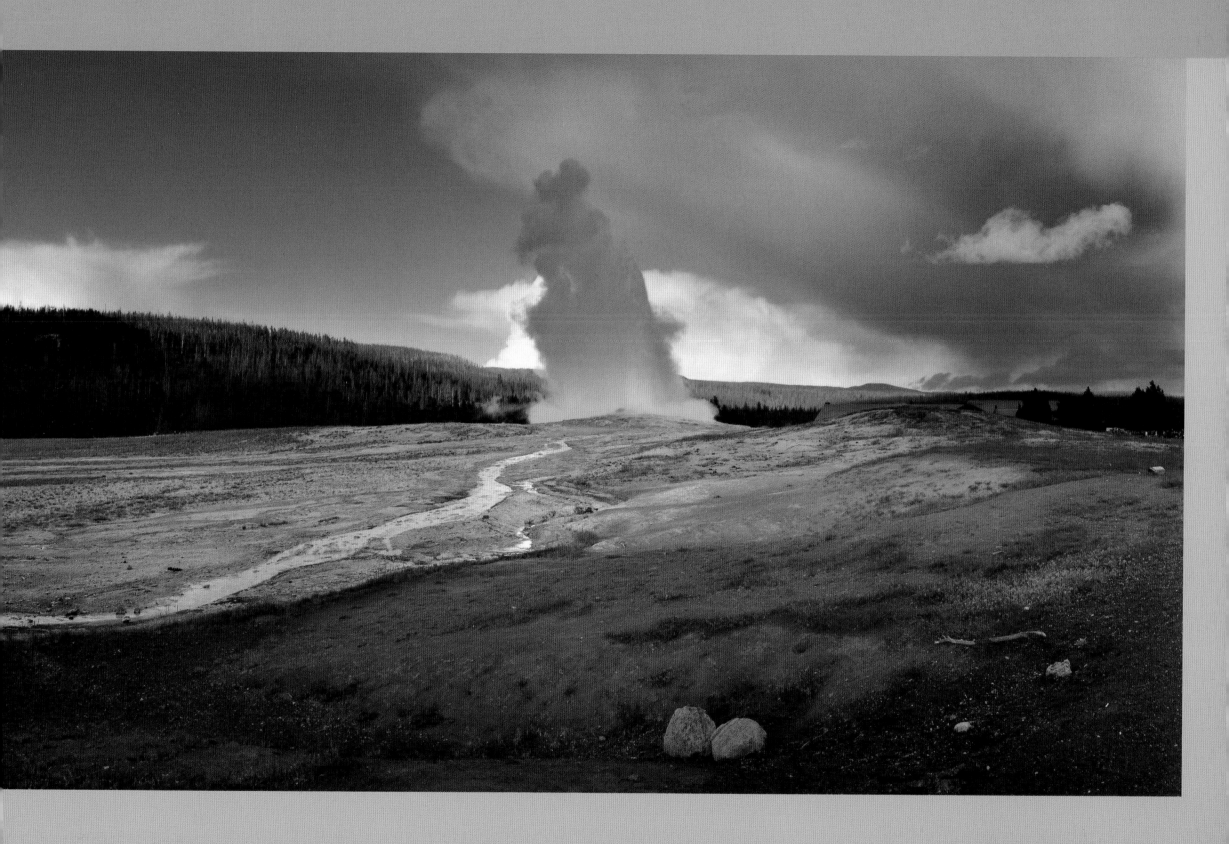

Project Manager: Eric Himmel

Editor: Nicole Columbus

Designer: Bob McKee

Everton, Macduff.
 The western horizon / photographs by Macduff Everton ;
 introduction by Edmund Morris ;
 commentaries by Mary Heebner.
 p. cm.
 Includes bibliographical references (p.).
 ISBN 0–8109–4562–2
 1. West (U.S.)—Pictorial works. 2. Landscape—West (U.S.)—
 Pictorial works. 3. West (U.S.)—Description and travel.
 I. Heebner, Mary. II. Title.

 F590.7 .E74 2000
 978'.0022'2—dc21
 00-35524

Pages 2 and 3: Great Sand Dunes National Monument

Pages 4 and 5: Yellowstone National Park, Old Faithful

Pages 6 and 7: Craters of the Moon National Monument, edge of storm

Harry N. Abrams, Inc.
100 Fifth Avenue
New York, N.Y. 10011
www.abramsbooks.com

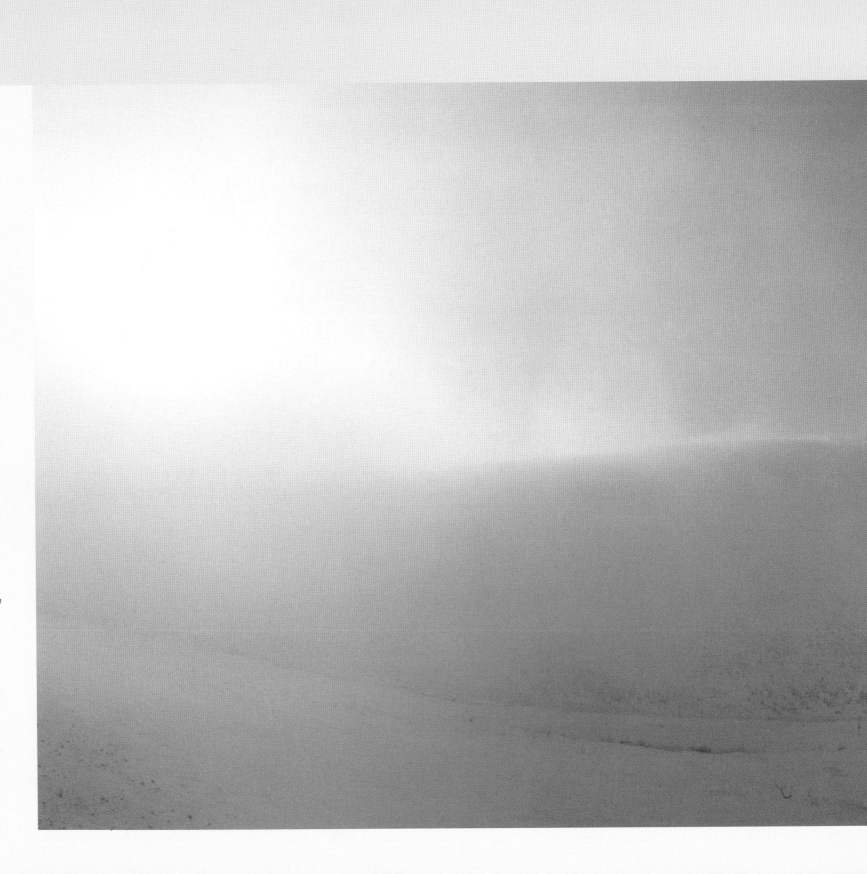

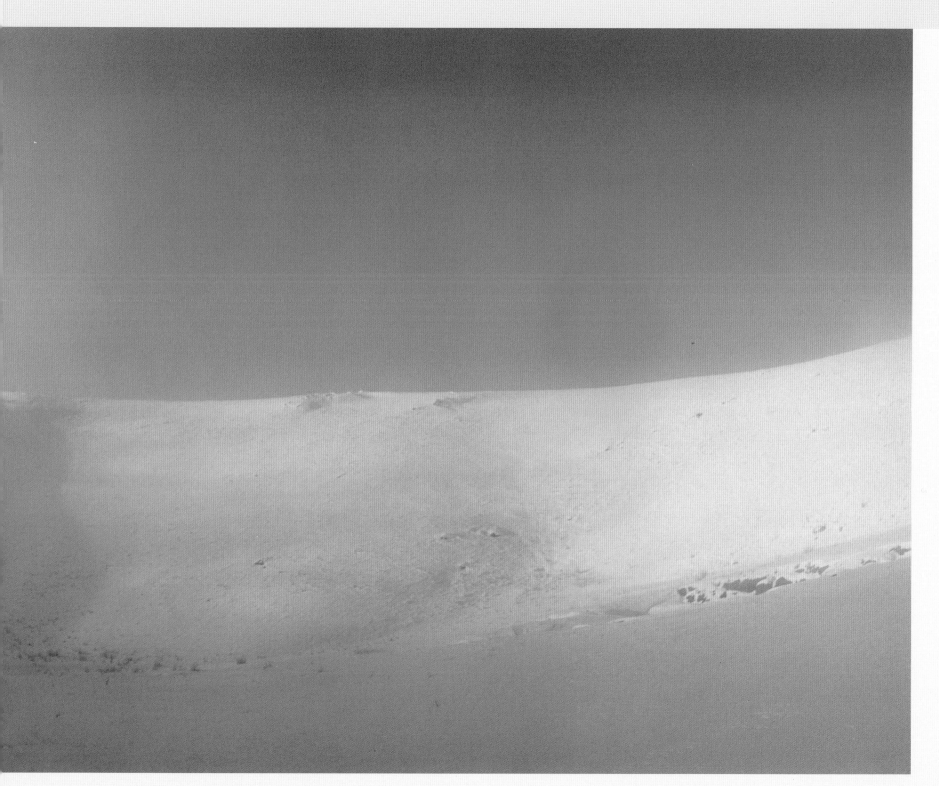

I bought my first panoramic camera, a Widelux, from Kornelius Schorle of ProPhoto in Irvine, California. The lens rotates and covers an area of approximately 148 degrees, or what the eye sees with peripheral vision. It has very few settings or speeds, and I used Kodak Gold 100, a wonderful film. The problem with the Widelux is it keeps breaking down. When Kornelius designed the Noblex, based on years of fixing Wideluxes, I was ecstatic. The Noblex is a very good camera. It has more speeds and settings, so I use Fuji's NHG II—another excellent film. Most of the photographs were handheld. I hate carrying a tripod. However, I used a tripod for the shots taken at dusk. In order to allow enough light onto the film, the lens has to make several revolutions. The photograph of the lightning storm at Grand Canyon required 123 rotations, more or less. It was completely dark by the time I finished, and I stopped counting after eighty and then let it go for another five or ten minutes. It was a beautiful night, and I wasn't in a hurry.

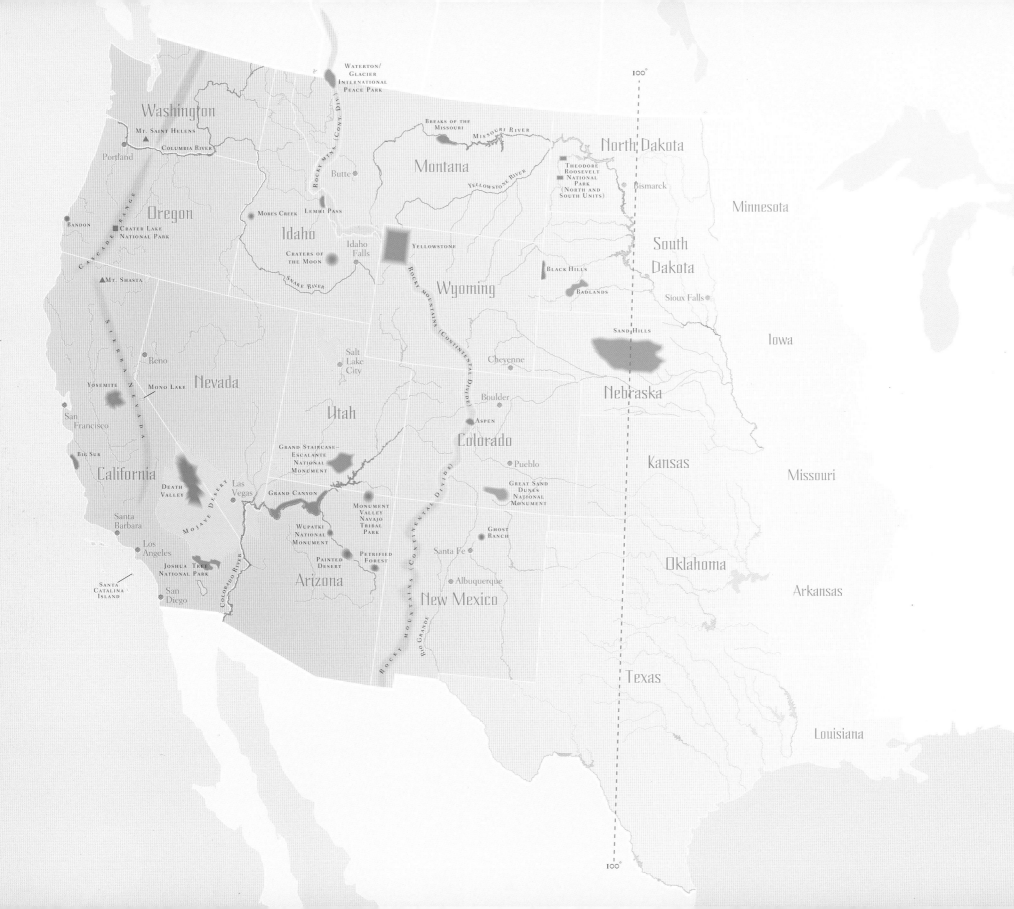

Preface by Macduff Everton

Until recently, when people took "the Grand Tour," they traveled to Europe, and perhaps to Egypt and the Middle East. Today the Grand Tour is the American West. The Europeans know it; the Japanese know it—if you want to practice a foreign language, take a summer job at a national park.

The American West is one of the most beautiful areas of the world. It is grand and glorious, spacious and sublime, a land of dreams and myths. This vast region defines how we see ourselves as Americans, as well as how foreigners see us.

The West is in my blood. I'm a fifth-generation Oregonian. On my mother's side, the family went west in the early 1840s on the Oregon Trail. Marion, Oregon, is named after my great-grandfather, Francis Marion Pickard. My grandfather and his brother homesteaded on the Skagit River in Washington in 1912, working as mule skinners and guides in the Cascades. However, they lost the homestead to a major timber company that filed on their claim because they hadn't made any improvements on it while serving in the armed forces from 1915 to 1919. It was a rude homecoming after the war for my grandfather and his new Scottish bride.

On my father's side, the family traveled by ox team across the plains to Oregon in 1853. There is an Everton Riffle on the Rogue River near Grants Pass in front of the old family ranch. My uncle was a river guide. My parents took my brother and sister and me camping every summer. We'd get in the station wagon loaded with a tent and sleeping bags and head off into the sunset.

I never stopped. Over two decades, I cowboyed, wrangled, packed mules, and ran rivers as a whitewater guide. I spent more time in a sleeping bag than in a bed. I carried a camera in my cantle bag, but the pictures never seemed to capture what I was feeling. I started using a panoramic camera because it succeeds like nothing else at capturing a sense of place—a West of unlimited horizons.

Macduff Everton

RANCHO TIXCACALCUPUL

30 AUGUST, 1999

Introduction | *Edmund Morris*

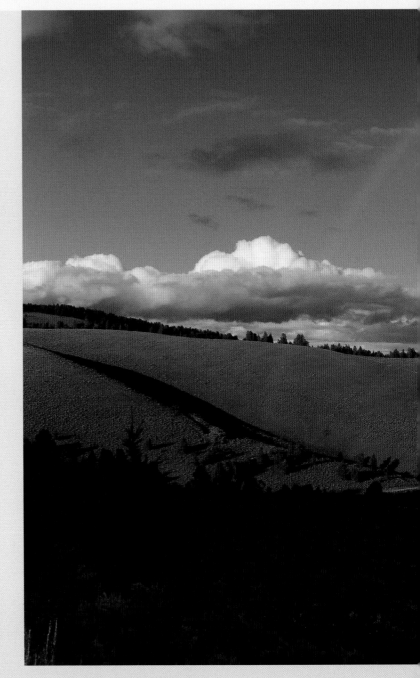

Westering is a beautiful word—archaic now, alas, but beloved of our seafaring and frontier-pressing ancestors. To *wester* is to thrust contrary to the world's swirl, into the teeth of its prevailing winds, to be undeterred by the constant dying fall of sunsets. Long before Columbus, blond men went westering, convinced that meadows and mountains lay beyond the hard blue line that only seemed to be the edge of the world.

Once the American continent was discovered, the westering drive of frontiersmen carved farms out of forest, linked rivers to rivers, and ran roads and railroads inland, farther and farther from the sea. The more they left familiar longitudes behind, the more the land flattened out and dried—trees thinning to prairie, prairie to dusty plain—while the sun got bigger and the sky's dome expanded in synch with the horizon. Finally (was this the end of westering?), a wall of mountains loomed up, white with forbidding snows.

Yet, on closer view, every interstice between the peaks offered a pass toward more possibilities. The mountains broke apart to disclose higher plains, but these proved so sterile that westering became less a desire to discover than an effort to flee the desolation of salt wastes and canyon lands. Just when the world seemed reduced to bedrock, two lesser walls of mountains gave way to an ultimate country of flowers and fruits, and forests so drenched with rain that beyond them there could be nothing but ocean.

According to Frederick Jackson Turner, "the existence of an area of free land, its continuous recession, and the advancement of American settlement westward explain American development." In other words, the national dynamic is powered by a sense of physical and economic limitlessness that in turn powers personal ambition. Nothing more graphically evokes this expansive feeling than the unconstrained Western horizon, which has so long fascinated artists, photographers, and cinematographers.

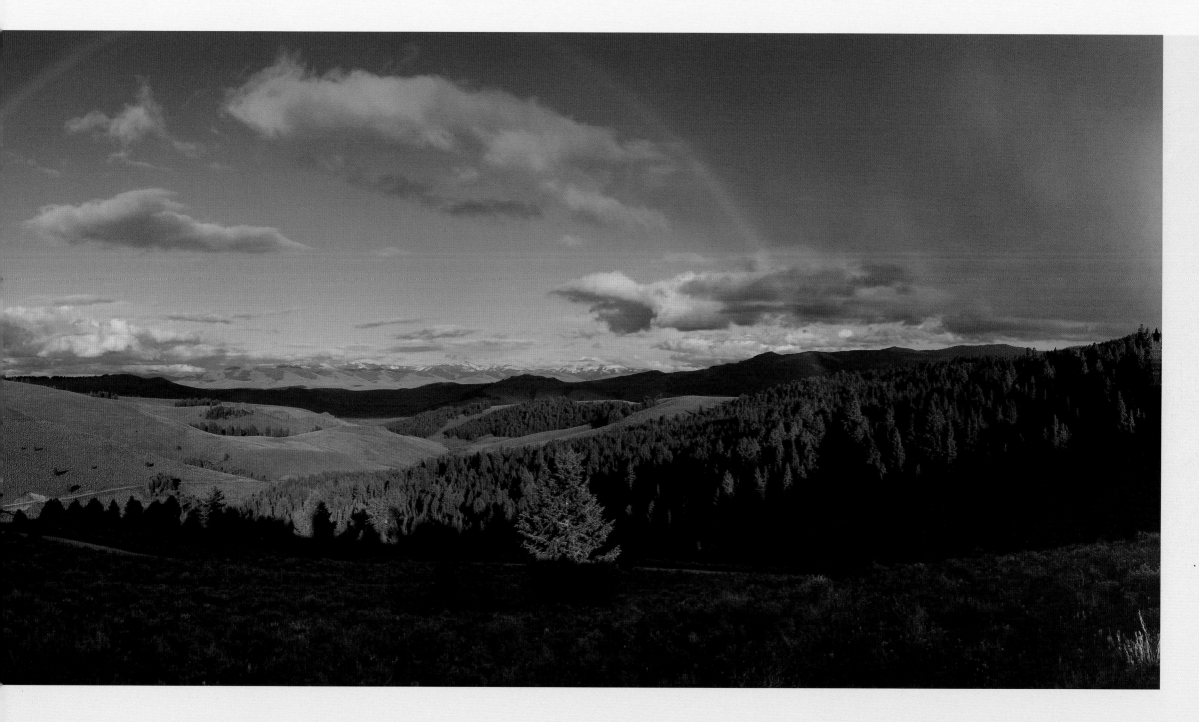

Horse Prairie Valley from Lemhi Pass | 11

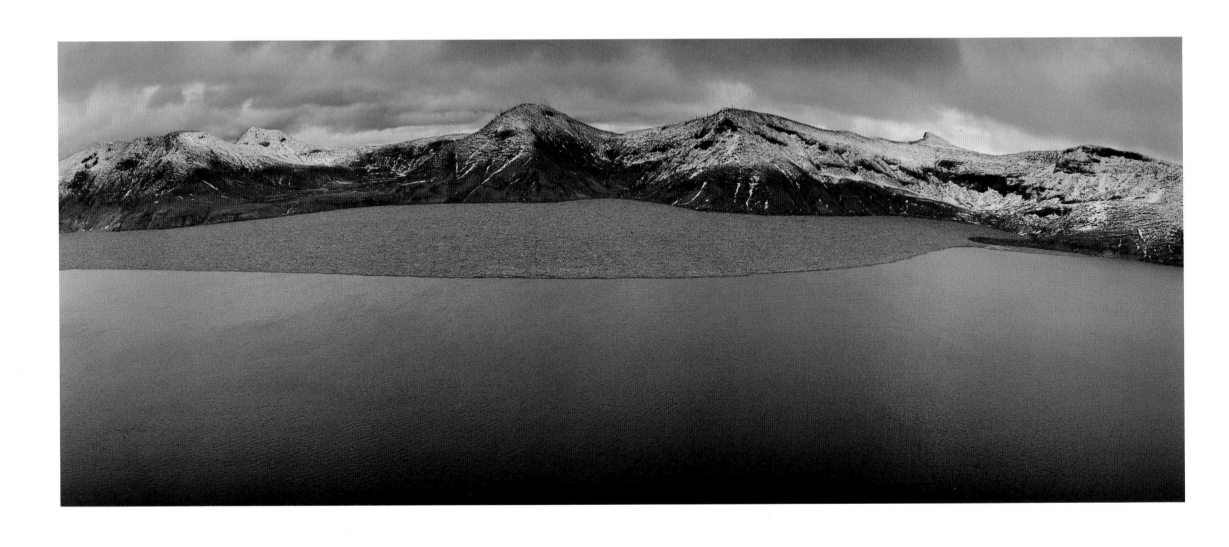

More than a century has passed since Turner enunciated his famous "frontier" thesis, and revisionist historians have long since delighted in pointing out that, as this Union now extends from sea to shining sea, we must look elsewhere than the West to sustain our dynamism. Economically, perhaps so—although nothing has been more remarkable in our recent history than the explosion of enterprise in the West and Southwest, fueled by a willingness to cross technological and intellectual frontiers of which Turner could not even conceive.

Spiritually, the westering impulse would appear to be as strong in us at the dawn of a new millennium as it was to Leif Eriksson at the dawn of the last. Only now we look on the mountains and deserts and forests beyond the Mississippi as welcoming and not threatening—consolatory, indeed, in their power to remind us that vast tracts of our country are still pristine. When we imagine the South or the Midwest or Northeast, we tend to project architectural clichés: white pillared mansions, grain elevators, skyscrapers, and smokestacks. When we imagine the West, all these puny structures crumble and blow away. Our mind's eye is at once filled with the clean sharp lines, the translucent color washes, the millionfold replicating patterns of a topography in which man has no part—except to protect and preserve.

It's a sentimental vision, of course: we know that if "American development" had its unrestricted way west of Denver, all mountains of any eminence would be as hideously highwayed as Pikes Peak, and malls and theme parks would uglify the spaces that are now perfumed with sage. All the more reason to imprint that Western vision ever deeper in the national psyche, to make our children understand that the real "gold in them thar hills" is spiritual rather than mineralogical.

The decline of Germany's Black Forest offers a cautionary case in point. About twenty years ago, statisticians in the Federal Republic began to notice a curious correlation between "forest sickness," caused by acid rain, and rising levels of depression reported by psychiatrists. Only gradually was the moral message perceived. Deep in the Teutonic soul lies the notion of *der Wald,* the green, many-chambered home of so many German heroes and heroines. If the security of that home should be threatened, then so was the inner security of the German people. Something similar would undoubtedly happen to our own self-image if the essence of our West were spoiled.

What cross-country air traveler, looking down on the landscape of, say, North Dakota under snow, does not thrill (especially at night, when each sparkling township lies in its own pale aura) to America's sheer immensity? And North Dakota lies only at the edge of the even vaster landscapes photographed for this book by an artist whose preferred "frame" is wide enough to give a surveyor vertigo.

It was there in 1886 (specifically, on a political platform just outside Dickinson) that the twenty-seven-year-old Theodore Roosevelt exultantly declared, "Like all Americans, I like big things; big prairies, big forests and mountains, big wheatfields. . . . I am, myself, at heart as much a Westerner as an Easterner." Only an Easterner would make such a claim, then or now. No Westerner would dream of stating the opposite.

TR first saw the Dakotas—or Dakota Territory, as it was then called—in 1883, when he came to the Bad Lands of the Little Missouri in search of buffalo. He managed to shoot but one remnant of this formerly fecund species, after many days of desperate pursuit. The chase was not so obsessive, however, that the beauty of the Bad Lands did not cast a spell over his strenuous soul. Ever literary, even as he thirsted for bison blood, he came up with two perfect lines from Robert Browning, to illustrate the look of buttes at dusk:

> *The hills, like giants at a hunting, lay*
> *Chin upon hand, to see the game at bay.*

Lincoln Lang, a teenage boy who befriended him at this time, acutely compared his "wild enthusiasm" for the West to "an ineradicable, creeping plant" that caused him "more and more to think in the broad terms of nature—of the real earth." It was the reaction of an asthmatic, congenitally ailing New York aristocrat to a world so spacious, so unpolluted, so stripped of urban comforts and social pretensions, that its very emptiness was therapeutic.

Roosevelt came back again in 1884 to stay, after a double bereavement that simultaneously deprived him of his young wife and his mother. In calendar terms, he remained little more than two years, ranch-

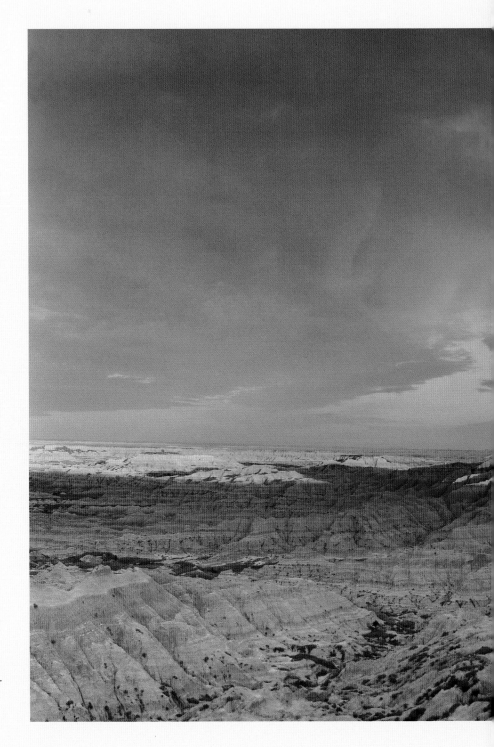

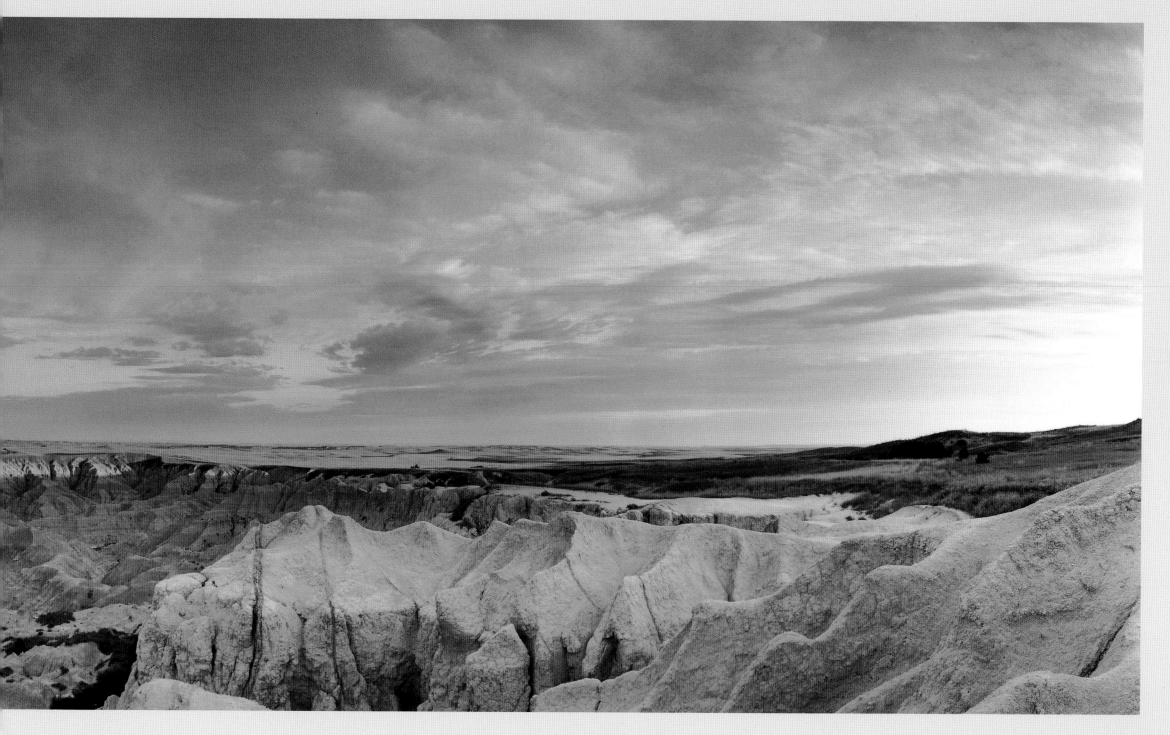

ing in what are now the south and north units of Theodore Roosevelt National Park. But in terms of physical and spiritual growth, he burgeoned to such an extent that by the time he made his Dickinson address, he was clearly destined for supreme power. "If it were not for my years in North Dakota," he wrote later in life, "I would never have become President of the United States."

TR inevitably looms over most of the landscapes in this book, not simply by virtue of his own westering instinct, but because, as the first of our "Conservationist Presidents," he signed many of them into a state of sacrosanctity. Other parks and monuments-to-be were cited for preservation in the great catalogue of national resources initiated by him in 1908. Subsequent Chief Executives seeking to follow his example have been inspired by the way the first Roosevelt used every resource of office—legislative barter, executive fiat, recess endorsements, and "bully pulpit" sermons—to create a permanent environmental commonwealth. Of timberland alone, he bequeathed to us almost 150 million acres—an area bigger than France, Belgium, and the Netherlands combined.

Hence, when we see pillars of rain supporting a pediment of cloud over the Grand Canyon, lit from within by flashes of lightning, we hear the long-ago thunder of his voice: *It is beautiful and terrible and unearthly . . . Leave it as it is . . . The ages have been at work on it, and man can only mar it.* When we look down that long wet road at Yellowstone, we picture him trudging off into the same black forest on April 12, 1903, the last President ever to enjoy the luxury of complete solitude in the wilderness. Those sleek buffalo in the Fort Niobrara National Wildlife Refuge owe an ancestral debt to him, as patron of the American Bison Society. Those waving Montana grasses—is it already more than a century since they cooled the flanks of his hot little pony, Manitou? Perhaps, in spirit, he still camps out on the misty ledges above Yosemite, listening spellbound (over John Muir's snores) to a "choir" of Rocky Mountain hermit thrushes, believing himself to be in "a place of worship."

Such, at least, are the associations that a Roosevelt biographer unavoidably attaches to some of the extraordinary landscapes Macduff Everton has captured in this book. Other sensibilities will react differently, yet most likely with the same sharp sense, image after image, that we belong in these sparsely populated spaces. Here is a photographer who identifies, to an almost aboriginal degree, with the American West. His camera feels out its contours, explores its mysteries, stares unblinking at its acts of savagery (has the sheer *force* of the 1980

Mount Saint Helens blowdown ever been more shockingly evoked?), and celebrates its beauties with a constant sense of joyous rediscovery, quite different from the alienation, even terror, we can feel in the works of pioneer photographers.

"There are two ways," Schiller wrote, "that Nature without living creatures can become a symbol of the human: either as representation of feelings or the representation of ideas." Everton has no didactic purpose, no ecological or political message to convey, except the oldest and most reassuring lesson of nature, exemplified by the thick green reforestation of Mount Saint Helens: that life will always spring out of apparent sterility. He simply allows our Western horizons to unfold before us, in images so wide that they extend common perception. As a result, the phenomenon of landscape as memory, first articulated by Schiller, begins to work. *This is my own, my native land,* one feels oneself saying, as page succeeds page and familiarity combines with strangeness.

Those Joshua trees—a vegetative form found nowhere else on earth—seem to hail us with uplifted arms, even though they stand sentinel over one of the most forbidding landscapes in America. That enormous toadstool of cloud over Wupatki, Arizona, eerily recalls the one lowering over Los Alamos, New Mexico, on July 16, 1945. Yet we thirst for its rain, as does the dry sagebrush at our feet, with no sense of need for shelter. Crater Lake, an improbably bowl of sapphire blue floating high above Oregon—what mysterious springs keep it so pure? Everton's godlike camera presents a view of magical complexity, wherein the lake (necklaced with thawing snow) seems to consist of sky and clouds as much as water, and the mountain's hidden peak is transformed into an island. One does not have to be an Indian to feel that something divine is encapsulated here.

Perhaps the most enduringly American image in the book is that of Mount Shasta, California. In the foreground, a split rock, above whose dry cleft the distant summit struggles toward the sky. In conventional metaphoric terms, it might represent our national dream. But tilt the photograph rightwards up, and that foreground rock suddenly morphs into the profile of a dead giant, half Mongolian, half Indian, chin-bearded, huge-helmeted, his cruel mouth agape, his nose shattered in some elemental battle. If there is memory or dream here, it is petrified, forever reminding us that whatever peaceful heights we may hope to attain in our westering, we can never quite escape the savage East of our past.

The Great Plains

Sand Hills, Nebraska

The Great Plains have been a treeless grassland for more than 10,000 years. Residue of a far more ancient sea—sediment, sand, and silt— mounded into bosomy hills, filled with birdsong and emptiness. A long tongue of prairie ranging across Montana, the Dakotas, Wyoming, Nebraska, Colorado, Kansas, and into New Mexico and Texas, at approximately the one-hundredth meridian, the Great Plains have been called both paradise and wasteland, depending upon how hope weighed against observation.

To Native Americans, the Plains were a sere land beneath a changeable sky, yet it rode upon an immense aquifer and was home to a wealth of game—a giving land if one knew how to take. For immigrant adventurers, it was an endlessly horizontal impediment, the Great American Desert. A prairie receives only ten to fifteen inches of rain a year, but it is not truly a desert. Major Stephen Long coined the phrase while on an exploratory expedition in 1819, and it appeared afterward on maps and globes for more than fifty years. Prairie is not lush land, but the virgin soil, cut by neither plow nor tractor before the arrival of western settlers, provided a good habitat for 70 million bison, 40 million antelope, elk, bear, numerous burrowing animals, and a wealth of migratory birds. The movement of large herds aerated the soil, grazing stimulated fresh growth, and the animals fertilized the land.

The Sand Hills region is the largest dune area in the Western Hemisphere, stretching for 265 miles across the prairies of Nebraska and into South Dakota. Bunch grasses grab the dunes with their fibrous root systems, tenaciously laying claim to a thin cowl that covers and stabilizes the sand. Knotted switchgrass, spangled love grass, Indian grass, bluestem—these pencil-thin monocots speak the language of wind. The mid- and tall-grass prairie looks like the product of fast-action animation as it mimes the wind's every movement. Grasses tease the wind out of the air, and a field moves as one being, rattling, waving, making serpentine shapes, shimmying, as it is whipped and combed by the wind. A landlocked wooziness akin to seasickness can overtake the traveler enveloped within sandhills so broad and undulant. One's feet are

hardly an anchor in a land without landmark or tree, only the unstoppable woolly grasses in all four directions.

Wind brings the scent of a storm. The land buckles under heavy, thunderous skies; the air is electric, the sky smolders. Smears of yellow light seep from gaps in a cloudscape that runs a chaos of shadows over the terrain. Mammatus pouches of rain sag from black clouds—and then the rain plummets, hammering the ground. Sheet lightning illuminates an inky sky, its branches stabbing the dunes with a tympanic, stereophonic, cracking magnificence. If ever weather had an orchestra pit, it would be the Great Plains.

The grasses are raspy, the sandy soils are porous, and large groundwater reserves collect beneath the Sand Hills. The area is veined with the Snake, Platte, Niobrara, Loup, Calamus, Elkhorn, and Dismal Rivers, and numerous creeks, all fed by underground water. The dunes are flecked with pools of water. Some are transitory, depending on rainfall and snowmelt, whereas others exist year-round, ringed with black reeds, providing a nesting ground for gadwalls, mallards, blue-winged teals, and other birds. The Central Flyway cuts through the Sand Hills, and every spring more than 150,000 migrating ducks, as well as sandhill cranes, trumpeter swans, great blue herons, white pelicans, and many songbirds, enjoy the wetland and the smooth sail above the flats.

Since the seventeenth century, trappers and traders, artists, and naturalists explored the land west of "civilized" America. Their images and stories became America's collective dream. To Thomas Jefferson, settling the Plains was an imperative tinged with his own aspirations of empire; he conceived of one undivided nation spreading from ocean to ocean. Jefferson was dedicated to space exploration, like John F. Kennedy after him. In Jefferson's day, however, "outer space" was the western half of the continent. Similar to the race to the moon, scientific

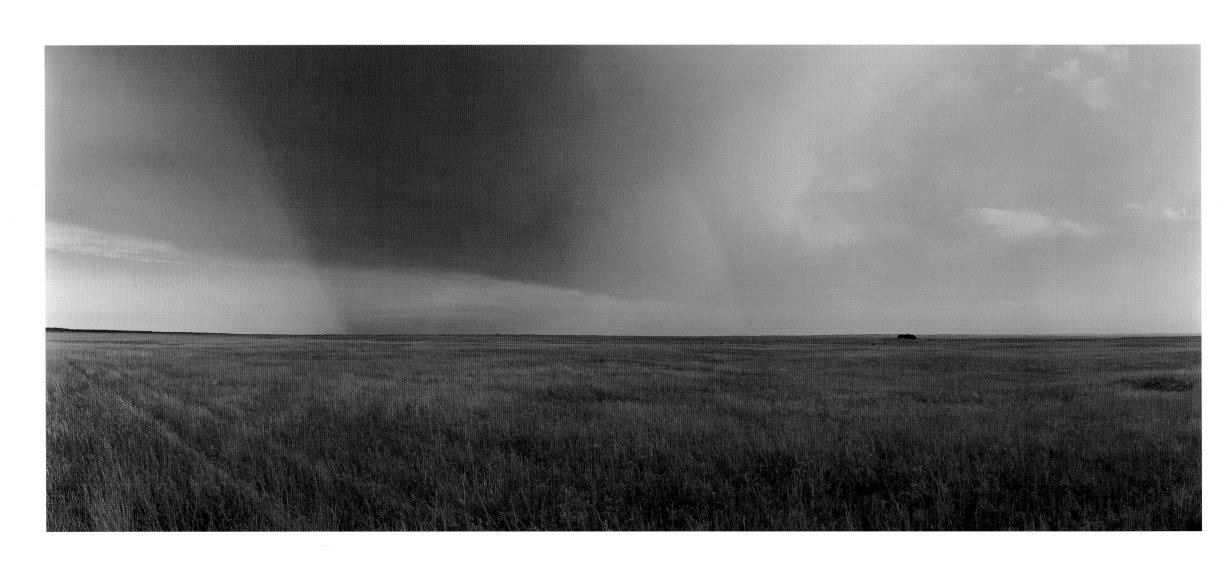

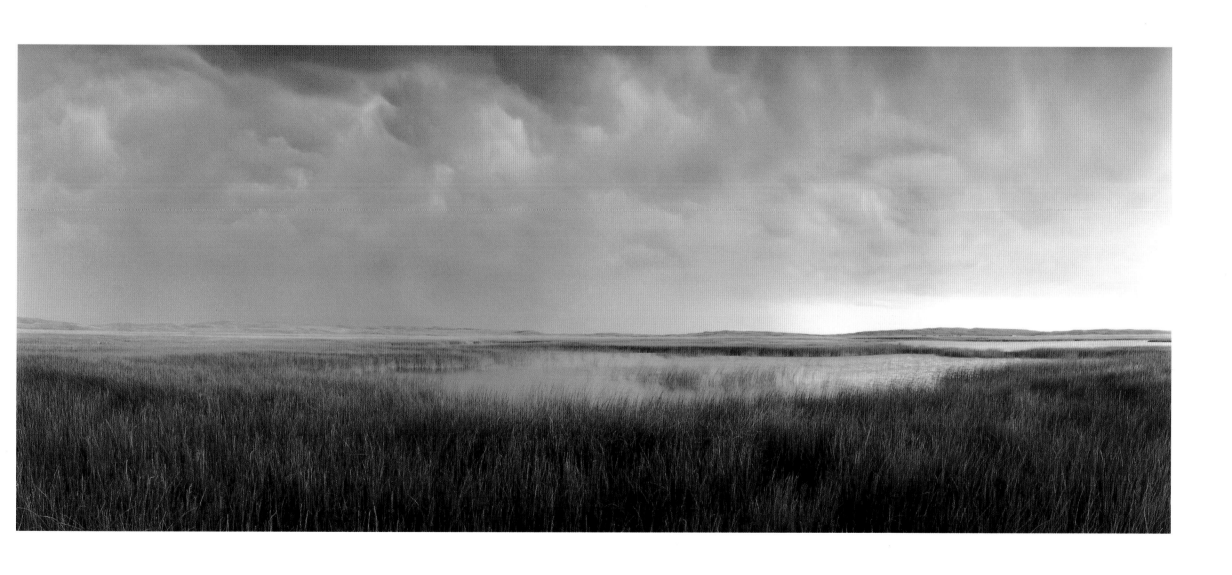

inquiry in the frontier promised to serve the country's economic and military interests. To this end, Jefferson negotiated the Louisiana Purchase in 1803. He imagined futuristic forms of travel by air balloon and by rail, because beating time seemed the only possible way to knit so vast a territory together.

The question of whether a transcontinental railroad should take a southerly or northern route was decided by default when the South attempted to secede. In 1862, the Pacific Railway Act chose to build along the fortieth latitude; the Union Pacific would build from east to west, and the Central Pacific would race to meet them, building eastward from Sacramento. The railroads were paid and given land grants for each mile of track they laid, and eventually the railroads amassed acreage close to the size of Texas. Even today, corporations descended from railroad companies are among the largest private Western landowners. Free ranges were now spliced and inscribed with permanent lines of commerce.

Cattle replaced the herds of bison in the Plains. However, in the mid-1880s, problems caused by overstocking and overgrazing were worsened by severe drought and the freezing, wind-wracked winter of 1886, which decimated thousands of cattle. Many people gave up ranching altogether, and most ranches that remained were owned by large investors. Smaller ranches that survived had to reduce their herds to a size they could feed year-round. Some of them pioneered the way for today's preferred rangeland management: they learned, among other things, the long-term benefits of pasture rotation, which distributes grazing pressure and allows the hardy but fragile grasses to rejuvenate. The Nebraska Sand Hills are one of the last extensive unfragmented grasslands in the United States.

The passing traveler driving along country roads is corralled within a narrow strip of asphalt, but on designated preserves a resurgence of bison, elk, and other wildlife are left to roam. The open space of the prairie, however, is no longer made of whole cloth: today it is a patch-work, mended with fences—a coalition of brands, a tight network of neighbors assuaging distance and isolation.

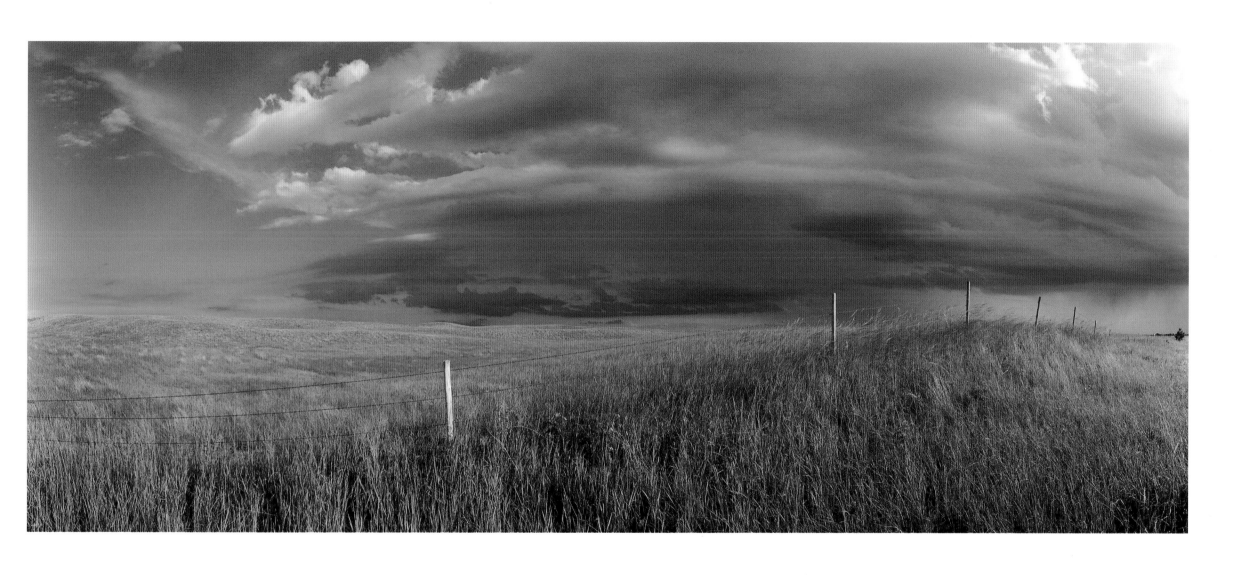

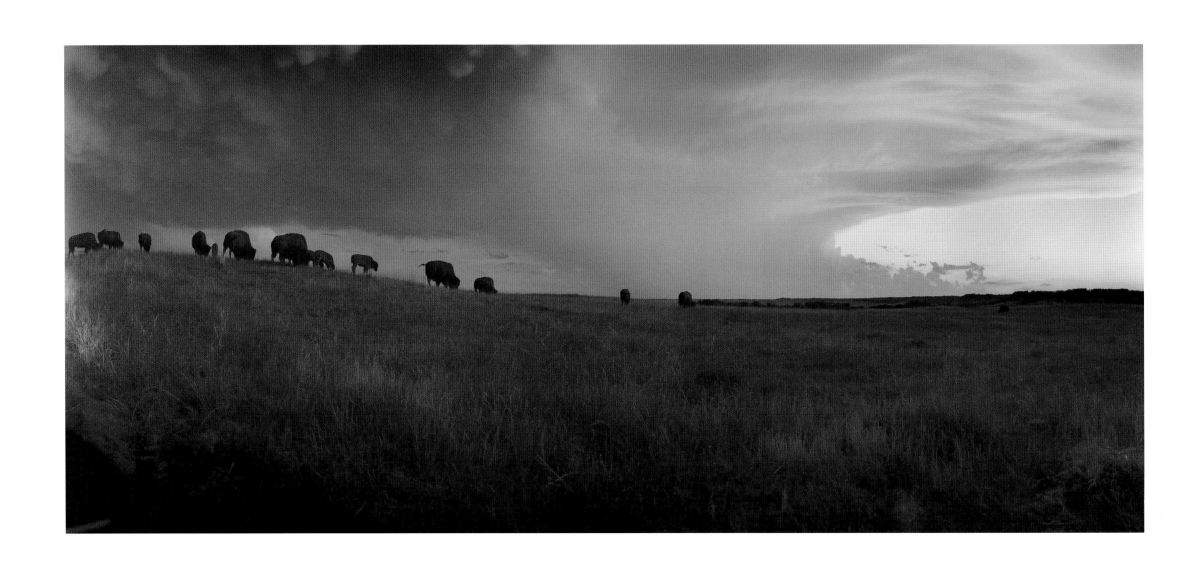

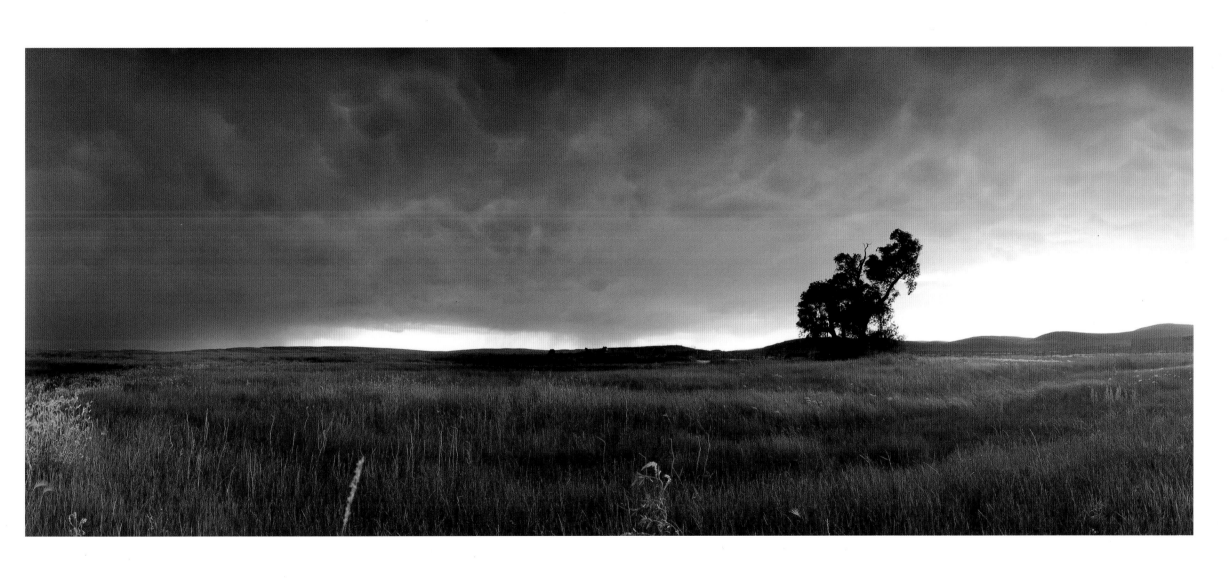

Badlands National Park, South Dakota

A prairie's horizon is at the edge of eyesight. In twilight, the shadows of a falling night cast a denim haze over the flats, which are as expansive as an ocean in depth and in breadth. Odd wedges of land, whittled by water and wind, sawtooth the sky. Beginning with steady and regular deposition of silt and river sediment, time is laid down flat and neat like ruled notepaper primed for a geologist's annotations. This is old and uncomplicated land, and the only way to survive here is to conform to its enduring rhythm.

Long ago an inland sea washed over the Great Plains. To the west, the Pacific and North American plates collided, volcanoes erupted, and the system of the Rocky Mountains emerged. This genesis caused the sea plains to rise and the water to drain away, leaving subtropical forests where prehistoric pigs, horses, tortoise, and rhino browsed on leafy plants. The climate shifted and dry periods inundated by tremendous floods began to carve out the gullies, buttes, and wide prairies known as the Badlands, in the Dakotas. Innumerable mammals were caught in the floodwaters, and their bones created one of the earth's richest fossil beds. Nearly every natural history museum in the world has fossils and reconstructed animal skeletons from the southern Oligocene deposits of the Badlands. These fossils also proved invaluable in the uphill battle to pit theories of evolution against time-honored creationist dogma.

The White River Badlands erode about an inch a year, outpacing deposition, and it is a wonder that the region still exists. A single thunderstorm can sculpt dramatic changes in the wafer-thin protrusions and pinnacles, softening the formations to the consistency of muffin batter, carvable with a spoon. They look and feel like warm stumps of a million melted candles.

Approaching from the north you can miss the Wall, the backbone of the Badlands, sunken within 100 miles of dry South Dakota plain. But drive the southern route and the Wall rises like a ruined city, compressed spatially and of such slight gradation in color that the flanges of rock seem veneered together. Layers of fluted pinnacles masquerade as each other's shadows.

The human history of this area is rife with violence. It is the site of the last confrontation between Native Americans and whites in this country's long and shameful history. The 1868 Treaty of Fort Laramie set aside land for the Sioux, including the Black Hills and the surrounding area, which the Indians considered to be sacred. But the Black Hills contained massive deposits of gold, and the United States reneged on the treaty nine years later. The General Allotment Act passed by Congress in 1877 subdivided ancient tribal lands into 160-acre lots, one for each nuclear family—a system that was completely alien to the Native Americans' communal way of life. As much as half of their land was "left over" after the allotment, which was then auctioned off to white settlers.

In 1890, 350 men, women, and children followed Miniconjou Chief Big Foot through the ragged ravines of the Badlands to Stronghold Table, an elevated mesa in what is now the South Unit of Badlands National Park, in the Pine Ridge Indian Reservation. The people were depleted by hunger and disease, and the loss of their land had further eroded their cultural heritage. Suspending disbelief, many Indians heeded the apocalyptic message of Wovoka, a Paiute raised by white missionaries, who blended a brand of Native American religion with Old Testament fire and brimstone. He led his followers in a pan-Indian Ghost Dance, an unending trance-dance of purification through exhaustion, which would bring about a return to the days before the whites had arrived on the continent: the Ghost Dance promised the resurrection of the Indians' dead brethren and the buffalo, and the disappearance of the *wasichu*—white man— from their beloved plains forever.

Hundreds danced their hearts out for five days on Stronghold. Some native elders, like Sitting Bull, remained skeptically removed, pained at the desperate situation of their people. A Pine Ridge participant, who remembered joining the Ghost Dancers as a young boy, told Sioux anthropologist Ella Deloria, "I suppose the authorities did think they were crazy—but they weren't. They were only terribly unhappy."

Whites in the region, nervous and fearing an uprising, summoned the U. S. Army. Twenty-five miles to the south of Stronghold Table, at Wounded Knee, the army encountered the Indians as they were making their way back across the difficult terrain. The army forced an encampment and then massacred approximately 300 Sioux. They were buried in a

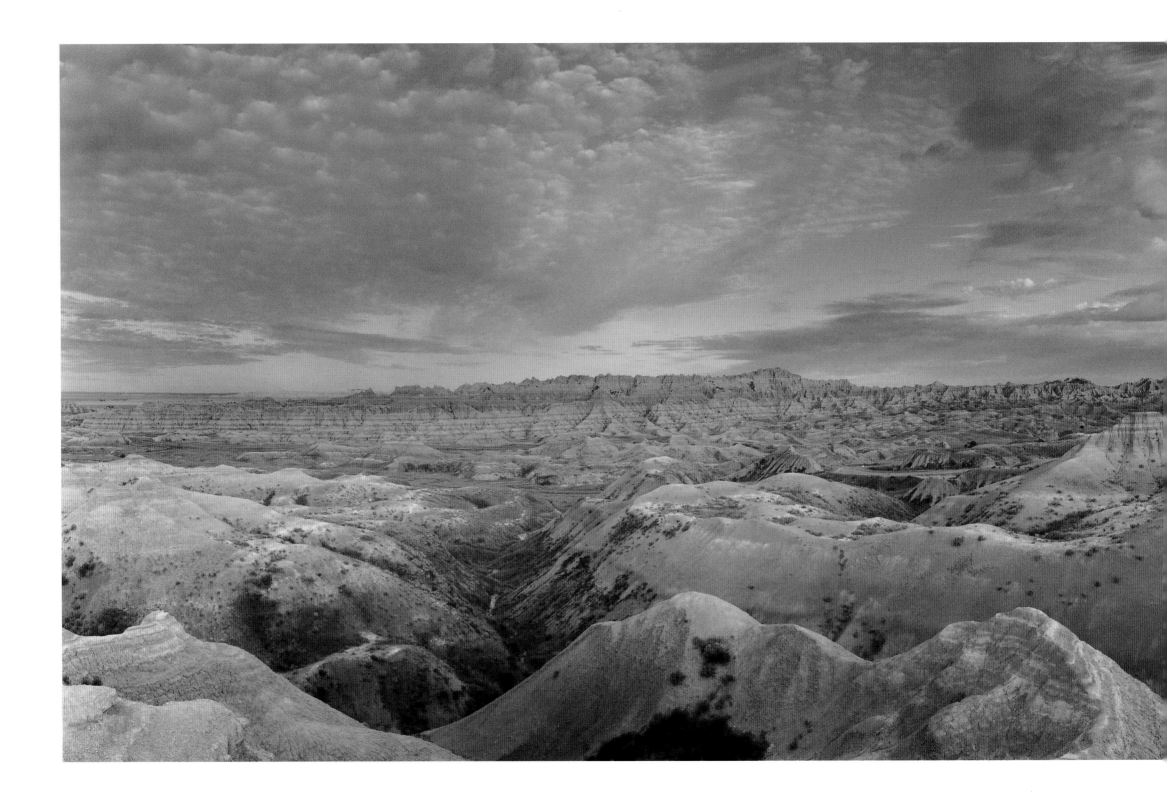

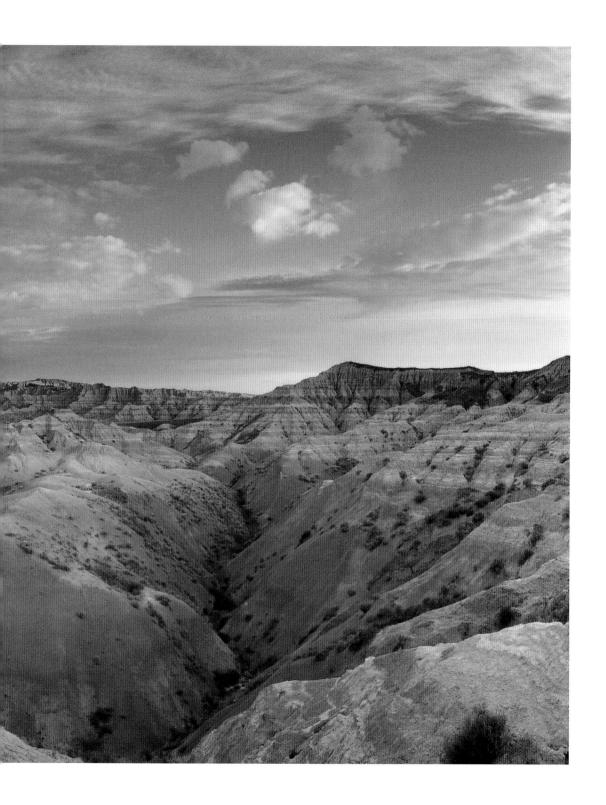

mass grave. The Indians' very presence, their differentness, fueled America's passion to obliterate them. Uneasiness with their language and religion, their claim to the land as their home, and their remarkable strength and endurance soured into a calculated plan that is termed ethnic cleansing today. At the time of Wounded Knee, the Indians had already been defeated—stripped of their lands, forced onto reservations—but the army took advantage of the moment to commit further genocide.

In 1973, 200 members of the American Indian Movement took control of Wounded Knee for seventy days before they surrendered to federal marshals. They declared an independent Sioux Nation and demanded a review of all government treaties. Again in 1990, several Lakota reenacted the ride from Pine Ridge to Wounded Knee, "to release the spirits of their ancestors and to mend the sacred hoop."

Once the Indians were restricted to reservations, the plains became severely overgrazed, clouded with insects, and stricken by drought—badlands only an inch away from turning into desert. Thousands of "sodbuster" families were driven westward, hungry, desperate, and homeless. The winters and the devastating droughts of the 1920s and 1930s were a cruel blessing. The settlers suffered untold hardship, but the abandoned prairie had a chance to heal. Grasses slowly returned, the water table stopped shrinking, animals multiplied. In the 1930s, President Franklin D. Roosevelt and Secretary of Agriculture Henry Wallace ini-

tiated a program that taught farmers to plant windrows of trees, called shelter belts, to protect against the wind, curtailing the dustbowl effect on damaged lands.

Beginning in 1909, South Dakota Senator Pete Norbeck spearheaded efforts to designate the Badlands as "a place of uncompromising beauty," the guideline qualifier for National Park status. But the Badlands were no Yellowstone. How could something called "bad" be any good? The shriveled formations demanded a complex appreciation. The land has a cronish beauty, beyond use, but which helps to keep the planet's geologic memory alive. The Badlands were finally designated a National Park in 1978, co-operated by the National Park Service and the Sioux Nation.

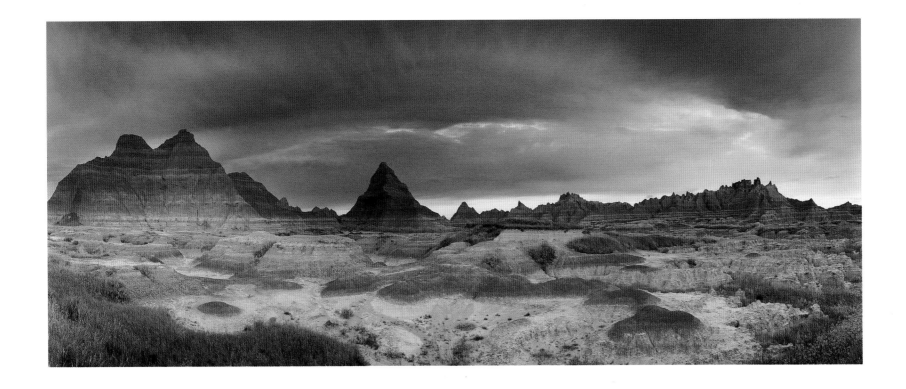

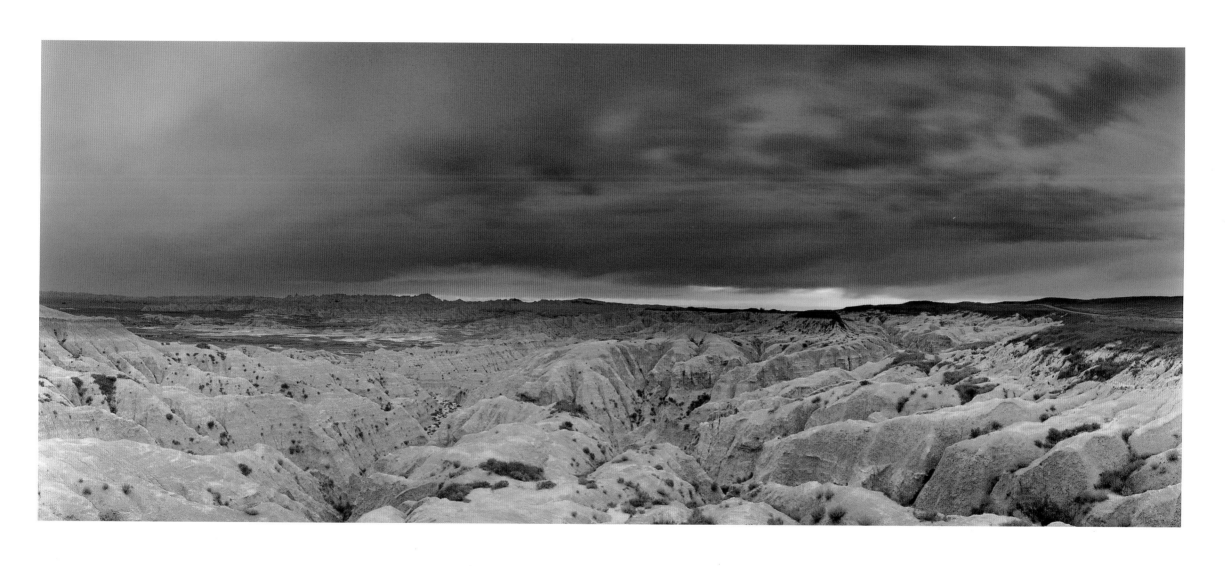

Theodore Roosevelt National Park, North Dakota

The Great Ice Age began three million years ago and peaked 20,000 years ago. It seems a very long time ago—it *was* a very long time ago—and we forget that we are still in an age of ice. We are currently experiencing a warm phase within the ever-changing universe whose cadence is too slow for us to fathom, too imperceptible to hold in mind. At the end of the last Ice Age, approximately 10,000 years ago at the beginning of the modern climatic era, the mammoth, giant bear, camel, and horse became extinct in North America. Evidence suggests that, in addition to climatic changes, early humans hunted these massive creatures to extinction—thus, man killing off entire species is not only a recent phenomenon.

The great bison of the Ice Age perished, but a smaller, fitter cousin survived. The bison has a natural helmet of fat, fur, and muscle; bison stand and face approaching storms, because their heads are the most protected part of their bodies. A bison appears mythic from its majestic, ursine front to its powerful shoulder and leonine loins; its bearded profile conjures up the cave walls of Lascaux and the jazz great Thelonious Monk. The sound of bison stampeding across the flatness rivals the thunderheads above. Felling a bison on foot in this terrain was no easy task. As a Native American park ranger says, describing the terrific speed of the animal, "A full-grown bison can go from nothin' to thirty-five in nothin' flat. He can turn on a dime and give you nine cents' change."

When the Ute and the Plains Indians appropriated the horse, which had been reintroduced by the Spanish to the Americas in the sixteenth century, it revolutionized the way men had hunted bison for millennia. John Fire Lame Deer, a Lakota Sioux medicine man, said, "For bringing us the horse, we could almost forgive you for bringing us whisky. Horses make a landscape look more beautiful." For the first time, Native Americans had the wings of Pegasus and could fly across the prairie.

The United States government, eager to inhabit its expanding boundaries, initiated the Homestead Act in 1862. Land was given away west of the hundredth meridian in checkerboard allotments. Ridding the plains of bison to make way for cattle paralleled the systematic and calculated removal of the Native Americans to make way for the new Americans. Bison were picked off like ticks on a green rug. It was a heyday for "buffalo hunters." The slaughter was quick and nearly absolute. Bison became tanned chamois cloth, fur coats, trophies, and rotting

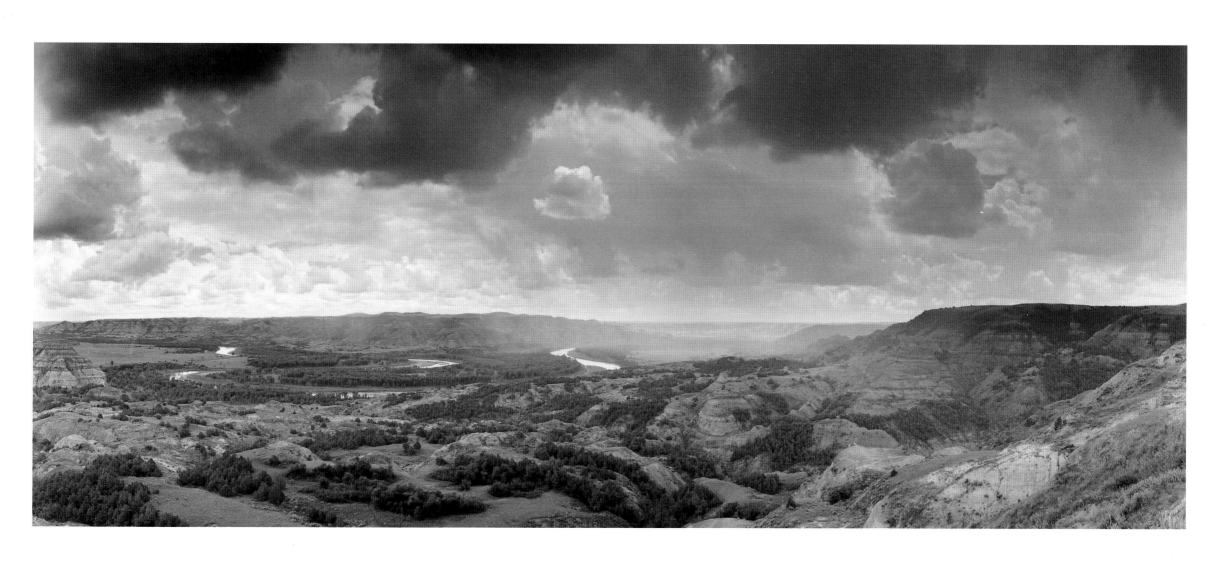

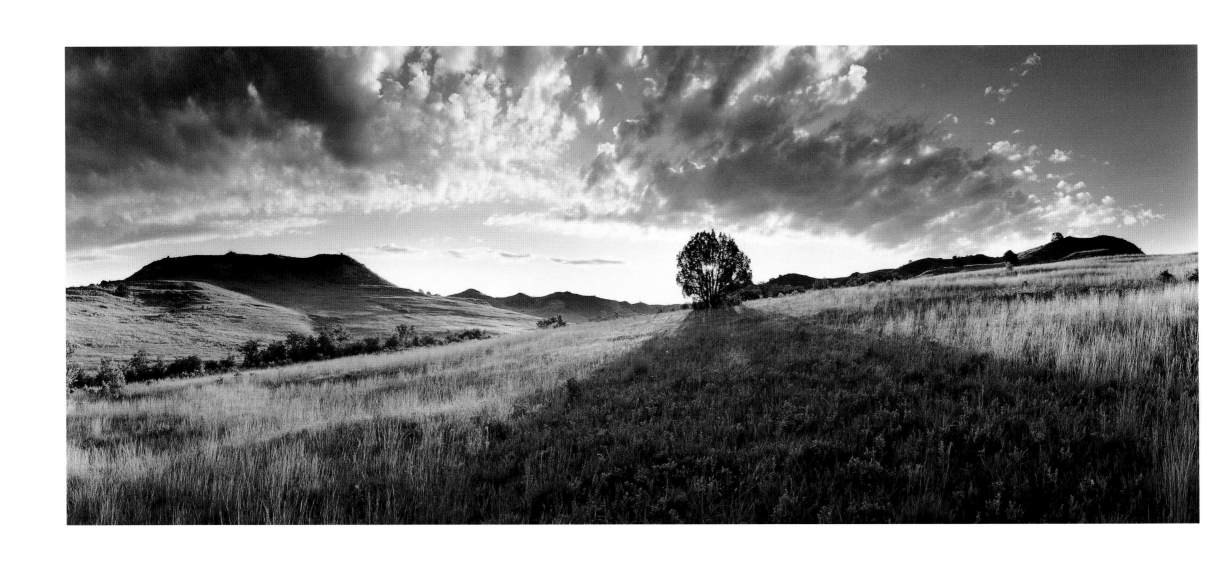

corpses so innumerable on the plains that the stench carried for miles. In 1800, 60 million bison, 40 million pronghorn, and countless species of birds and mammals prospered in the American West. In 1899 only 100 bison remained, only eleven of which roamed in the wild. An ancient way of life was erased in a historical nanosecond.

In 1883 a twenty-four-year-old New Yorker lost his wife during childbirth and his mother died of typhoid on the same day. He sought the comfort of raw winds and open sky to ease his grieving heart. Certain places can work on a person, change their lives forever, and the western plains had this effect on Theodore Roosevelt. He came to hunt bison, American-safari style, which was popular among the nineteenth-century elite. North Dakota rains and chill invigorated him, but two weeks passed before he spotted a single bison.

Roosevelt bought grazing rights for 400 head of cattle on the Maltese Cross Ranch and then bought the Elkhorn Ranch, gaining the respect of fellow North Dakotans. He rode, worked, loved the land, and was broken, along with countless others, by the Great Freeze of 1886–87. He lost 65 percent of his stock, and this experience taught him the complexities of the problem. Homesteaders had been dealt from a stacked deck. Allotments of 160 free acres were handed out to families, plots determined by ruled lines on paper without regard for the lay of the land. To make matters worse, a pseudo-scientific theorem that preached "rain follows the plow" encouraged countless farmers, with the hopefulness of the poor, to tear into land that had not been disturbed since the last Ice Age. As they waited for the promised rains to come, the settlers ran cattle continuously over small plots and tried to grow wheat until the earth and their dreams turned to dust.

Roosevelt went west to heal his heart, but he discovered that this new country needed help as well. During the eight years of his presidency, Theodore Roosevelt pushed forward the 1906 Antiquities Act to establish National Monuments, doubled the number of National Parks, established numerous wildlife refuges, and, at the urging of Gifford Pinchot, created the United States Forest Service.

From mid-1700 until the turn of the nineteenth century, our young country opened up the western frontier like a box of Turkish delights. It was sweet, exotic, and absolutely addictive, and Americans gorged on it—they nearly consumed it all. Roosevelt predicted that the greatest challenge of the next century would be to mitigate the damage done to this environment, to replenish and restore, conserve and revere our precious and finite resources. He stated: "There can be no greater issue than that of conservation. Just as we must conserve our men, women and children, so we must conserve the resources of the land on which they live."

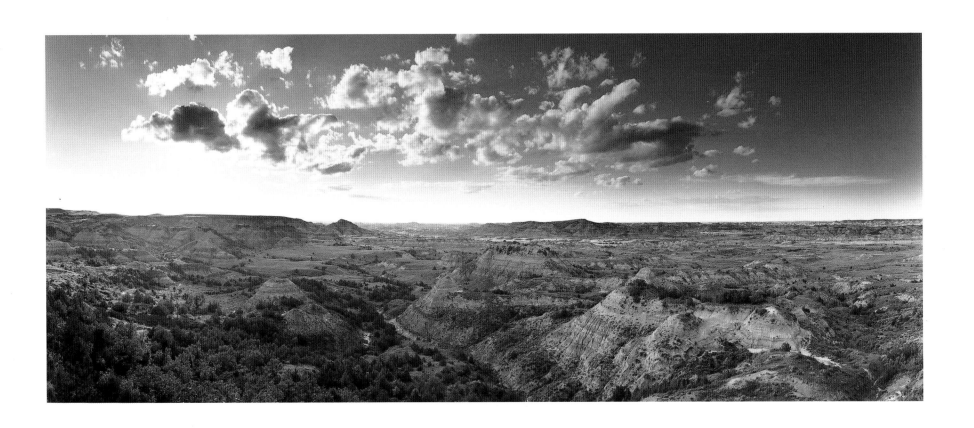

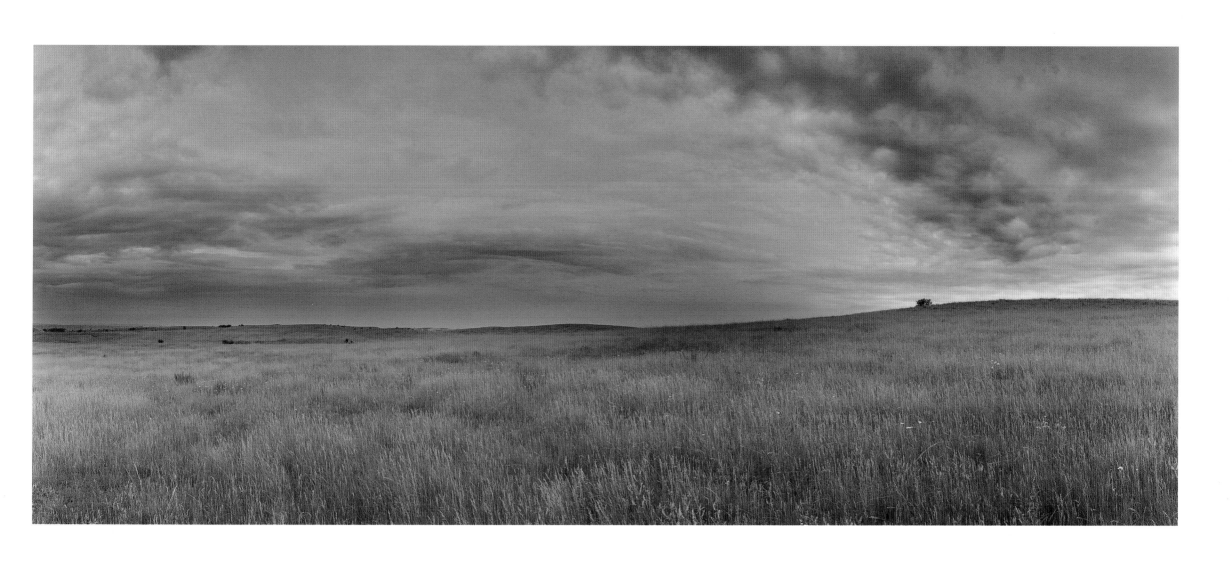

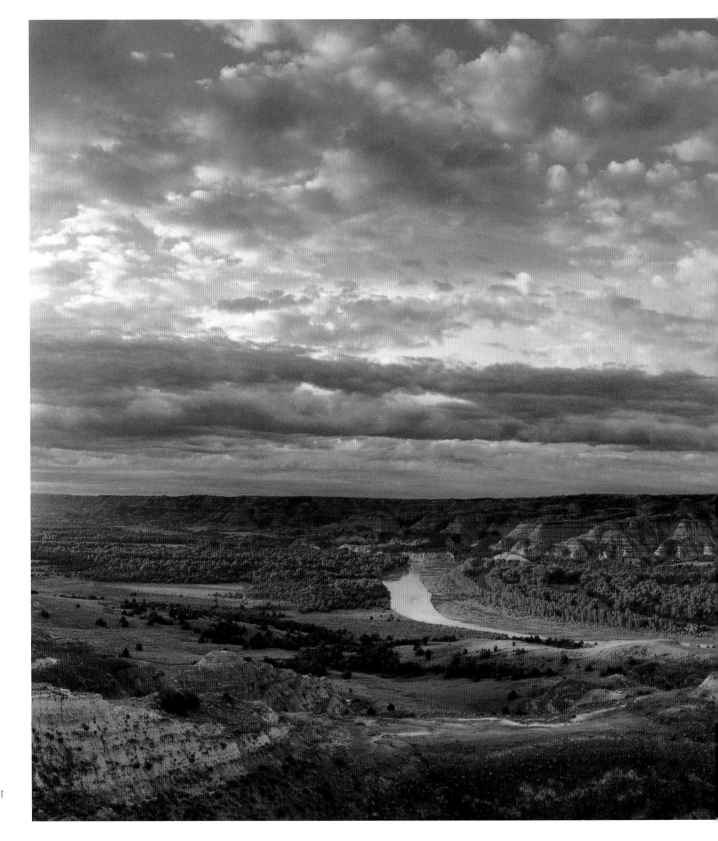

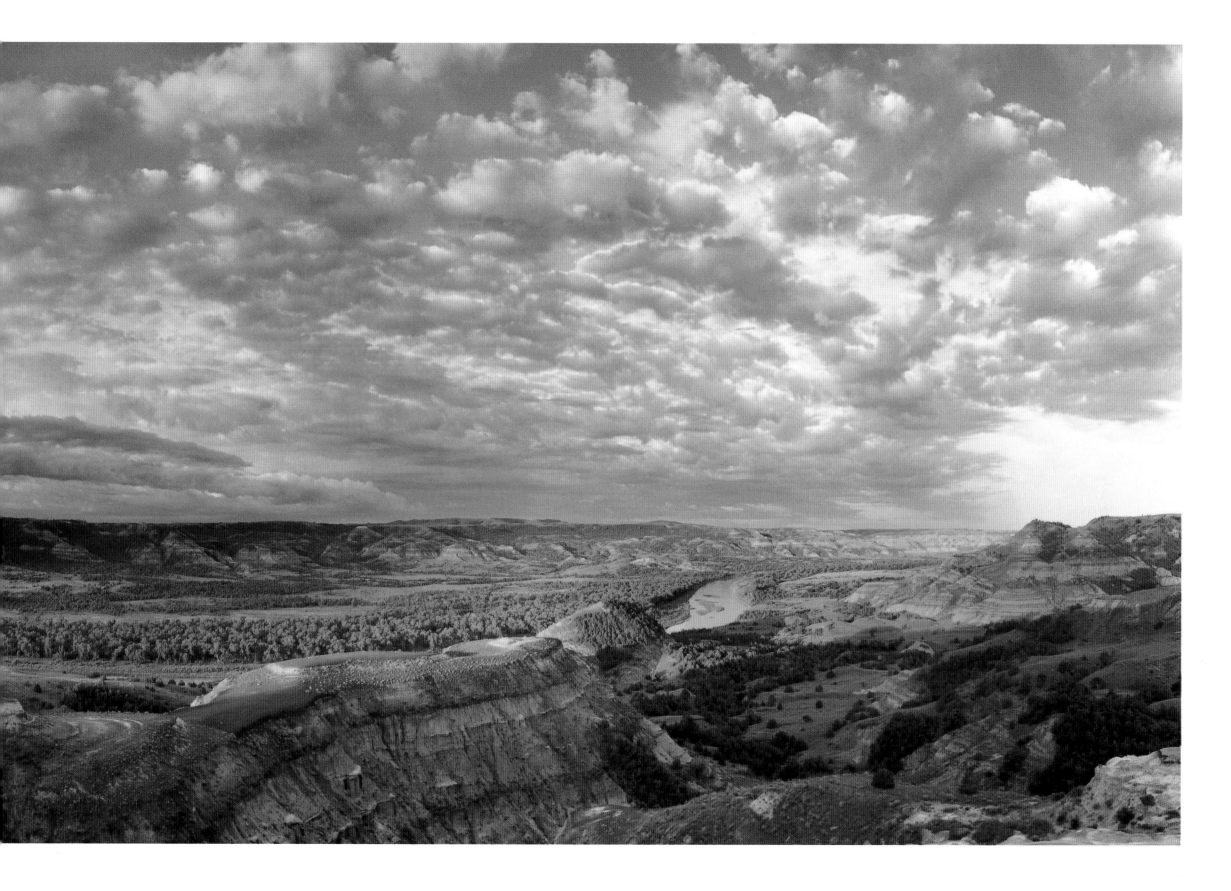

Montana Prairie

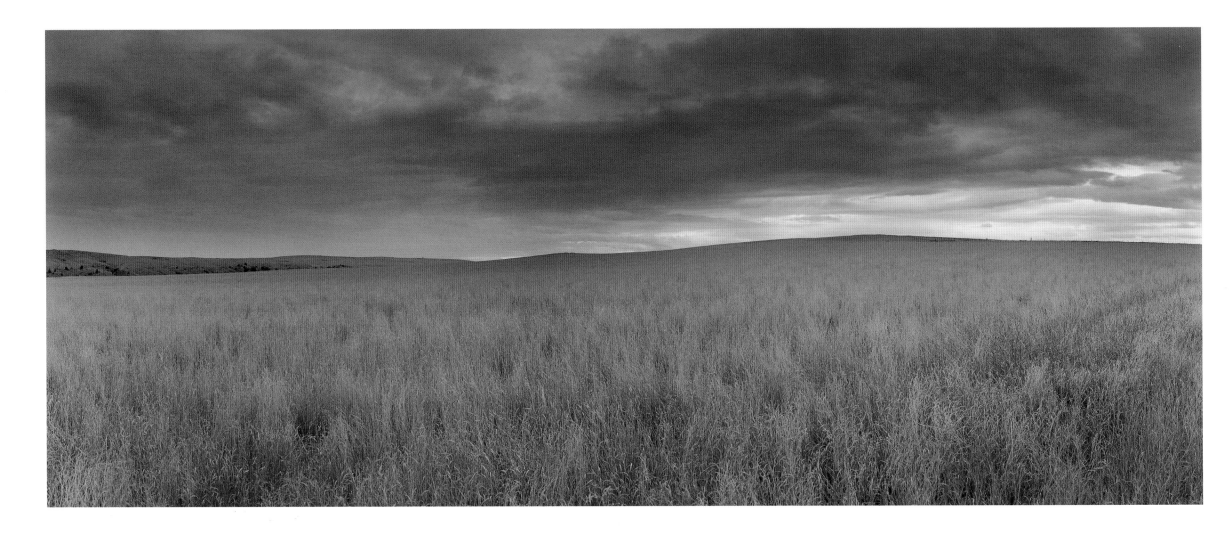

The prairie is amplitude inundated by storms, splashed with a changing palette of wildflowers, and swabbed with clouds. A dense impasto of grasslands extends for acres. Black Angus cattle, the bluish color of Indian hair, are hemmed in by wood post–and-wire fences. In the mid-1800s, hundreds of ranchers here refused to sell their land to the railroads, an unheard-of stubbornness. Now this is prime beef and hay country. Bales of hay are stacked high as houses. Landforms are called what they look like: a saddle, a hollow, a bar, a break, and a bench. A cowboy's lexicon has more words for open spaces than there are ticks on a coyote.

Not every nineteenth-century artist was lured to the West. Propping a canvas up against a tree in a dust-blown prairie was the antithesis of parlor painting. But the curious, flexible, and hardy embraced the bizarre and exuberant frontier. Frederick Edwin Church consumed the visual world, cataloguing everything that came his way as he traveled the world, especially the North American continent. German-trained Albert Bierstadt's heroic paintings took in the scenery with the entranced eye of a tourist or a convert. Thomas Moran's atmospheric luminescence swerved from charged minimalism to loopy idealism.

While John James Audubon was determined to depict every species of bird in North America in their natural habitats between 1827 and 1838, his contemporary George Catlin was with the same fervor making trips to the western territories and painting portraits of every indigenous tribe member he could persuade to sit for him. Each criticized the other for romanticizing his subjects, and each knew at gut level that what they were both documenting was vanishing faster than they could paint.

Nothing in the colonial imagination prepared Americans for the openness, the extremes, the majesty of the West; no landscape along the eastern seaboard could anticipate the sheer bigness, the raw geology. The artist's mind, like a prairie, was a blank canvas upon which the American West imprinted its new horizons.

Breaks of the Missouri, Montana

"I do not know much about gods; but I think that the river is a strong brown god—sullen, untamed and intractable," wrote T. S. Eliot. Hereclitus said that you can't step twice into the same river. In his travel log, British geographer David Thompson translated the Mandan name for the Missouri River to mean "troubled water." These are pictures of a river that are metaphoric and evocatively real.

A map, too, is an abstract metaphor that attempts to describe a real place. On a map, however, the thickness of a drawn line can mean the difference between a stream and a raging river. An unsure line, an offhand improvisation, can have consequences beyond imagining. In the late 1700s David Thompson made painstakingly accurate maps for the Northwest Company of Canada. He was perhaps the greatest geographer in North American history, credited with discovering the source of the Columbia River and finding several routes over the Canadian Rockies. Thompson's "Map of the Northwest Territory of the Province of Canada" was referred to by cartographers well into the twentieth century. In addition, he was an astute naturalist, taking copious notes on the topography and natural life he observed in the more than 50,000 miles he traversed on foot, horseback, and canoe in his lifetime. He charted astronomical sightings, was a linguist and a builder, and recorded aspects of Mandan life with an anthropologist's attention to detail. Thompson received little attention in his lifetime and died penniless, yet his maps were traced and retraced by countless others.

British cartographer Aaron Arrowsmith copied Thompson's map and injected his own revisions in 1802. The U.S. government surveyor Nicolas King worked from both Arrowsmith's and Thompson's versions to create one map that would incorporate the two. However, in the process of transferring data and reinterpreting the original charts, whole mountain ranges disappeared, rivers that were miles apart were drawn as one solid line. King's map was used by Meriwether Lewis and William Clark when they explored the Louisiana Purchase between 1804 and 1806. Because the map showed the Lesser Missouri River interlocking a southern fork of the Columbia, Lewis envisioned a short and direct route to the Columbia's headwaters. Misinformation born of hope replaced Thompson's carefulness.

The Missouri River winds through a 160-mile stretch of superb wilderness called the Breaks of the Missouri, between Fort Benton and Fort Peck Lake in north-central Montana. A "break" is much what it sounds like: a busted-up section of land, not good for commerce, agriculture, or real estate. And therefore the beauty of this geologic caesura of isolated, undeveloped land is that it is left unbothered. The Breaks of the Missouri can only be seen from the river, no roadside view exists.

The landscape, despite the huge reservoir, Fort Peck Lake, is very much the way Lewis and Clark found it in May 1805. The area was so arid that a tablespoon of water would evaporate in thirty-six hours. The river worms in a convoluted way, which forced the Expedition to tow their boats through gumbo clay, brave icy water and stinging winds that raised mouthfuls of dust, and pull and pole against the swift and shallow current—first west, then northwest; north, then southwest. They traveled at a snail's pace as the river cut tortuously through faulted twists of rock and pitted crevasses. It was an upstream fight through the shallow, rock-strewn river below the White Cliffs, but Lewis fell in love with the landscape, calling it a "visionary enchantment." He compared the stately cliffs to ruined edifices and statuary of exquisite workmanship, "so perfect indeed that I should have thought that nature had attempted herre to rival the human art of masonry had I not recollected that she had first begun her work."

It was at the Breaks of Missouri that Lewis climbed a bluff and saw the Rocky Mountains for the first time. He had based his expectations on the maps, the speculative drawings that were the only buffer between him and the blank page of unknown territory. The maps sketched another scene, of mountains like the Appalachians, gentler and passable in a few days' time. "When I reflected on the difficulties which this snowey barrier would most probably throw in my way to the Pacific, and the sufferings and hardships of myself and party in them, it in some measure counterballanced the joy I had felt in the first moments in which I gazed on them." The geography of the imagination had come head to head with the geography of reality.

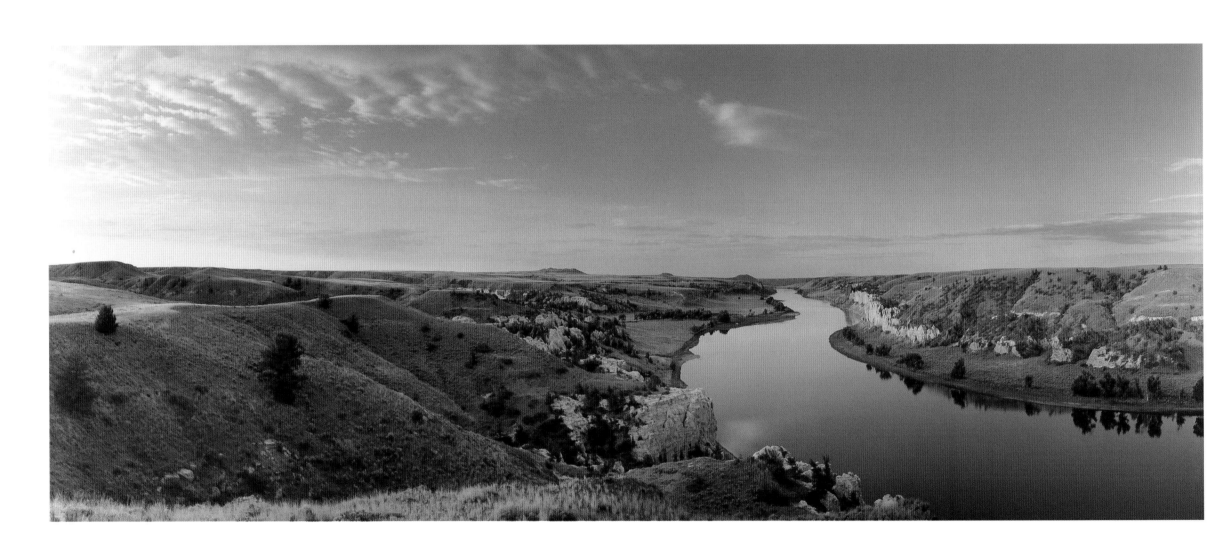

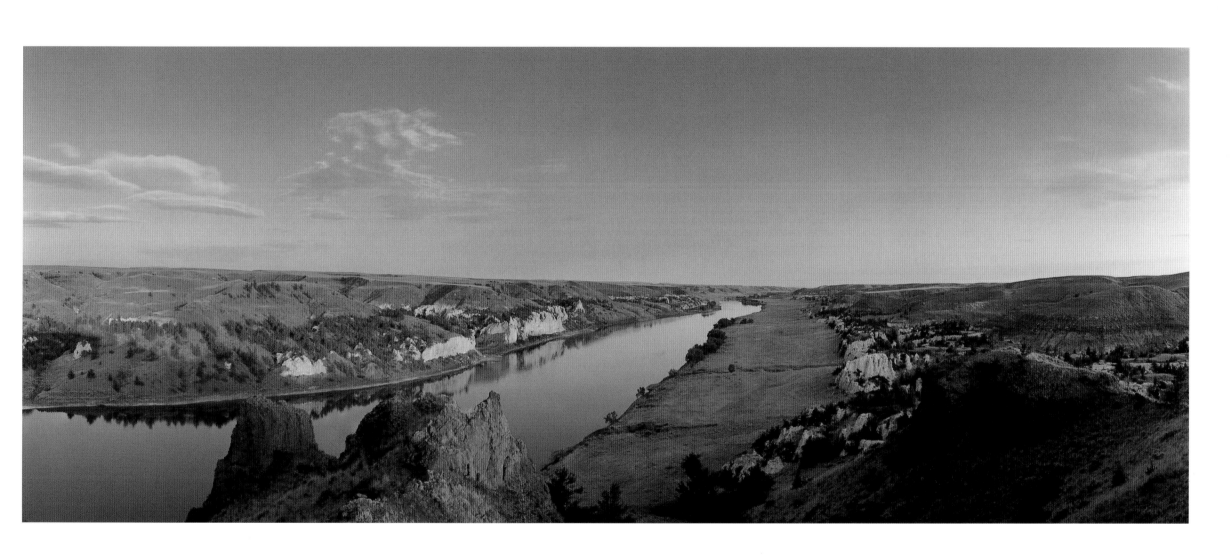

Rocky Mountains

Yellowstone National Park, Wyoming

An overwhelming response to sheer beauty changed the face of America. Whoever visited the land of yellow stone saw geysers flinging rainbows. They inhaled the white-hot breath of rocks rising through fumaroles and the spray from magnificent waterfalls, filling canyons with ribbons of platinum water. Elk herds flickered like a magic-lantern image through the sunlit slits in a lodgepole pine forest.

Painter Thomas Moran and photographer William Henry Jackson were an integral part of the 1871 U.S. geological survey expedition, which set out to verify the nearly mythic accounts of this "Wonderland," as it was called. Mountain men spun tales of petrified trees surrounded by petrified animals, waters so hot that the fish came off the hook fully cooked, and geysers shooting a hundred feet into the air. The two artists chose scenes that caught the rhythm of the place. Their work dispelled any doubts about Yellowstone's splendor—but laid to rest any thoughts of firing the camp cook.

Moran's seven-by-twelve-foot painting of the Grand Canyon in Yellowstone (as opposed to the Grand Canyon in Arizona) is sunwashed in yellow heat. Yellow evokes both the warmth of candlelight and the haze of morning; Moran's palette, greatly influenced by the English painter J. M. W. Turner, embraced the scene with lush light. Knowing a picture is worth a thousand words, Moran showed his painting in the Halls of Congress and let the painted surface work its magic on the congressmen assembled. The response to the work was unanimous: an Act of Congress on March 1, 1872, set aside 2.2 million acres, an area larger than Puerto Rico, as the first National Park in the world, "for the preservation, from injury or spoilation, of all timber, mineral deposits, natural curiosities or wonders and their retention in their natural condition."

Conservation on this scale was a bold and unprecedented move, especially for a young country, still reeling from the impacts of civil war, where the best postwar antidote was believed to be economic expansion. The boundaries for the

WHITE DOME GEYSER

National Park were drawn with reference to geology, at a time before concepts of watersheds, migration patterns, and biological communities had taken hold. In 1983, a coalition for a Greater Yellowstone Ecosystem was formed under the rubric that park boundaries do not circumscribe islands but living networks that extend beyond the designated park acreage. A proposed 18 million acres in the Northern Rockies, including two national parks, six national forests, three national wildlife refuges, and adjacent public and private lands, encompasses a more cohesive wildlife and biological reserve; it is an ambitious but logical step for the twenty-first century.

CRYSTAL SPRINGS

The National Park Service reversed its policy on fire control after 100 years of active firefighting in the park. From 1972 to 1988, more than 140 spot fires were allowed to burn, and in the dry, hot summer of 1988, lightning strikes began a conflagration that swept over one-third of the park. Acres of lodgepole pine killed by the fast-moving fires stand like silver quills embroidered against the hills. Elk, bear, moose, and bison graze on willow sprouts and new grass, and lodgepole pine seedlings shine in the sun, as the cycle loops back toward regeneration.

As tectonic plates drift around the earth they can pass over "stationary spigots of fire" called hot spots. Six hundred thousand years ago, the tectonic plate containing Yellowstone drifted over a hot-spot plume—liquid rock that is lighter than the surrounding rock and forces its way to the surface in a balloon-on-a-string shape—that originated more than 15 million years ago in the Pacific Northwest. The plume tore through the earth's crust in a volcanic cataclysm that blew out a thirty-by-forty-five-mile hole, half a mile deep, called the Yellowstone Caldera. Yellowstone is a mere tail of this massive basaltic floodplain, the latest event in the ongoing process of tectonic movement. After the initial explosion, the hot spot's umbilicus continues to feed a steady flow from the mantle to the surface, fueling the more than ten thousand thermal features of Yellowstone. Aside from Kamchatka in Siberia, Yellowstone is the only essentially undisturbed geyser basin in the world.

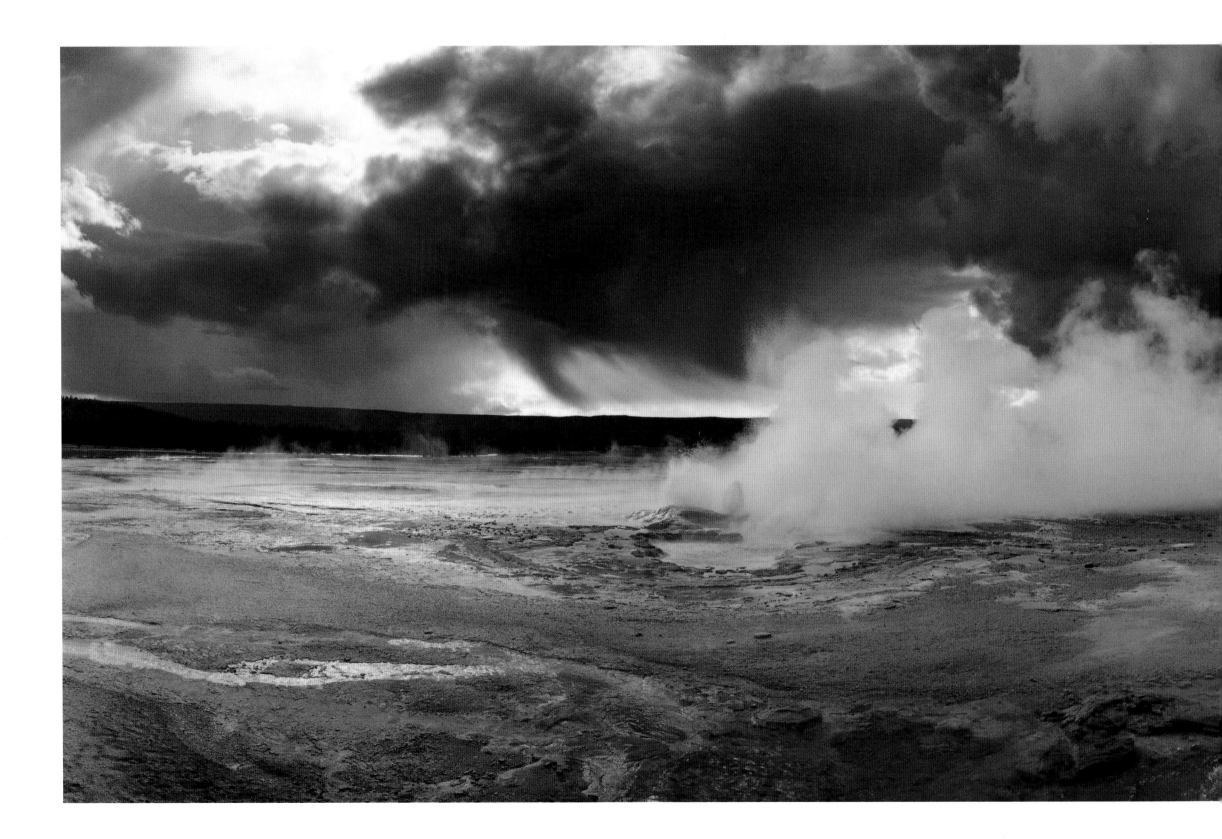

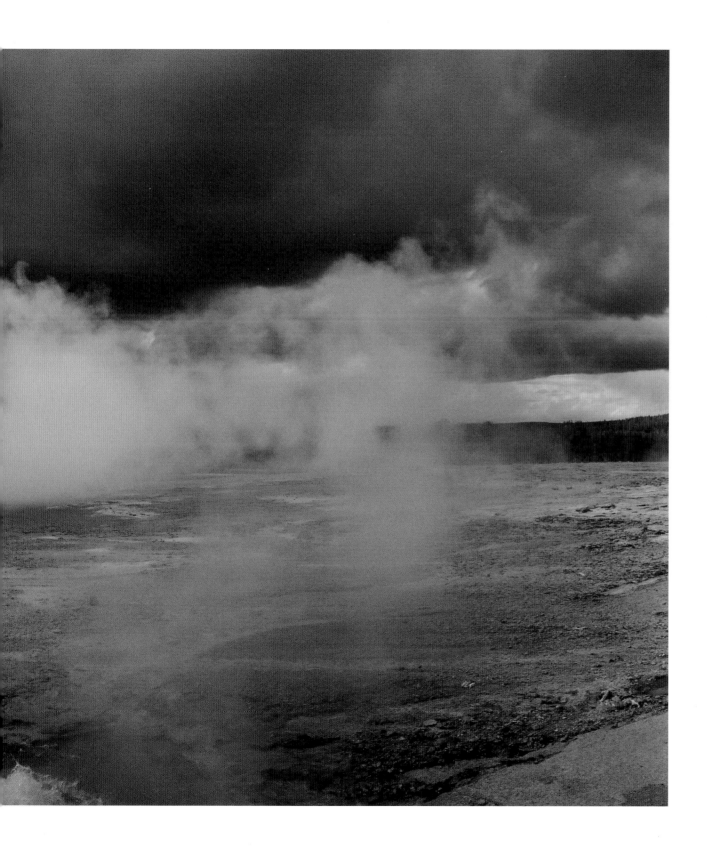

Seventy-five percent of the earth's natural geothermal activity occurs here. Other countries, such as Iceland and New Zealand, have chosen to tap their extensive geyser basins for geothermal power.

Geyser beds act as a giant respiratory system aerating the pores of the earth. Cool water rushes in through cracks in the rock and picks up heat, pressure builds along a constricted embouchure, and eventually hot steam and water gush upward, and the earth cools itself down. Spewed minerals around azure pools have the unearthly look of color-coded satellite images. Ashen mounds cup Ming-glazed sunken pools, and sulfuric steam rises like temple incense. Old Faithful sends up a mist of ragged clouds, and its surges of water arc in Gothic symmetry.

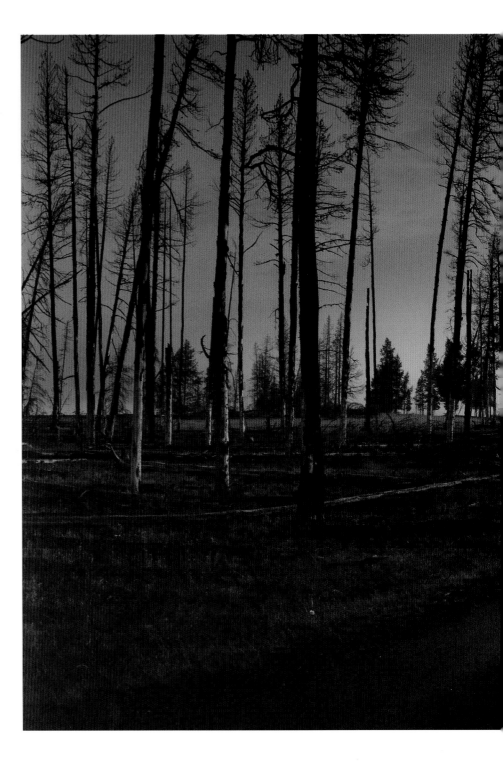

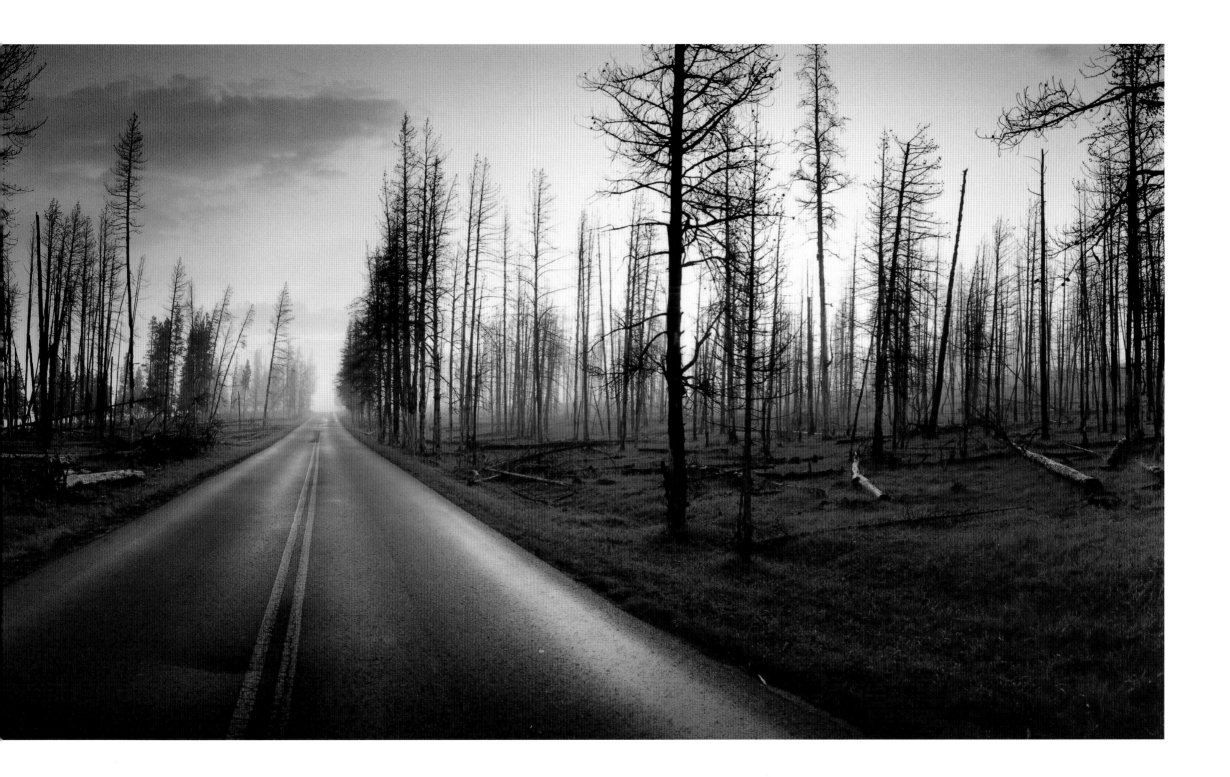

Waterton/Glacier International Peace Park, Montana

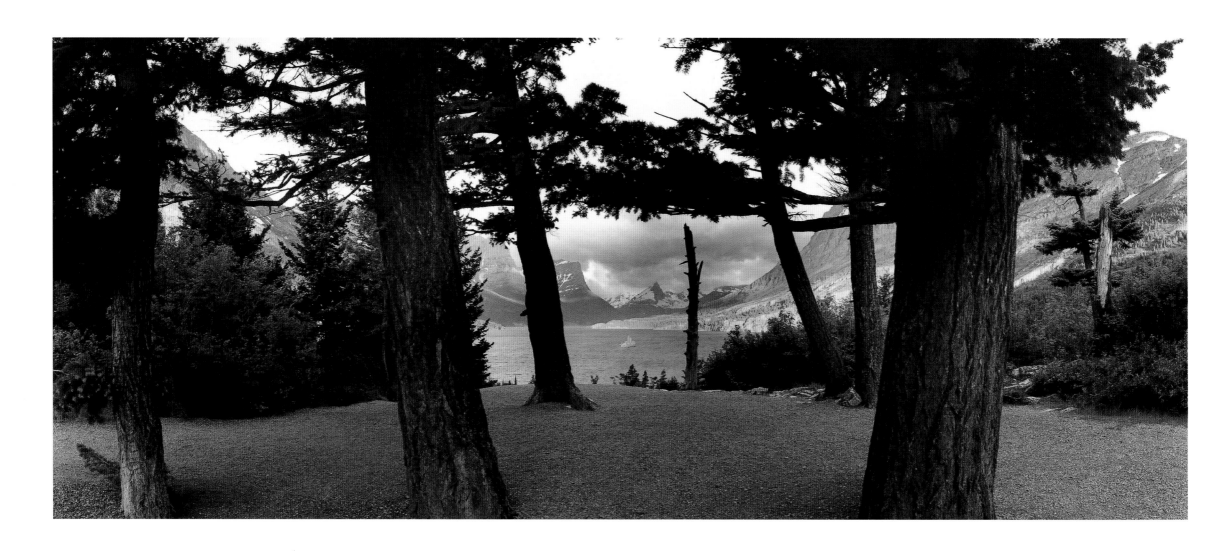

The Continental Divide is a 25,000-mile-long topographic spine that snakes its way from Alaska's Brooks Range down to the Strait of Magellan. Waters part at this apex, and rivers carry rainwater and snowmelt either east to the Atlantic or west to the Pacific. Triple Divide Peak, a mountain horn whittled by glaciers, is part of the Continental Divide as it crosses Waterton/Glacier International Peace Park. Water flows from the peak into three major drainages: Hudson Bay Creek becomes the Saskatchewan River as it flows north to Lake Hudson; the Atlantic Creek joins the Missouri River seeking the Gulf of Mexico; and Pacific Creek turns into the Columbia River, making its way to the Pacific Ocean. The peaks outline the Divide as graphically as skywriting. The last vestige of day traces a thin cuticle of light along the mountainous contours as if the sun were a cartographer.

The park, in northeastern Montana, is a land of extremes. The smallest bird in North America, the Calliope hummingbird, which weighs less than a dime and has a heart that beats a thousand times a minute, and North America's largest predator, the grizzly bear, both live in the park. One-hundred-degree shifts between warm Chinooks and Arctic cold fronts can happen in twenty-four hours—in contrast to daily weather's rapid transit, a slow and lumbering process created this landscape.

A glacier is a slow train moving downhill. The pressure of successive layers of snow that summer sun has failed to melt forms layers of brittle, compacted ice. The cumulative weight eventually creates an odd plasticity in the deepest layers of ice, allowing the mass to move. Only once it begins its downflow is it called a glacier. A glacier's convex-shaped snout advances inexorably, bulldozing tons of rock and debris, grinding away entire mountainsides, and scooping out cirques or hollows between a wake of mountainous protruding ribs. Glaciers transform river-tight canyons into chalice-shaped basins waiting to fill with glacial melt. The lake water is permeated with glacial flour that remains in suspension, absorbing all colors of the spectrum except an icy, aqua blue. A glint of blue from a calving glacier might be the only color in a frozen landscape enshrouded in cloud.

Whitewater spumes down the sides of mountains. Water weeps from sedimentary argillite along road cuts and from hanging valleys. It deepens glacial lakes and braids itself through meadows, forests, and bare rock canyons. The effluence of water is living evidence that the remaining thirty-seven glaciers in the park will probably be gone by 2030. At the height of the late Pleistocene era, approximately 20,000 years ago, continental ice sheets covered most of northern Europe, northwest Asia, and a 4,000-mile span across Canada and the northern United States, pushing as far south as New York City and west to the foothills of the Rocky Mountains in Montana.

Glaciers created our most spectacular landscapes: the Great Lakes, Yosemite Valley, the lumpy hills of Boston, and the rolling hills of the

Midwest. Ten thousand years ago at the end of the Great Ice Age epoch, as the earth turned toward warmth, seas rose and glaciers retreated to cover only ten percent of the world's land surface. We are still in a warming period of the Quaternary Ice Age. At its height 150 years ago, a "Little Ice Age" added to the park's glaciers. But since then they have been slowly ablating, leaving behind lakes, fine chiseled peaks, and abundant river systems.

As glaciers retreat, a succession of vegetation takes hold. Single-celled algae, seeds, and mosses develop in the moraine debris. Soon enough soil exists for leafy shrubs and trees to develop. Aspen's rhizome system of roots net the soil. Lodgepole pine is quick to sprout and provides a canopy that shelters shade-loving fir and spruce. This linear progression is constantly thwarted by natural disasters—a lightning fire, or an avalanche—and the slopes are swept clean to begin anew. A pastiche of forest, meadow, and brush creates diversification of plant and animal life.

What does it mean to preserve wilderness? The impulse to convert the wilderness into a contained, Edenesque garden where wild animals were imagined as pets or sport has metamorphosed into an understanding that people are but a part of a vaster, wilder system. In the 1920s, at the peak of the National Park's predator control program, a single park ranger, Chance Beebe, was said to have killed more than 300 grizzly bears in three years. Wolves were trapped and killed; coyotes were poisoned and killed. Park policy was to groom the landscape to be visitor friendly and predator free.

To set aside land and do nothing with it is contrary to the very industriousness that "won" the West. Yet cultivating an eye for the broader sweeps of time, learning the gentle art of letting nature alone and treading softly within it, allows us to imagine a time beyond our own heartbeat. What will this land look like to people 200 years from now?

President Lyndon Johnson signed the Wilderness Act of 1964, which designated undeveloped, primeval land to be set aside as wilderness areas to be preserved and protected. These are places where natural forces predominate and human imprint is negligable. He remarked, "If future generations are to remember us with gratitude rather than contempt, we must leave them more than the miracles of technology. We must leave them a glimpse of the world as it was in the beginning, not just after we got through with it."

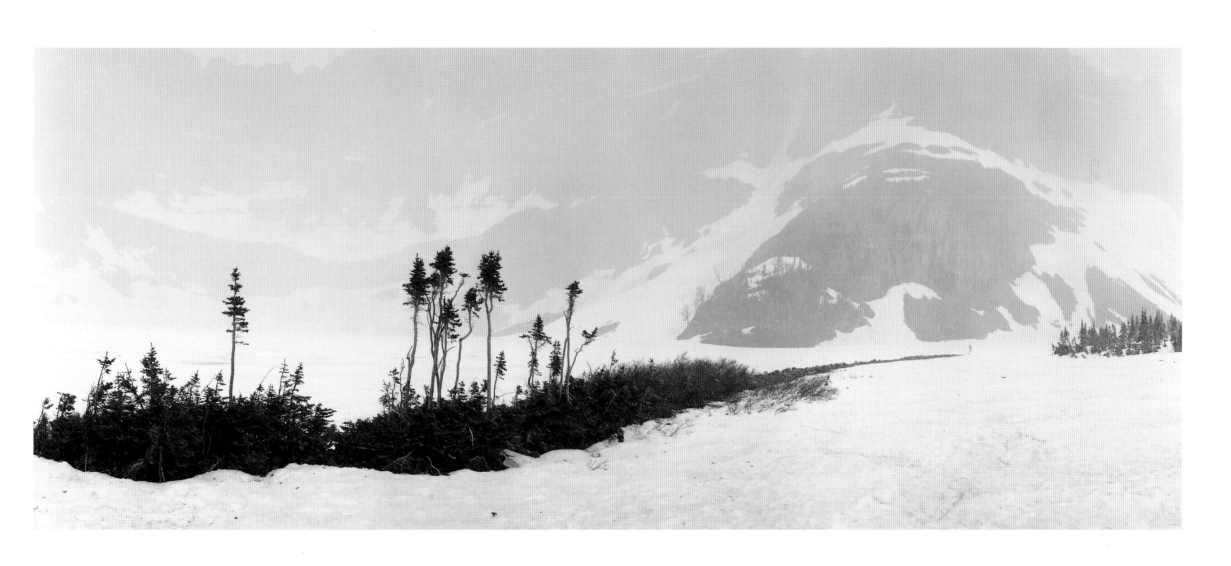

Lemhi Pass, Montana

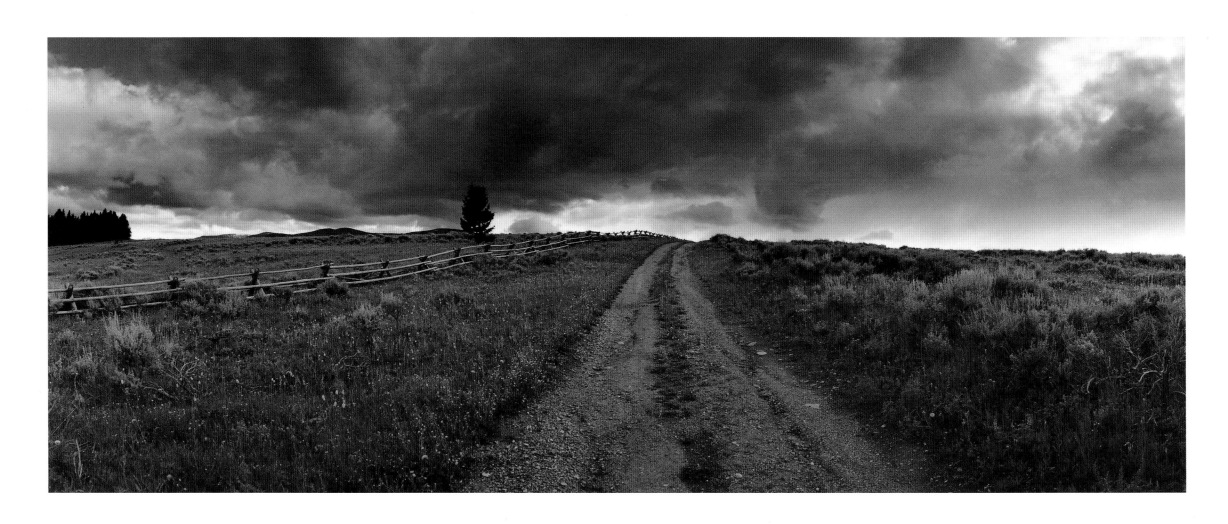

The Blackfeet people call the Rocky Mountain range, which forms the nation's divide, "the Backbone of the World." Settlers called it "the Great Divide." It separates the major continental drainages and forms the watershed of the Americas. Great rivers, the Missouri, the Columbia, the Colorado, and the Rio Grande, are born in the Rockies. Rain and snow give us water, which is stored in the Rockies in glaciers and lakes that feed the broader aquifers. West of the one-hundredth meridian, water is the most precious commodity—if anything unites the western states, it is aridity.

In southwestern Montana on Highway 15 at the exit for the Clark Canyon Dam, the landscape becomes somnolent, lulling. Dry, roller-coaster hills are tinged fleshy rose and tufted with sage. Occasional rock outcrops, like stacks of plywood, point skyward. Just after crossing the Beaverhead River, the grade begins to climb, and a peaceful view falls away from Lemhi Pass across a valley. This is where the Continental Divide crosses Lemhi Pass, marking the border between Idaho and Montana. Were it not for a historical marker, one might not know that this spot marked a pivotal moment in the Lewis and Clark Expedition, one of great joy doused with tremendous disappointment.

When Meriwether Lewis reached this spring he exulted in what must be the source of "the mighty Missouri in surch of which we have spent so many toilsome days and wristless nights." Lewis then "descended the mountain to a handsome bold running Creek of cold Clear water. Here I first tasted the water of the great Columbia River." He assumed that this creek, flowing westward, would take him and his companions to the Columbia River, and on to the Pacific Ocean. He knew that on August 12, 1805, he and William Clark were the first Americans to stand on the western side of the Continental Divide. He also knew that where the watershed of the Missouri River ended, in Upper Louisiana, so did the legal bounds of the United States.

At the Breaks of the Missouri, Lewis and Clark saw the Rockies for the first time. From Lemhi Pass, at 7,373 feet, they saw that they had half a mountain range yet to cross. The beauty of the Expedition was that they endured in their bewilderment, they kept going. It would be another three months before they would finally reach the ocean.

Mores Creek, Idaho

The West is a place of extremes. There are deserts that are searing and mountains with below-freezing temperatures that often dip into the double digits. The distance between Mount Whitney, the highest place in the forty-eight, and Badwater in Death Valley, the lowest, is only eighty miles. Along the northern Pacific, coastal rain forests contradict the rest of the West's arid profile. Politically and economically, water will be the oil of the twenty-first century. The challenge of the West will be to not obfuscate the lessons of the past; water was the operative word then, and it is now.

Survival depends upon adaptations to these quantum swings of nature that define the West. Native Americans and the first explorers and settlers bravely endured extremes in temperature, drought and deluge, vertigo, the claustrophobia of cabin fever, and profound disorientation in a sea of grasses or endless desert. Like the flora of the West, people had to be ready to uproot and resettle on the most slender means, in inhospitable environs, beneath a fickle sky.

Mores Creek flows into the Boise River just east of Boise. It eventually empties into the liquid border between Idaho and Oregon, the Snake River. Snow comes earlier to Mores Creek and lasts longer because it is at a slightly higher elevation than Boise. Snow bites into the heart of winter. It stings when carried on wind and can obliterate footprints in a lost world. It gives the illusion that it is preferable to sleet or rain because you can walk on it, but it can bury you. Yet snow is achingly beautiful. It hides all the flaws of daily living, the junked automobile, the scrap pile, the mangy grasses left from a summer's drought. Snow truly is a blanket, softening the edges of daily life and imbuing it with the texture of finely abraded marble.

Abstraction is based on natural phenomena. From the most minimal gesture of a frozen river between snowbanks to the baroque clutter of rain forest foliage, a language of pattern and thought is born and given the name abstraction. Through it we seek to understand what beauty is in all its forms.

Aspen, Colorado

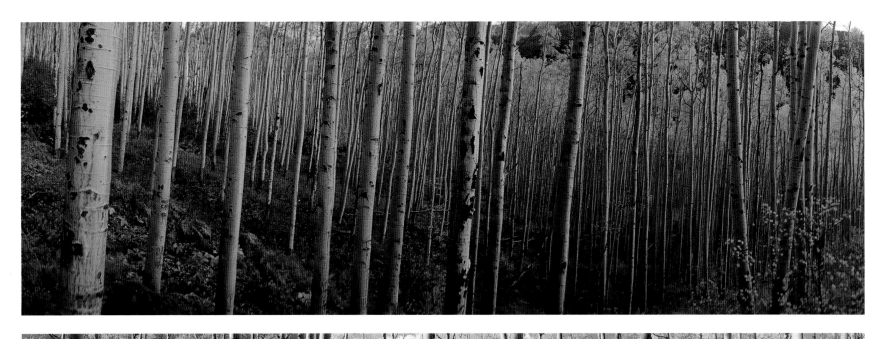

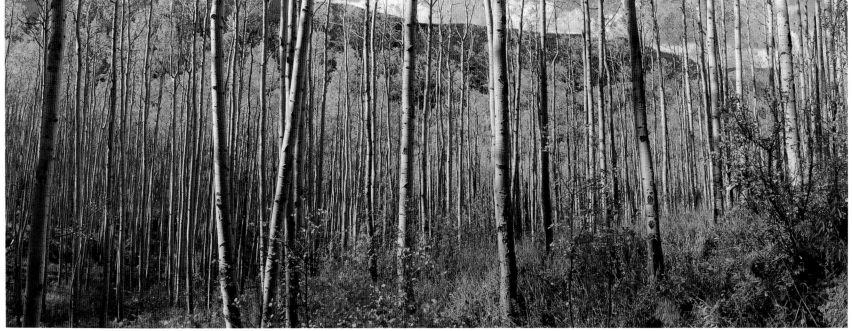

Outside Aspen, Colorado, the winding red road U.S. 24 switchbacks through Independence Pass, in the White River National Forest. The road skirts just northwest of Mount Elbert, which at 14,433 feet is the highest point in the state. The curve of the highway line, painted in cadmium yellow, rises up to meet a forest of similarly colored trees.

Aspen trees cause traffic jams every fall when, for a brief moment before winter strips them bare, these somber trees are haloed in coin-shaped golden and vermilion discs that spangle the air in a shimmering, visual vibrato. Native Americans dubbed them "noisy leaf." Their flattened stalk causes the leaf to move up and down like a hinge, quivering in the wind—hence the scientific name, *Populus tremuloides*.

The largest living thing in the world is an aspen grove in Colorado. Groves are genetically identical—secondary shoots, or suckers, cloned from a common and vast horizontal root system—a single organism that can cover hundreds of acres. A mountain dappled with patches of green, yellow, and red aspens indicates three distinct clones, each responding to the shortening length of daylight according to an internal, genetically based timer. Aspens are the most widely distributed tree in North America, and beyond what meets the eye, measureless networks of underground root systems are laid down from Alaska to Labrador and south through northern Mexico.

Aspens are related to cottonwoods and willows, all members of the *Salicaceae* family, which are used to produce aspirin. Its bark contains a bitter substance ingested by early travelers as a substitute for quinine. Aspens spring up along roadsides and cow-trampled highlands, shooting skyward 60 to 100 feet, pioneering through pockmarked, volcanic terrain, or thriving in wet upper pasture. After fires or landslides, aspen rhizomes and roots stabilize the soil and add valuable nutrition through leaf litter, which creates an inviting environment where conifers can take root.

Under snow cover, the elegantly thin trunks of the aspen etch the stark white surface. From close up, the bark looks like a musical score, black notations on translucent vellum. Deer, elk, moose, goat, and sheep graze on the root suckers and leaves when the trees green out in late spring. Beavers gnaw the papery bark, cut the logs, and cache them underwater as food stores and construction material for their dens. By the mid-nineteenth century, trappers using steel-jawed traps with aspen lures had nearly decimated the beaver population, outfitting the East and Europe in fashionable pelt.

Deciduous foliage turns from green to bronze in a cold snap, one of the natural patterns of generation, death, and return that convey the solace of reiteration we come to expect year after year. An aspen trunk rarely lives out a century, but the clone can regenerate for millennia.

Great Sand Dunes National Monument, Colorado

A field of dunes is a landscape broken down to the smallest pixel. Wind deteriorates the hardest rocks, pummels them into soft shapes that seem almost human, vulnerable. Mountains shed minerals, gravel, and pumice. Out of billions of granules, the wind creates studies in chiaroscuro, showing the moonlike way light bends toward darkness, as if darkness were a caress.

From afar, the Great Sand Dunes National Monument in south-central Colorado is a mere smudge against the 14,000-foot Sangre de Cristo Mountains, forest black and capped with snow. These mountains are the lower vertebrae of the Rocky Mountain cordillera that extends from Alaska to Mexico. But distance deceives. Walking among the dunes, the world becomes nothing but an envelope of sky and tawny mounds of sand. These are the tallest sand dunes in North America, rising higher than 800 feet above the San Luis valley floor, for forty square miles. Ponderosa pines are smothered beneath dunes that blew up to the mountains' knees.

Trudging uphill on a surface that keeps giving way, as if one were on a treadmill, makes it hard to believe that the maximum angle of repose for any sand dune is just thirty-four degrees. At a steeper angle, the mound collapses on itself like a crumbling wave. Looking back on one's own footprints, they seem as small as a birds. The wind blows gritty clouds of blinding, stinging sand, obliterating the hollows of heel and toe.

Occasionally a storm blows in from the northeast, and the shapely transverse ridges

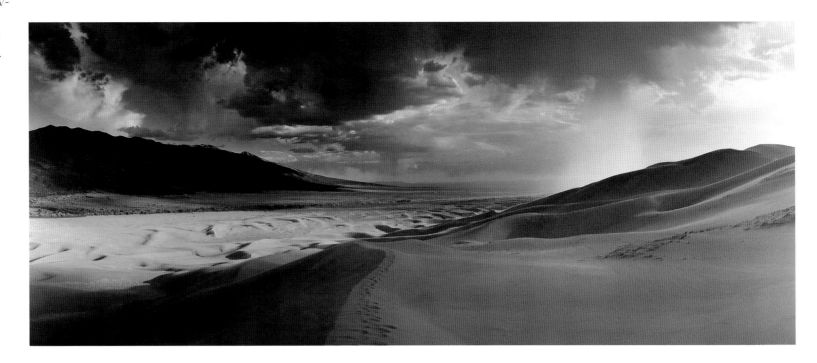

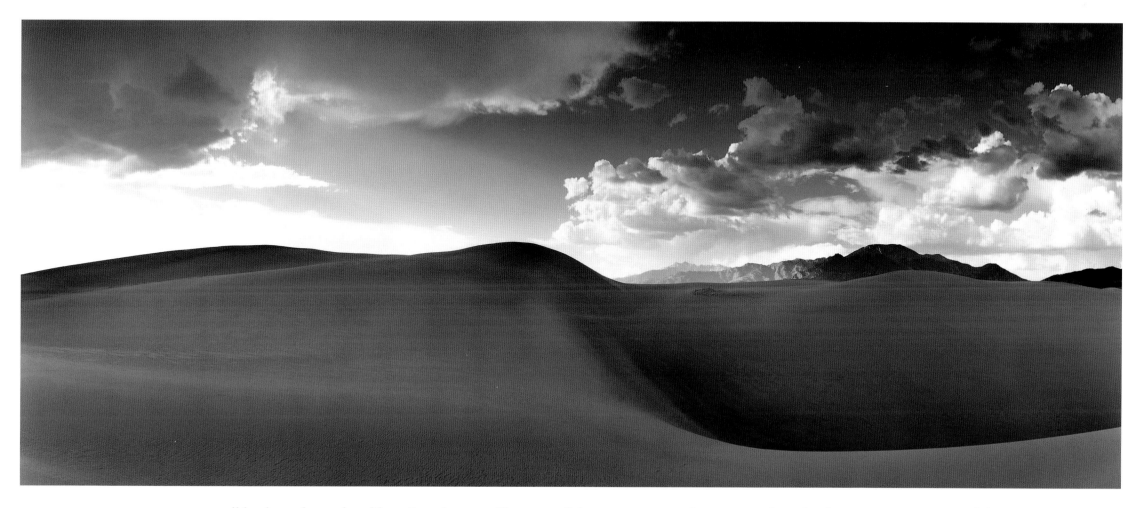

roll back on themselves like a French seam. This type of dune, its crests sashaying atop the ridge line, is so reminiscent of the Great Wall of China that is called a Chinese wall.

Great Sand Dunes National Monument is located in the right hip pocket of the San Luis Valley. When eruptions and upward thrust along fault lines created the San Luis and the Sangre de Cristo ranges approximately 66 million years ago, the intervening earth stretched into a broad mountain valley. Millions of years of erosion and deposition laid a bed of sediment over the valley floor that is as thick as 30,000 feet. As mountains rise up, the bottom falls away, and eroded mud and sediment gradually fill in the gap in the ground. Wind and water work relentlessly to wear the earth down to level ground. Since the last Ice Age, the Rio Grande became swollen with glacial melt and debris that

added to the sediment. Rivers continuously change course, and old river channels are constantly abandoned, leaving behind mounds of sand and silt as the river slowly migrates.

The San Luis and the Sangre de Cristo mountain ranges, like the walls of an hourglass, have trapped this sand for hundreds of centuries, and the prevailing wind from the southwest pushed the bulk of the dunes eastward. When the sand-thickened wind hits the stony blockade of the Sangre de Cristo Mountains, it drops its heavy cargo and expends itself funneling through the Music, Mosca, and Medano mountain passes. Medano Creek curtails the sand dune's drift, creating a watery boundary at the bottom of the mountain.

The Great Sand Dunes are remarkably stable because of a high water table, the result of summer rain and winter snow. Each sandstorm brings slight permutations in form, but five to ten inches below the surface the sand is moist to the touch. Only the top layers of sand grains creep, jump, roll, and hop in the wind, as if they were alive, looking like an argument for spontaneous generation.

In the 1950s, conservation writer Freeman Tilden cited a *Life* magazine article that stated, "Next to nudes, sand dunes are probably the greatest delight of camera-men who like to take the arty type of pictures called salon photographs." Tilden amended this, saying, "Sand dunes *are* nudes."

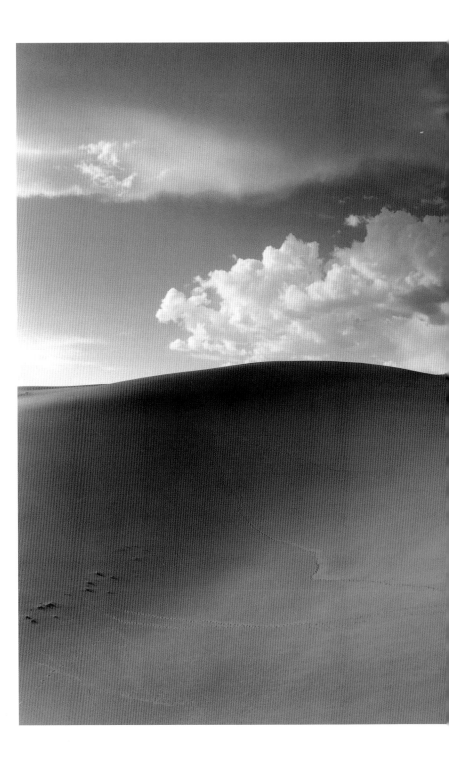

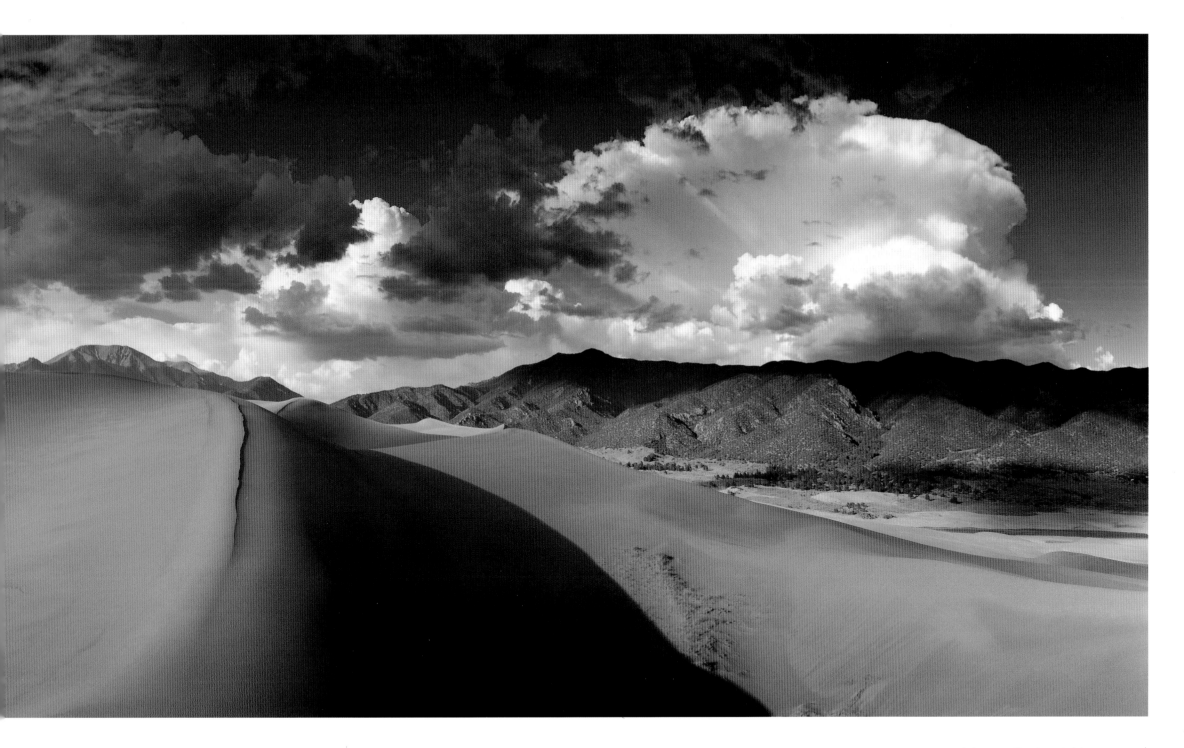

Colorado Plateau

Grand Canyon, Arizona

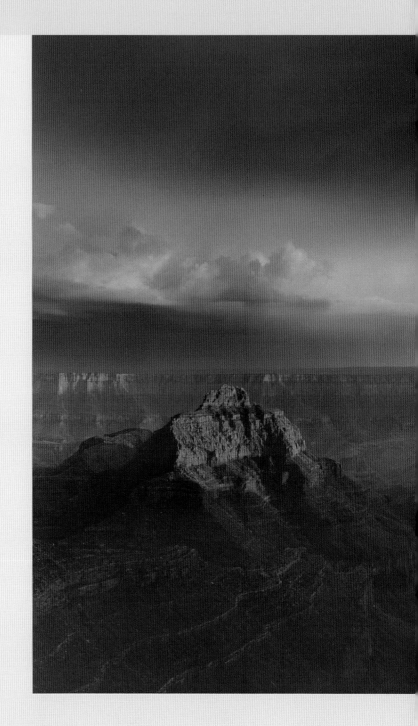

In the early morning, before light seeps into the tea-colored canyon, before the slurry of foreign tongues and the whirr of the video camera invades the silence, a ground fog blurs its edges. The sky cracks open as a lone crow caws through the trackless air. Peering down into the maw of the canyon from the safety of the rim is like sampling Bosch's Hell without having to confess.

At dawn, ridges can be discerned through the milky air. At noon, the canyon is foreboding and hot. But at day's end, the sun trails a jeweled train of deep-bronzed light across its fluted pinnacles. The canyon is filled with shadows that shift with the moment. Next comes the sundowner wind. Red rock is painted with deep purple hues, and wind-whipped swallows and bats play chutes and ladders. Then, darkness.

The Grand Canyon cuts a westerly swath from Utah to just south of Las Vegas, Nevada. Descending into the canyon from the South Rim, along Bright Angel Trail, the eroded pillars and buttresses function the way walled cities do, limiting the eye and containing vision. The trail sutures its way across the canyon wall, past a lightning-struck tree standing like a Giacometti sculpture in the wind.

Beneath the plateau's topsoil we find an interbedded weave of colorful bedrock, a layer cake of time that tells the story of the ocean's comings and goings and the development of the early forms of life. One layer of burnt-sienna rock is a former seabed laden with trilobites. The trail's 4,400 foot descent to the canyon bottom cuts through 200 million years of Paleozoic time. Here is a changing portrait of the

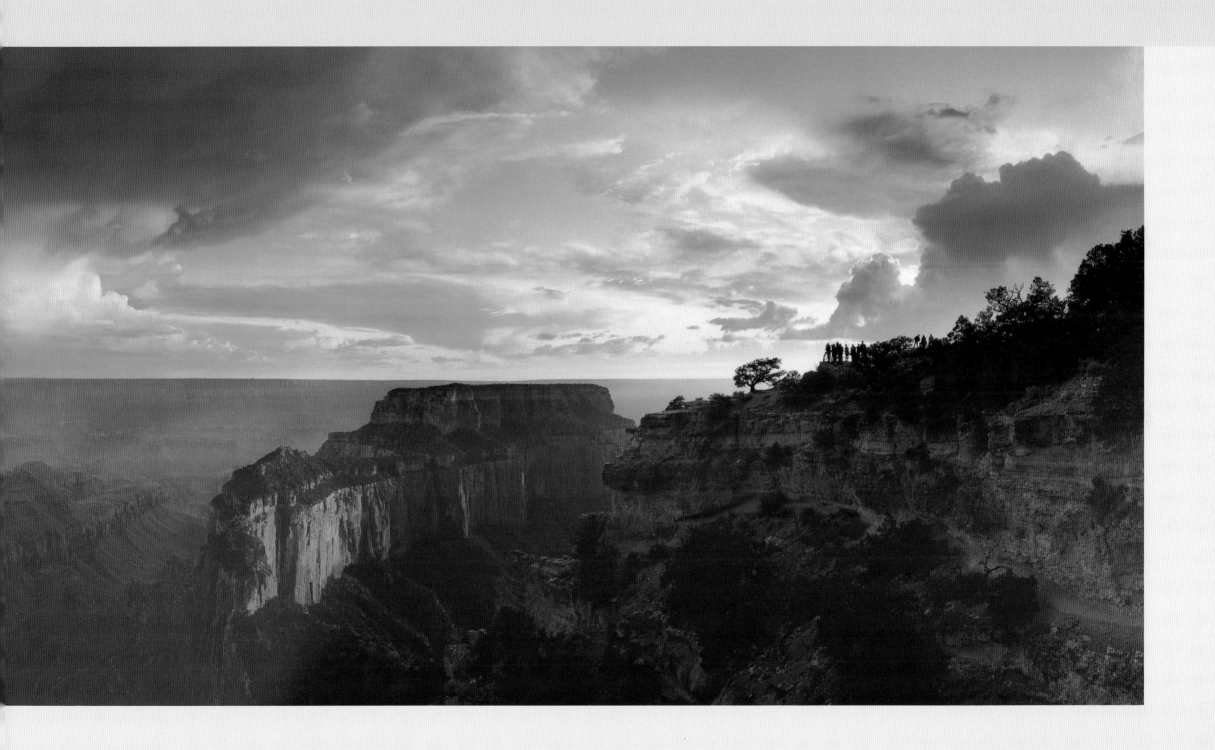

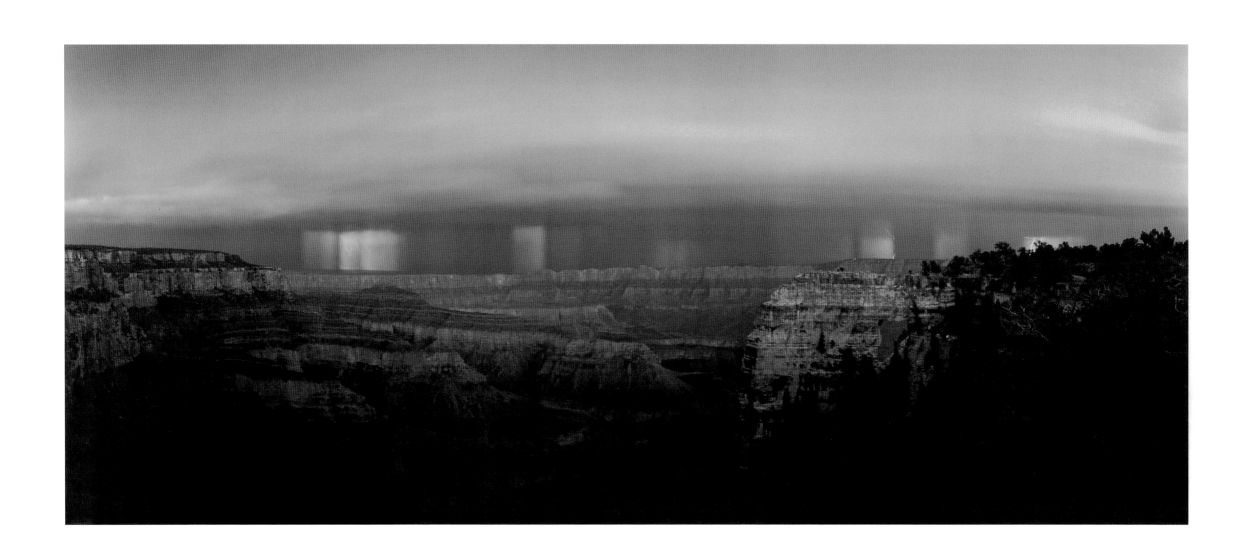

68 | Grand Canyon, North Rim, lightning from Cape Royal

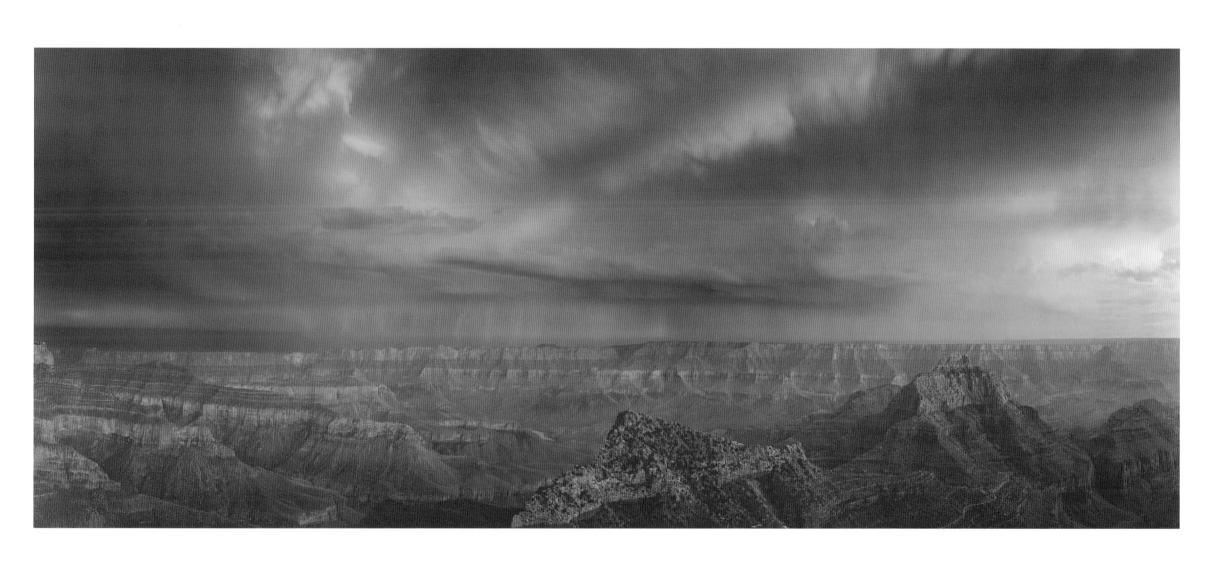

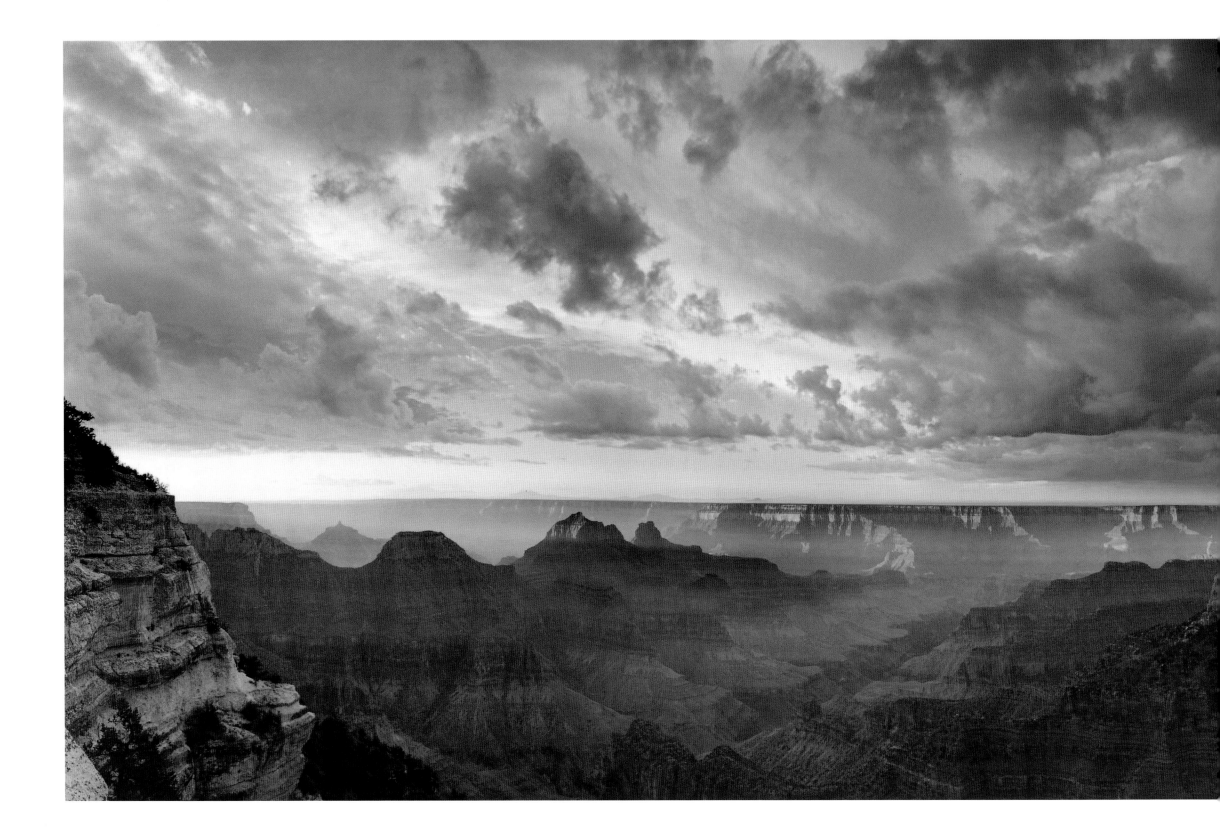

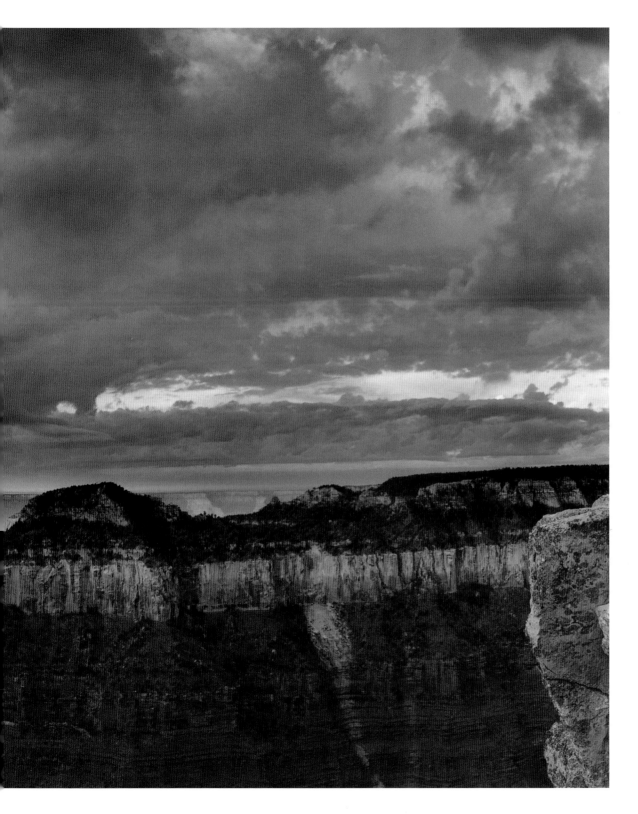

earth, a luminous, polychromatic mural that records the tracings of water that flowed before any creature tentatively touched its awkward legs upon dry land. Then, suddenly, Bright Angel Trail drops over an edge into the the inner gorge, down into the dark, ancient, shadow zone of taffylike baserock. These rocks arose from a much deeper, older part of the earth. Entire landscapes that once lay atop these deep earth rocks have been wiped away by erosion—a billion years' time in the geologic record, gone. This is the mysterious gap that is called "The Great Unconformity." The trail descends into these ancient rocks until they slip beneath the waterline of the Colorado River, where it continues into the earth.

The Grand Canyon is an enormous gap bitten deep into the land, 800 miles long and varying from 600 feet to 18 miles across. The Hopi people believe the canyon is the sacred umbilicus of the Universe, a vital conduit to the previous world, through which their ancestors emerged.

Viewed as a place to get across, it was hell. In 1540 the Spanish conquistador Coronado, in search of the "seven golden cities of Cibola," found neither gold nor splendid cities, only the modest pueblos of the Zuni. Nevertheless, he sent his lieutenant, García López de Cárdenas, to explore westward, seeking a river of which the Hopi had spoken. After twenty days' march, López de Cárdenas became the first white man to see the Grand Canyon of the Colorado River, but his party retreated when the canyon thwarted their crossing. Three hundred years later, a mountain man named James Ohio Pattie wrote in his journal of "those horrid mountains."

In 1857–58, Lieutenant Joseph Ives navigated up the Colorado in his sternwheeler, *Explorer.* He struck rock at about where Hoover Dam is now, abandoned ship, and continued on foot to reach the canyon. In his report to the federal government, Ives wrote, "The region is altogether valueless. Ours has been the first, and will doubtless be the last, party of whites to visit this profitless locality." From 1869 to 1940, a total of forty-four people traveled on the Colorado River through the Grand Canyon. By 1972, the number of river-runners was 16,428.

John Wesley Powell, a one-armed Civil War veteran in his early thirties, navigated the Colorado and Green Rivers in 1869–72, mapping the sunken, behemoth canyon lands of the Southwest. He scrambled from floor to rim routinely in order to document the geologic layering and name the surrounding mountains. Powell remarked that the Grand Canyon was the least eroded part of the country—compared to it, the rest of America had been worn down to a nubbin.

At the turn of the nineteenth century, writers like Clarence E. Dutton, whose prose matched the purple sunsets, romantically christened the buttes Isis, Ra, Vishnu, Osiris, and Zoroaster; artists Albert Bierstadt and Thomas Moran saw the Grand Canyon not as an obstacle but as a destination, and their paintings showed that when the sun played across its pinnacles and flanks, the canyon became a theater of light. Their depictions enticed a hardy, Byronic sort of tourist.

Landscape painters changed how people saw the land. The term *scenery,* as in a painted scene for a theatrical play, was newly used to refer to a beautiful vista of land. In 1908, President Theodore Roosevelt designated the Grand Canyon a national monument, describing the canyon as "the most impressive piece of scenery I have ever looked at—beautiful and terrible and unearthly." The Grand Canyon was no longer something that needed to be traversed in a hurry; it had been transformed into a view, a painting of garnet mountains beneath billowy, golden clouds. The possessable image of a western Valhalla replaced the primary experience of the earliest explorers, and the images in paintings and later in photographs seeped indelibly into the hearts and minds of Americans.

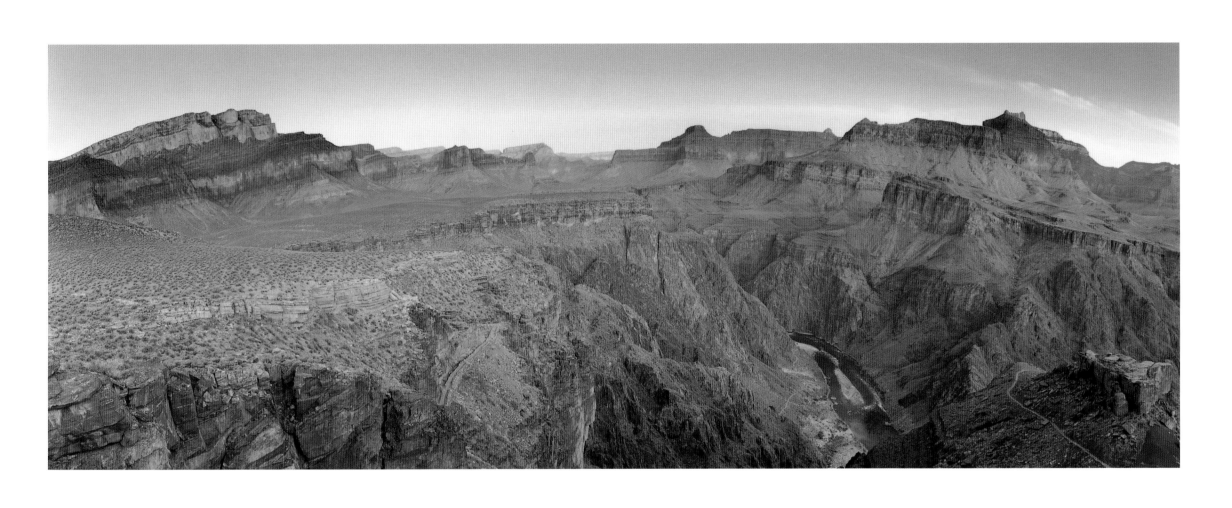

Grand Staircase–Escalante National Monument, Utah

In winter, snow graces the Grand Staircase–Escalante National Monument in southern Utah. A million and a half acres of slickrock canyons carved by the Escalante River and its tributaries—buttes, mesas, pinnacles, and broad, tilted terraces, steps that form the Grand Staircase—turn completely white. Before U.S. Highway 12 was built by the Civilian Conservation Corps in 1938, mail and goods were carried from Escalante to the town of Boulder by mule train. The pack animals would wind up and down a precipitous canyon path. This trail was the last to see this mode of mail delivery in the United States. Highway 12 roughly parallels another old wagon road, and a turnoff from the highway leads to a parking lot and the beginning of the Lower Calf Creek Falls Trail.

CALF CREEK CANYON,
'DESERT VARNISH'

Calf Creek runs through a finger-shaped canyon of massive walls that are boldly striped with chocolatey varnishes, the residue of clay and dust deposited by water, which are cemented onto the stone by microscopic fungi and bacteria. During the Jurassic period, a great desert covered the entire Southwest. Then the dunes were inundated by sea, and gradually another layer of sand was laid down, pressuring previous layers into stone. The stone eroded or tore apart, creating cliffs, slot canyons, and vast crevasses.

Near the bottom of the polished cliff face, 1,000-year-old paintings of horned and beaked figures as tall as a house are dwarfed by this natural mural. The formation is pocked with storage granaries and dwelling places of Fremontian and Anasazi Indians. The granaries were yesterday's safe-deposit boxes—caches of corn and other seeds stored above floodline and rodents. Submerged in the creek, Pleistocene cobblestones the size of bowling balls bespeak a time when the river waxed stronger.

Nobody lasted long in this wilderness except hunters and gatherers. About 900 years ago, approximately 250 Anasazi and Fremontian Indians—twice the number of people living there today—stayed for a period of sixty years in the area that is present-day Boulder. After the Indians had come and gone, this area unsuited for large farming communities seemed to attract a hardy breed of loners, as well as the occasional mystic.

A three-mile trail heading north parallels Calf Creek, meandering through piñon pine, juniper, ricegrass, and Gambel oak, ending at the Lower Falls. Spines of ankle-level prickly-pear cacti poke out of the snow. Snow absorbs sound, and winter finds this a silent place. The only intrusions on the silence are a few mourning doves, wild turkeys, and quail scuttling in the underbrush. The whitened trail scattered with oak leaves spreads out like an elegantly patterned kimono fabric. In the clear creek, pewter-grey fish startle the surface, swimming against the current. Wild turkey foraging for food emboss a complicated Escher-esque footprint pattern in the snow. The late November light filtering through the coppery birch trees at the trail's end is friendly, permitting details to be seen that, in a summer's glare, would be swallowed up in shadow. The Lower Falls can be glimpsed through a bower of trees, laden with snow that shakes from branches like a flurry of spring cherry blossoms.

The temperature around the Lower Falls is at least fifteen degrees colder than on the trail. The 126-foot fall is its own source of wind, flinging sprays of chilling water and air across the pond. The canyon bottom is scribbled with dozens of trails that have led to the Lower and Upper Falls for thousands of years, traversed by people trying to survive in this extreme land. The deeply hued rock face is laminated by the water like a fresco, with layers of gold and bronze, vermilion and terra verde. The garrulous sound of water plunging into itself is seductive and joyous. The falls are not just a pretty sight, they are a life source—a fact that makes them only a greater object of wonder and beauty.

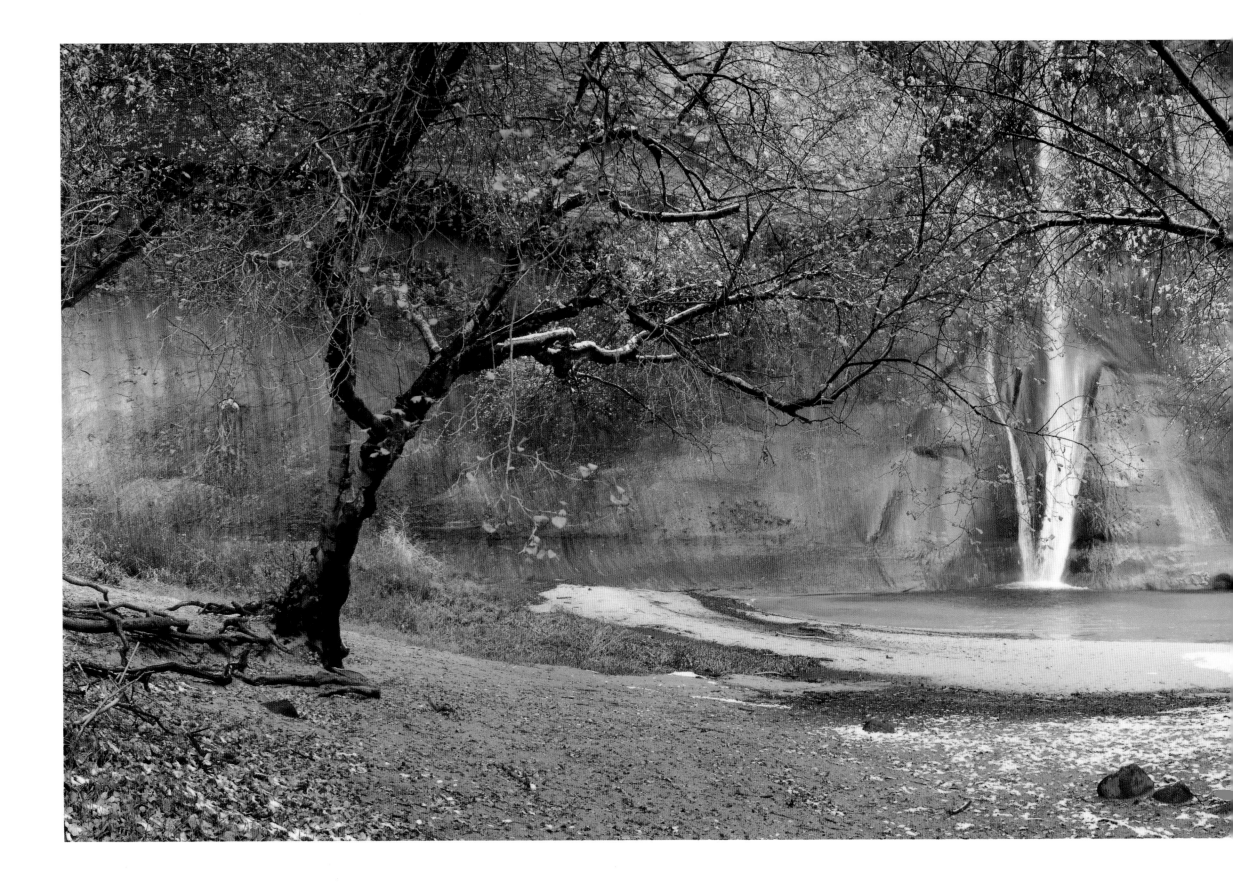

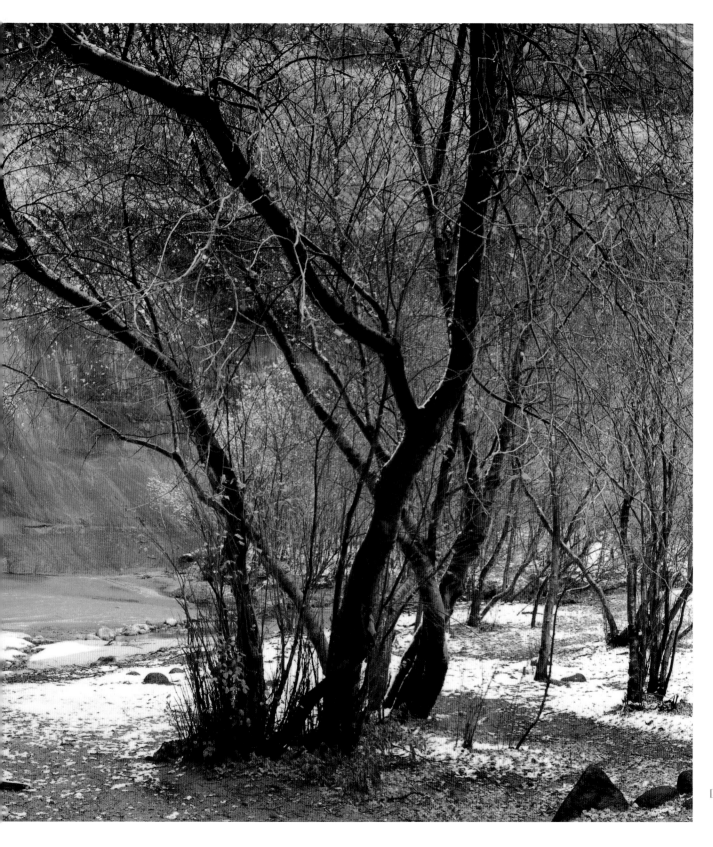

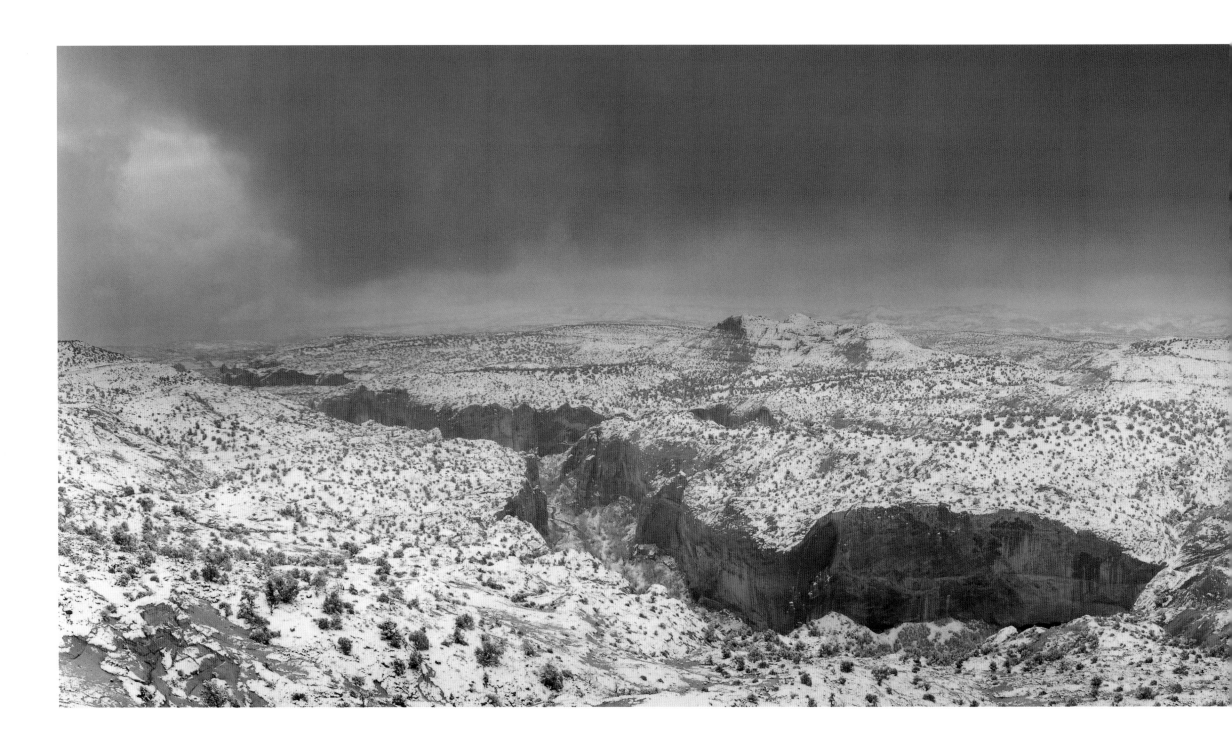

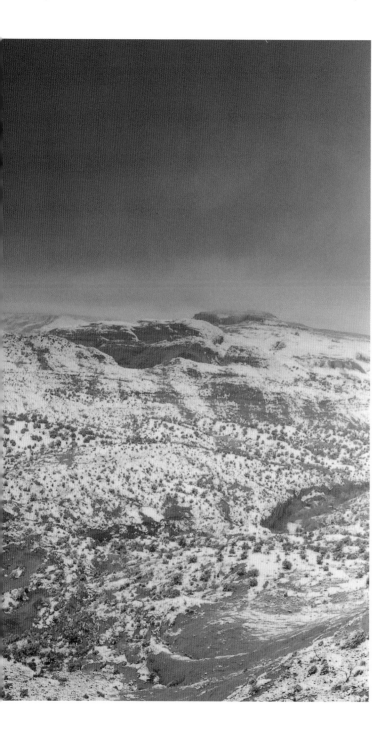

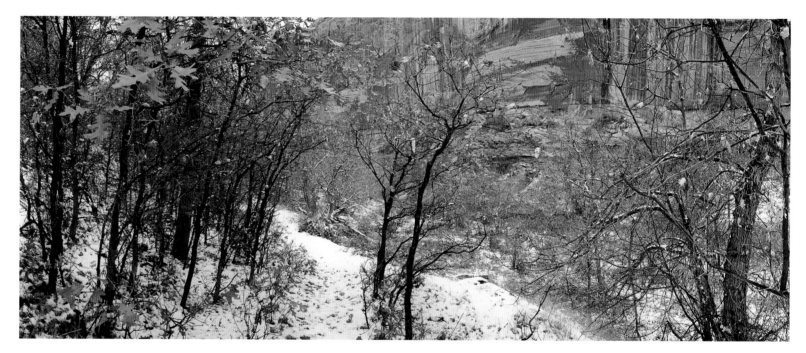

Ghost Ranch, New Mexico

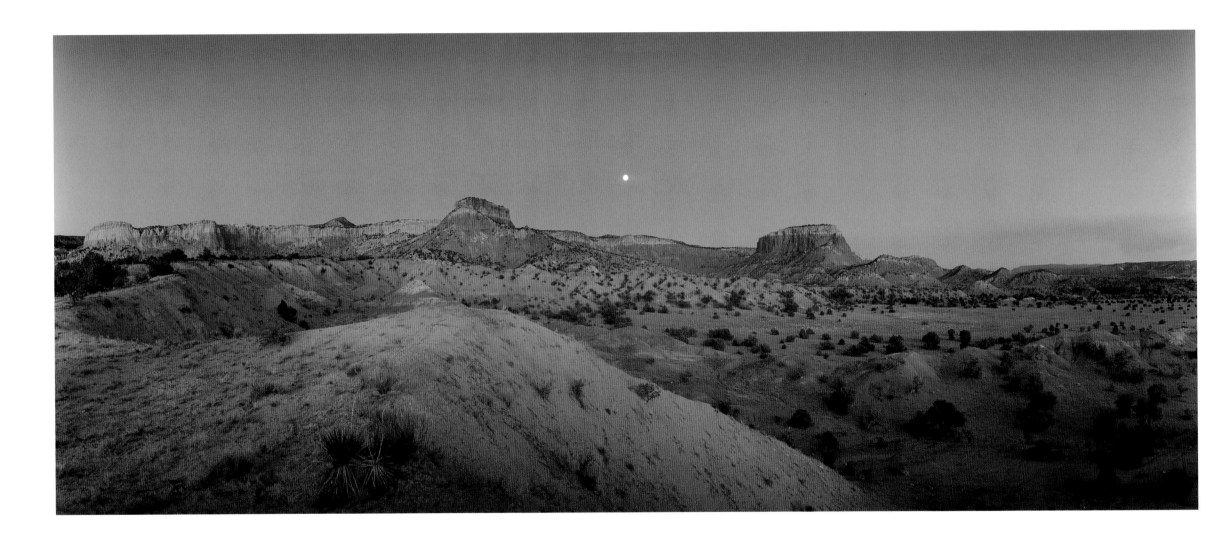

The red earth canyons of the American Southwest, gouged and hollowed by water and wind, are natural skyscrapers that shield the sun and immerse their interiors in deep purple shade. Signs of human presence, such as a twelfth-century Anasazi ruin tucked anonymously into the sleeve of an overarching rock face, seem like minor fibrillations in the steady contractions of a massive heart.

Driving away from Santa Fe, north on U.S. 84, the city appears an inch high within the horizontal rule of the land. The airwaves transmit haunting drumming and shrill-pitched singing, broadcast signals from the Native American nation within a nation. The hillsides, eroded by root-seeking sheep, bow to a widening sky. The Chama River Valley is a mosaic of water, rock, and the flat-bottomed thunderheads that ascend like mounds of spun white hair.

In the twentieth century, American artists such as Arthur Dove, John Marin, and Georgia O'Keeffe eschewed European trends in favor of the freshness that the American landscape offered. America's open spaces, its unpeopled and wild beauty, spoke to them. O'Keeffe first traveled with her sister to the American Southwest in 1917, when she was thirty, and in 1929, when she visited the eccentric Mabel Dodge Luhan in Taos, she brought a load of cow and horse skulls back to her New York studio to paint. The Southwest compelled her like no other place. A hole in a sun-bleached pelvis bone became the window to a lapis lazuli universe. In 1934, she returned, renting a cottage on Arthur Pack's Ghost Ranch property for several summers before he consented to sell her the small parcel. In 1955, much to her chagrin, Pack gave the rest of his land to the Presbyterian Church rather than selling it to her. She remained in her cottage, and the retreat house thoughtfully protected the painter's monklike privacy. She eventually settled into a three-acre ranch in Abiquiu, New Mexico, where she lived out all but the last year of her century-long life, painting "to find the feeling of infinity on the horizon line or just over the next hill."

Georgia O'Keeffe's lyrical abstractions of bones, flowers, and the desiccated badlands of the Colorado Plateau are icons of a distinctly American region. The locations she painted included Kitchen Mesa and the Pedernal, of which she liked to say, "It's my private mountain. God told me that if I painted it often enough I could have it."

Painted Desert and Petrified Forest National Park, Arizona

The Painted Desert in Arizona is approximately 50,000 acres of labyrinthine badlands, sweeping from near the east end of the Grand Canyon in the northeast to Route 66 and Petrified Forest National Park in the southwest. Its mercurochrome hues at sunset radiate in the distance like neon. Painted Desert is technically not a desert but a short-grass prairie, edging toward desertification. The American name for this earthen crescent of color echoes those given by the Spanish and Navajo: the Spanish called it "Desierto Pintado," and the Navajo named it "Halchiitah."

The entire Colorado Plateau, comprising southern Utah, Colorado, and central Arizona, including the Painted Desert, was once a tree-littered floodplain. Two hundred and twenty-five million years ago, in the Triassic period, the slow crawl of continental drift began to nudge this land from its moist, tropical location near present-day Panama to its current location. Approximately 65 million years ago, volcanic activity dispersed enormous drifts of ash, which silted and mounded up, laminating the Painted Desert over an ancient tropical forest.

Ever since the last Ice Age, recent increases in aridity and forces of erosion have formed badlands, riven with dendritic drainages that flow toward the Colorado River system. The drier the land, the more the silica-rich bentonite clay of the Chinle Formation bunched together like puckered, pleated fabric. The warp threads, stripes of carbon and oxidized layers of sunburnt-colored silt, wove in and out of the canvas-colored mounds.

The death of land and land's revival intersect in the badlands. Neither soil nor rock but dissolvable, ashen clay, these mounds of mineralized color sometimes turn a vital corner. Life is heralded by the moisture-catching webs of spiders, the churning activity of ants, seed tossed by burrowers and windfall. Clouds deepen to rain, and what is not washed away is nourished—a wisp of green appears upon its lunar scalp. Badlands erode one-quarter inch a year, or two feet a century. In twenty centuries an average forty feet of badland has sloughed away, and this process over the centuries has exposed treasures from the Triassic.

The Petrified Forest was created by alchemy beneath an incubator of volcanic ash. Ordinary wood, buried in ash perhaps after a blow-down similar to the 1980 eruption of Mount Saint Helens, became jewel-like stone. Comparative studies are under way at Mount Saint Helens, where the long process of petrifaction has just begun. In this process, fallen logs absorb silica that is dissolved from the ash and car-

ried by solution into their cells. Soaking in groundwater, superenriched by minerals and silica, preserves the wood tissue. Silica crystals break down the cell walls and start to grow in the cavity where the cell walls used to be. Other minerals such as manganese, copper, iron, and cobalt are absorbed, giving the mummified wood the color and gloss of oil paint on a van Gogh palette—cornfields, sunflowers, blood, and crows in a storm.

After the wood in this corner of Arizona badlands had petrified, the restless ground continued to lift; the logs, some buried a thousand feet deep and caught in the tension, snapped. They cleaved into neat, parallel slices like gigantic sushi rolls, which are today strewn across the short-grass prairie, jutting out of badland mounds, and tumbling down the creases of the wrinkled bentonite hills.

Petrified wood weighs 186 pounds per cubic foot. It is as strong as steel but can shatter like glass depending upon how it is impacted. Native Americans living here until the late thirteenth century knapped the agatized wood into tools for weapons, for household use, and for carving drawings into slickrock. Later, prospectors stole the wood by the cartload to sell as raw material used to make everything from table-tops to carved bunnies. Only five percent of the area's petrified wood, as well as numerous fossils from the era of dinosaurs, is protected within the Petrified Forest National Park boundaries. Rock shops line the park's periphery, like a border town, selling fossils, minerals, volcanic bubbles called geodes, and high-polished, high-priced chunks of the ancient wood.

Research has taught us that an archaeological find in situ can tell us volumes about the past. In contrast, a bone or flake taken out of context is a word torn from the page. Sometimes a rock or shell is a talisman that puts us in touch with the elemental, recasts a memory, or stimulates reverie—however, it often just becomes "stuff." The more we understand the beauty of the context—the whole—the less urgent the need to snatch a fragment of the past that will only gather dust on a window ledge or rattle in a bottom drawer.

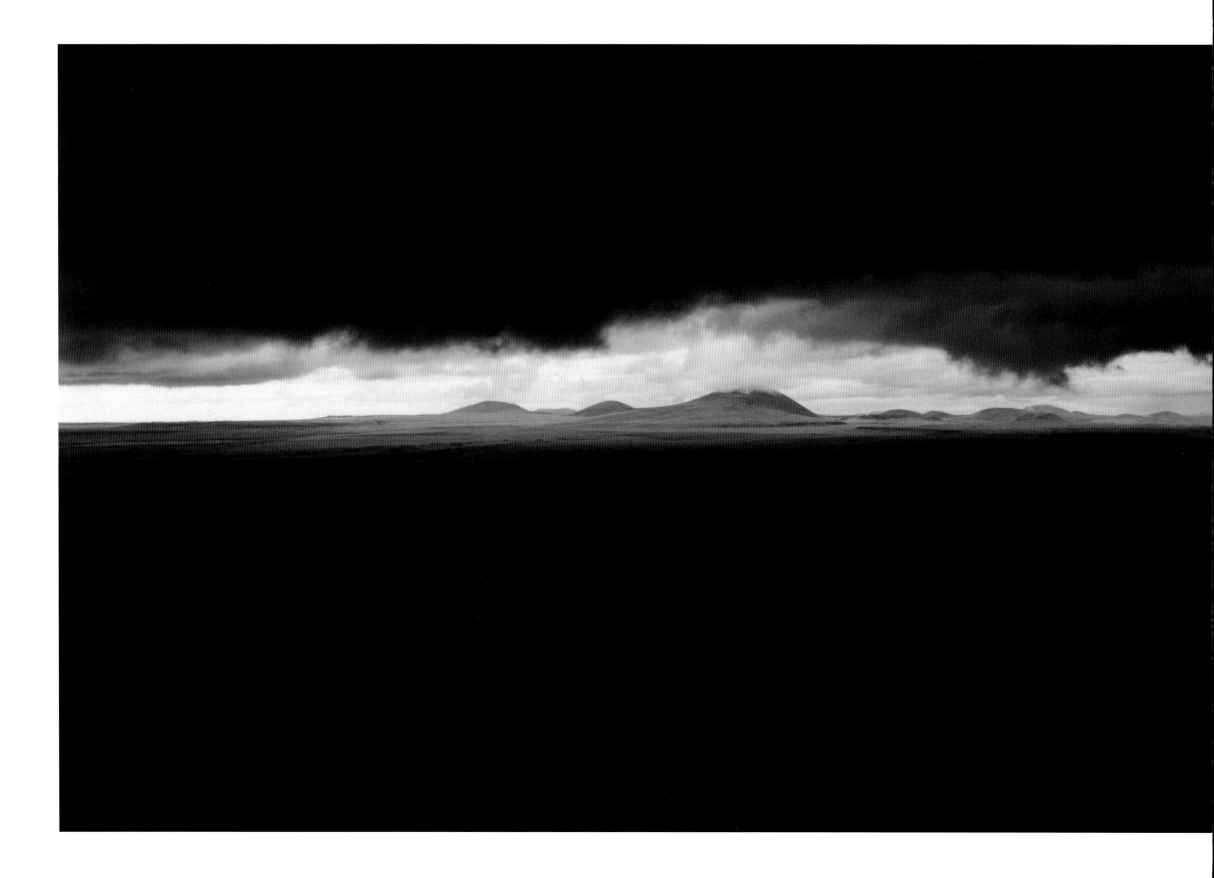

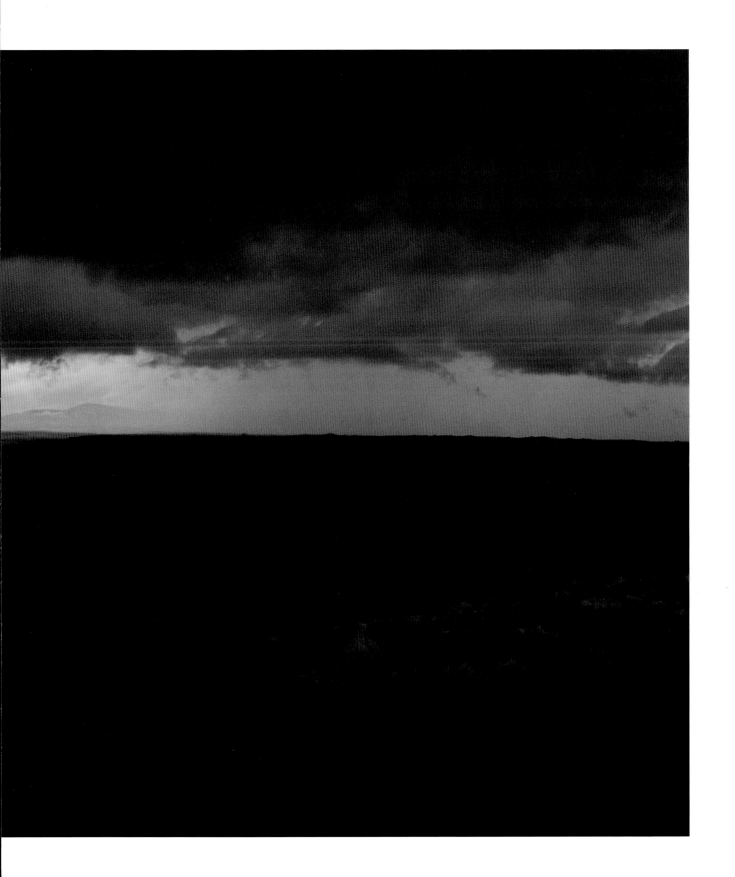

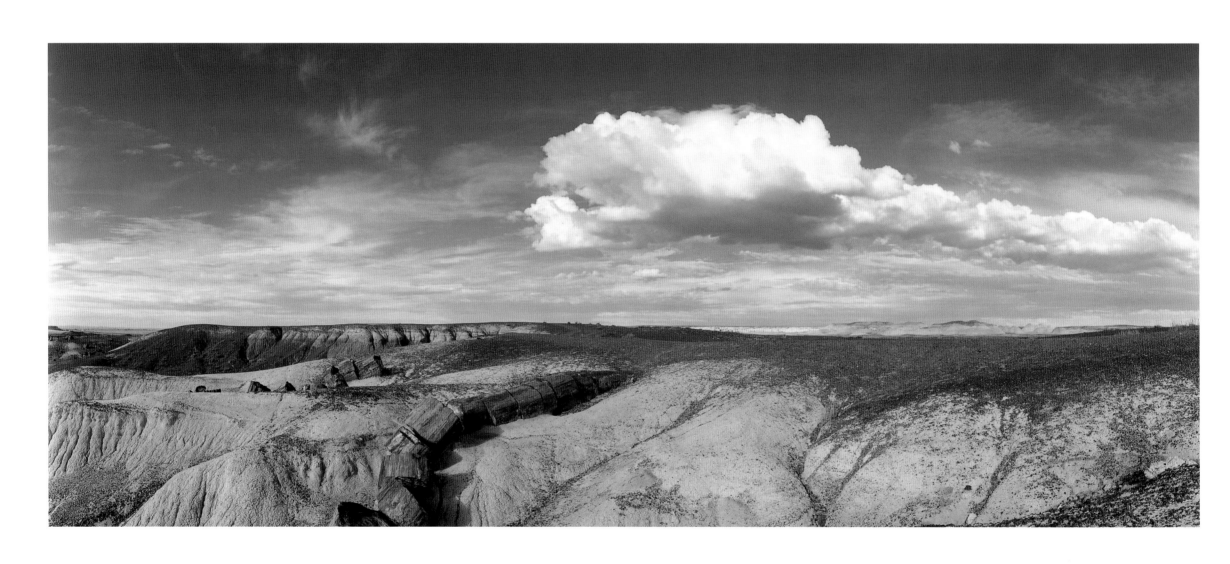

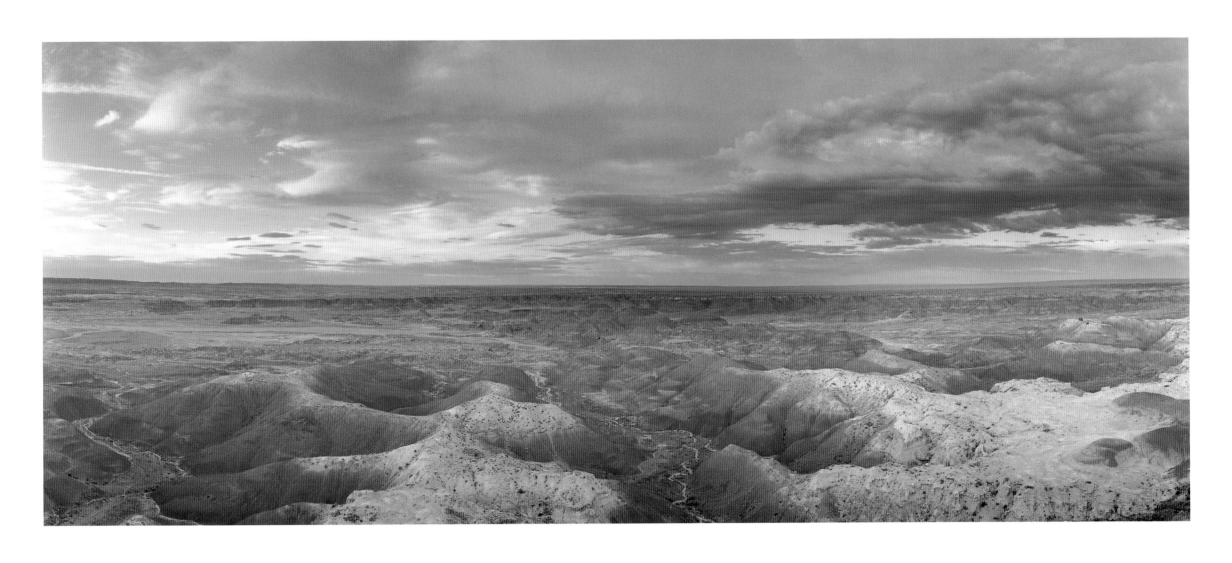

Monument Valley Navajo Tribal Park, Arizona/Utah

Monument Valley's regal, freestanding rock formations emerge like sculptural forms, carved out of the detritus that successive waves of sedimentation of sandstone, limestone, and shale laid down over millennia. These are not the weird contortions of frozen volcanic magma or the slumped curves of badlands; they are chiseled and deliberate, prodigiously proportioned. Monument Valley is a testimony to the earthen origins of sculpture and architecture. All the classic elements exist here naturally: plinths and capitals, saintly niches, colonnades, broad arches, pyramids, and pediments.

The Navajo call this open flatland "Tse Bii Ndzisgaii," the "clearings among the rocks." The San Juan River wraps around luminous rock walls, scoring deeply into porous sandstone canyons that reverberate the slightest whisper. Leathery slickrock pierces the turquoise sky. Lone buttes throw mile-long shadows, and broad-shouldered mesas foreshorten distance. This is what grabbed director John Ford's imagination and forever linked the Western film genre to this location. A cowboy or an Indian on horseback, backlit, on the ledge of a cliff, assumed the heroic dimensions of these operatic clearings studded with monoliths. Hiking into Monument Valley is like walking onto a film lot.

Wild West shows were the precursors to the silver screen. The New York Picture Company contracted with Joe Miller's Oklahoma-based 101 Ranch to film in Los Angeles. Miller's show featured Bill Pickett, an African-American cowboy who invented rodeo bulldogging and died of a horse kick at age 101. Buffalo Bill's Wild West primed both performers and audiences for the world of motion pictures. William "Buffalo Bill" Cody became a legend because of the tales that writer Ned Buntline spun about him in dime novels, which were based on Cody's life as a buffalo hunter and scout. The dime novels were followed by theatrical plays, frontier melodramas. Cody stepped into the role of himself onstage—and his onstage and offstage personas would never again be completely separable. In the 1880s Cody started his Wild West shows, huge spectacles that toured the country and Europe, with special perform-

ers such as Annie Oakley. In the simulated battles such as Custer's Last Stand, Native Americans swapped warpaint for greasepaint overnight. Even the great Sitting Bull appeared, posing in publicity photos as the former foe now turned friend.

Thomas Edison invented the movie camera at the turn of the twentieth century. He made films such as *The Great Train Robbery* in New Jersey and wanted unconditional control over all aspects of filmmaking and distribution. He patrolled the fledgling industry with a coterie of hired guns and lawyers. Filmmaker Allan Dwan recounts, "[They] hired goons for gunmen. If they saw a bunch of people working, and it wasn't one of their companies, they'd shoot a hole through the camera." By 1910 several movie makers left for California to escape Edison's Motion Picture Patents Company.

Actor William Hart was among those who left the East Coast to work in Los Angeles. He knew that the East Coast's "Westerns" were laughable—Indians in gingham shirts, cowboys riding horses in English saddles on paved roads. These films verged on the burlesque, with cheap sets of imagined landscapes. Hart's own experience living in the West enabled him to give a truer performance, even though, to our eyes, his lipstick was a tad too dark.

Harry Goulding and his wife lived among the Navajo in Monument Valley and ran the trading post. During the Great Depression, Goulding came to Hollywood with an idea that transformed filmmaking and our notion of the West. He brought a portfolio of black-and-white photographs of Monument Valley, taken by his friend Joseph Meunch. He hoped that director John Ford, who was about to film *Stagecoach,* would see its location potential.

Ford fell in love with Monument Valley. His cinematographer, Winton Hoch, shot low and long, capturing the mythic landscape that was Ford's signature geography of the Western horizon. The orchestral score, heavy on strings and spliced with war whoops, embellished scenes of a hundred Navajo extras riding horseback at full gallop across the valley's splashy, open spaces. Ford and his compadre John Wayne made innumerable films here, including *She Wore a Yellow Ribbon* and *The Searchers*.

A real Western backdrop, however, did not mean the films portrayed real life in the West. Survival in the arid, complicated landscape of the West depended upon cooperation more than individualism, neighborliness coupled with a careful tending of sparse resources. Few

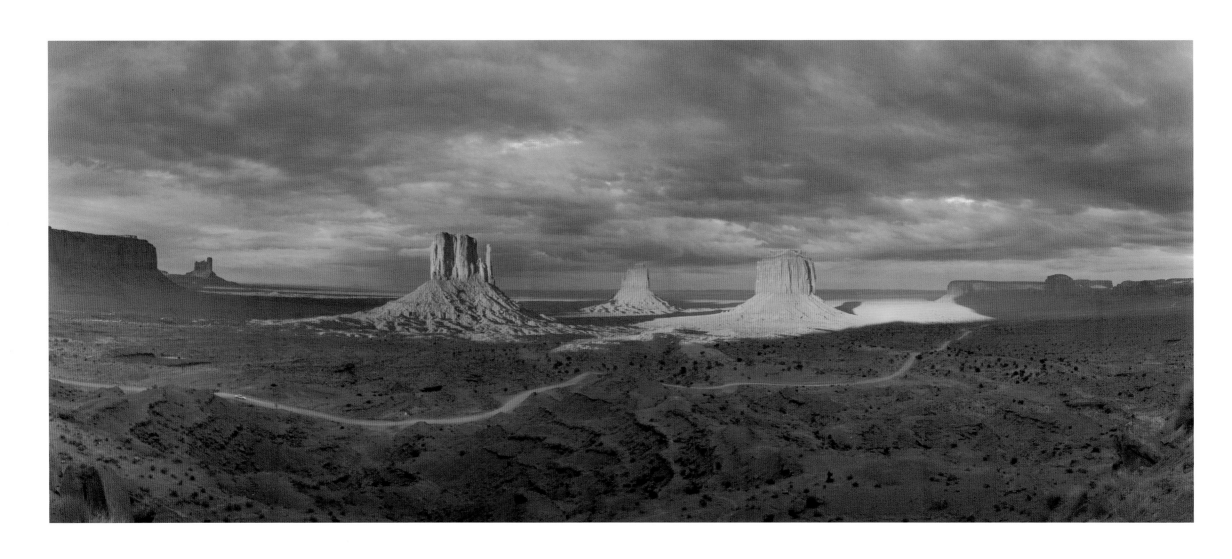

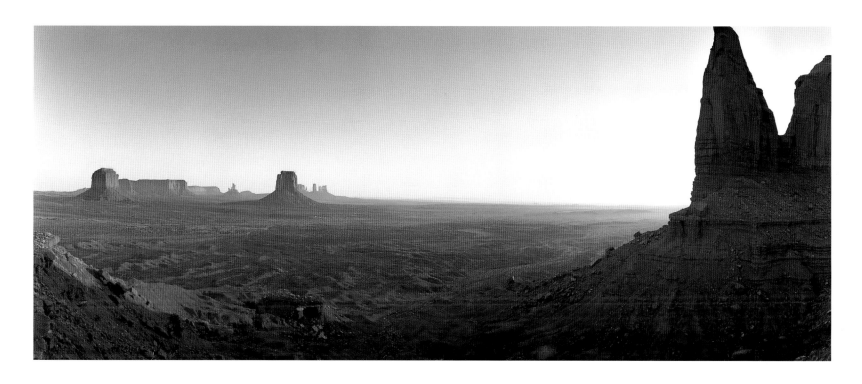

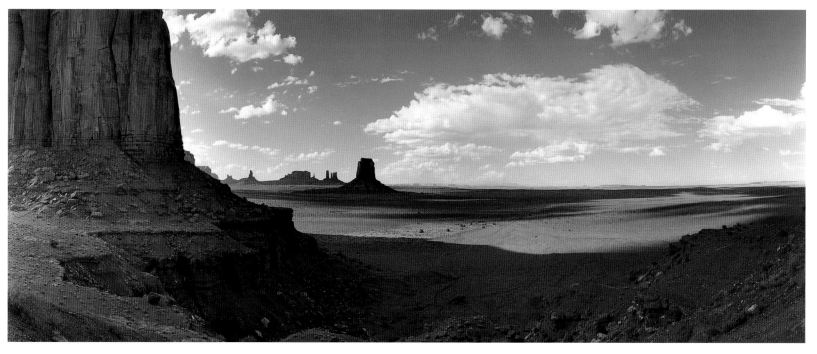

cowboys ever wore pistols—they were expensive, heavy, and threw a rider's balance off—and not all hookers had a heart of gold or looked like Linda Darnell. But when Maureen O'Hara said, "Savages, brutes, fiends! Why did I ever come to this nightmare of a country!" and when John Wayne drawled, "That'll be the day," the movies seemed real and true.

Westerns gave us pictures of how we wished to see ourselves: stoic men and women, tough yet tender, with boundless determination, solitary, brave, loyal and passionate.

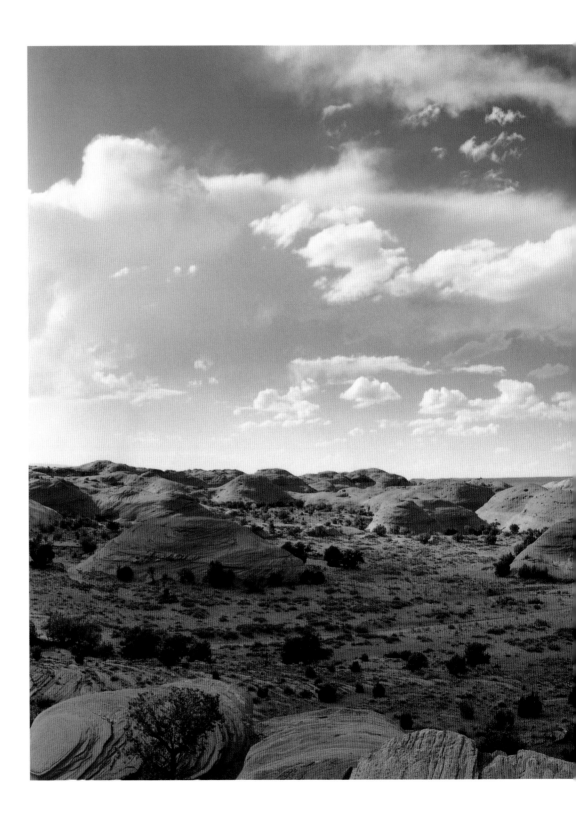

The Western persona was devoutly co-opted by cowboys, immigrants, and Indians alike. Ned Buntline would have smiled at how neatly art held a mirror up for life to imitate.

THREE SISTERS

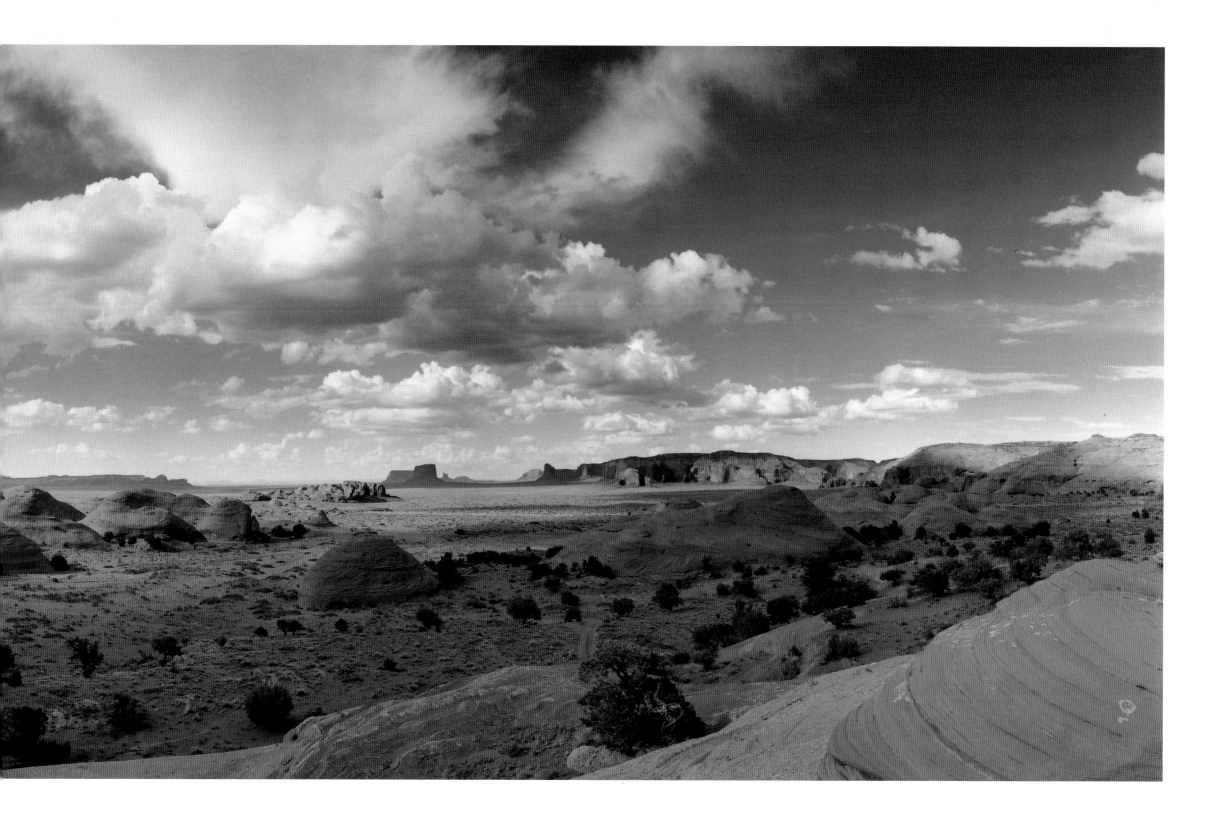

Wupatki National Monument, Arizona

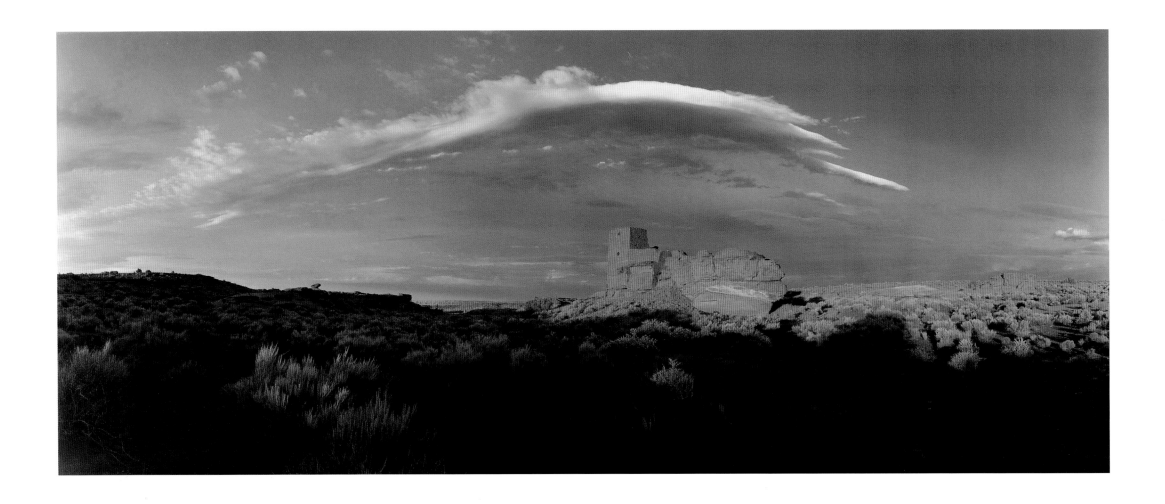

Millions of years ago the Colorado Plateau, which includes southern Utah, central Arizona, and Colorado, was uplifted by tectonic forces related to those that formed the Rocky Mountains. A large system of underground fissures aerated the entire plateau. When the fissures broke the earth's surface, they became earthcracks. Under certain barometric conditions, earthcracks can exhale blasts of cold air from deep within the earth in the summer and suck in cold air during the winter. In 1064 one such crack in the San Francisco Volcanic Field became the vent for an explosion of molten rock, blanketing 800 square miles of northern Arizona in cinder and ash, and the pit-dwelling Sinagua ("waterless") people fled.

About fifty years after the initial eruption, people returned to dry-farm beans, squash, and corn in the moisture-retaining black cinders that streaked and nourished the red ground. Wupatki pueblo was established fourteen miles away from the blast zone, along several of the mysterious earthcrack blowholes. Over the next ninety years, a thriving crosscultural community of Hohokam, Sinagua, and Kayenta-Anasazi families lived under the volcano's periodic eruptions. Gradually, volcanic debris built the cinder cone to a height of 1,000 feet. The volcano's final burst of lava in 1250 permanently tinged the crater with the sanguine colors of fire. The Hopi called it Red Mountain, and in 1892 John Wesley Powell, then director of the U.S. Geological Survey, named it Sunset Crater.

At approximately the time of the final eruption, the inhabitants of Wupatki suddenly disappeared. Where did everybody go? Wupatki was at the western boundary of the Anasazi world, which dominated the Southwest from 900 to 1200. The epicenter of this powerful culture of skilled masons, engineers, and elite priest-astronomers was Chaco Canyon to the northeast, an immense settlement of multistoried stone houses and road networks of military precision. Wupatki was a crossroads of trade routes that served distant cultures from Mesoamerica to the Pacific coast. Merchants exchanged copper bells, cloisonné, live macaws and parrots, and cotton from Mexico for turquoise, slaves, salt, and peyote from the north and abalone shells from the Pacific. Along with material items, new ideologies and technologies crossed cultural borders. But by the dawn of the thirteenth century, the Anasazi simply dropped out of history, leaving food in pots, corn in granaries, and disturbing evidence of a violent demise.

Wupatki, Hopi for "Tall House," was a warren of more than 100 rooms jutting out of red rock outcrops like knuckles from a fist. Looking from a distance, it is impossible to tell where construction takes over from the raw mass of rock. The land, Triassic deposits of silt and sediment, is the richly oxidized rust of the Moenkopi formation. The red sandstone overlaps in waves, holding the memory of ancient tidal flows.

Stone breaks apart naturally along these lines into buildable slabs, which were held in place with clay mortar. The pueblo, including kivas and a dance plaza, were modeled after Chaco-type structures, but the ball court reflects distinct Mesoamerican influence.

All cultures have their dark side. To deny that is to blanch them of their humanity. Violence shrouded in taboo surrounded certain locations Navajo call *chindi,* "place of bad ghosts." Many of these were Anasazi sites, where archaeological findings of mass graves, human dismemberment, and cannibalism punched a hole in the collective cultural memory. Pueblo Indian legends of unspeakable events gradually unfolded, like family secrets in a Southern novel. The demise of the Anasazi is a controversy that may never be settled, but there is substantiated speculation that a warrior-thug cult from the collapsed Toltec theocracy in Mexico infiltrated and subjugated the Anasazi by sheer terror, and some Anasazi might have joined their ranks. These marauders took advantage of a population in the grip of devastating drought, disease, and crop failure. Structures became increasingly defensive, like the Citadel, northwest of Wupatki. People desperately fled the flatland to live where swallows nested, in the recesses of the most inaccessible cliffs. In nearby Monument Valley, hundreds of child-sized handprint paintings cover a wall below a small Anasazi ruin. We will never know if they were done in the idleness of art, a religious act, or as a final gesture that cried out, "We were here."

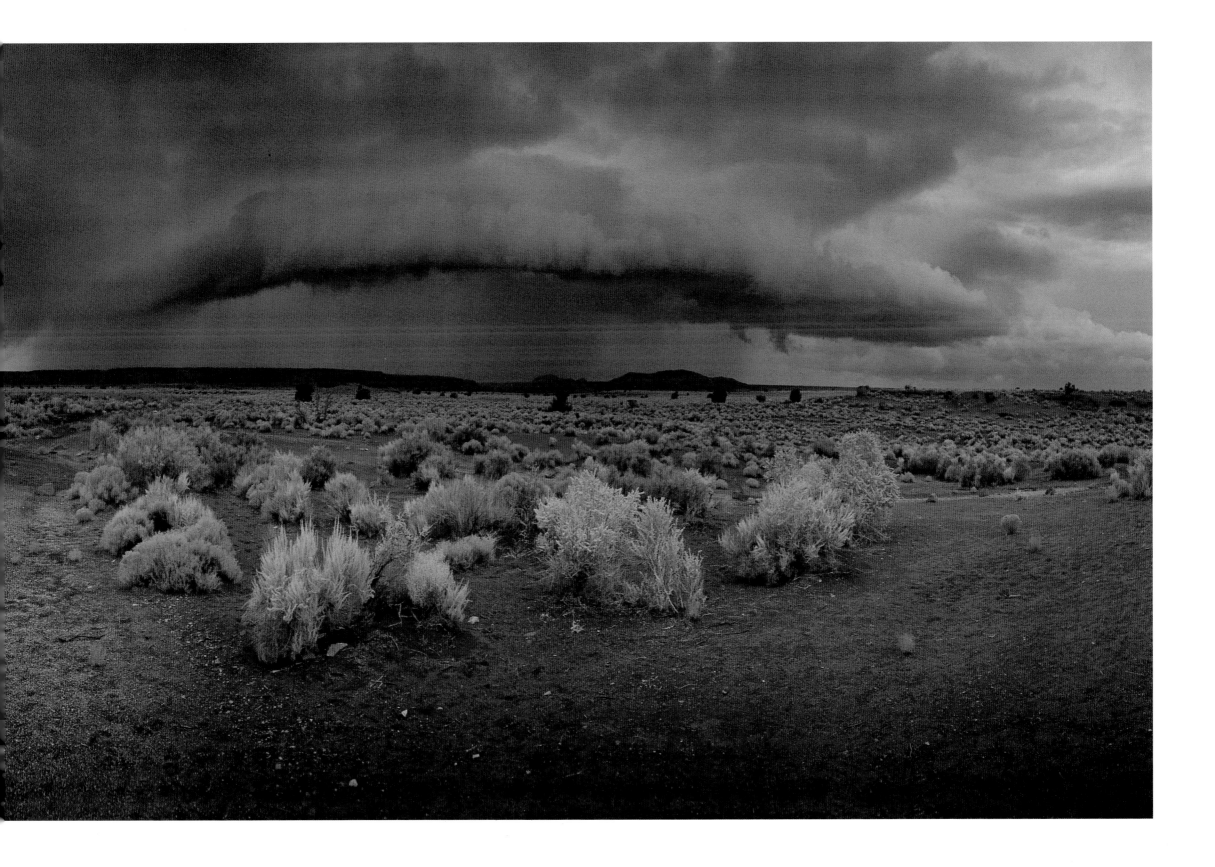

Mount Saint Helens, Washington

The mountain peaks that root the stony rampart of the Cascade Range in northwestern America deep into the earth's mantle lie within the Pacific Ring of Fire, a zone circumscribing the Pacific Ocean in which seventy-five percent of all the world's volcanic activity occurs.

The earth's crust is the scum embedded in the tops of the dozen or so tectonic plates that cover the planet. When continental plates collide, mountains are thrust up, and when they pull apart, abysmal oceanic plains are created. The Pacific plate carries water along with it as it dives down into the subduction zones around its perimeter. The water melts the deep, hot mantle rock, and the melt bubbles up to the surface like a lava lamp, brooding, then birthing volcanic new land.

The Cascade Range spans from Canada to northern California. It is a fairly recent uplift studded with several active volcanoes, including Mount Rainier, Mount Baker, Mount Lassen, Mount Shasta, and Mount Saint Helens. The activity of this last mountain in the 1800s was faded news until suddenly, in 1980, residents living in the vicinity of Mount Saint Helens watched in disbelief as their familiar, scenic horizon vanished. Eruptions were supposed to be exotic fare: Krakatoa, Mauna Loa, Mount Pelée. No volcanoes in western Europe, with the exception of southern Italy and far away Iceland, had been active for eons. Historically, nothing in the European lexicon, outside of biblical passages of the Creation and the Apocalypse, alluded to volcanic events. What could have prepared these recent immigrants psychically for the rambunctious, volatile American West?

When white men arrived in America, they substituted native place-names, which referred to the geologic and historic past, for those of saints and politicos. In a generation or two, these new inhabitants had forgotten that Mount Saint Helens—named in 1792 by a British Royal Navy officer, Captain George Vancouver, for a British ambassador, Baron Alleyne Fitzherbert Saint Helens, who never set foot in America—was once called "Smoking Mountain" and "Mountain of Fire" by Native Americans in the region. And these names accompanied a myth of

cyclical change: the mountain is a beautiful maiden, who transforms into an old dowager, destructive and wrathful; and then, she turns into a beautiful maiden again. White settlers saw only the seductive, snowy peak, oblivious to the myth's warning.

To the native peoples, America was an ancient home. Their myths told its story and placed them in mindful relation to it. Western-bound settlers with roots only a few generations deep in this soil saw the same land as a brand-new frontier. They had an undaunted belief in their right to claim and subdue it. Manifest Destiny kept the wagons rolling westward. Profit from the sheer bounty of water, timber, minerals, and other resources quelled any doubts that this land could be infinitely harvested and controlled. Towns sprang up beneath the shadows of volcanoes and above scarred and quaking fault lines—places native people regarded as powerful, to be cautiously revered and even avoided. One people's point of view totally mystified the other. As Canadian artist Paul Kane noted in his journal in 1847, "I offered a considerable bribe to any Indian who would accompany me in St. Helens exploration but could not find one hardy enough to venture." His Romantic paintings document several mid-century eruptions.

When the eruption of Mount Vesuvius destroyed Pompeii and Herculaneum on August 24, 79 A.D., it preserved an eerie and detailed tableau of life cut off suddenly and violently. The father of all naturalists, Pliny the Elder, died in the suffocating ash. His nephew recounted what he witnessed at age eighteen in a letter to the historian Tacitus: "They went out then with pillows tied to their heads with napkins; and this was their sole defense against the storm of stones that fell around them." In a flourishing city where lava turned the living into ash and mud sculptures, "it was now day everywhere else, but there a deeper darkness prevailed than in the thickest night."

A series of 1,000 earthquakes in seven weeks, several eruptions, and in the final month, a bulge on Mount Saint Helens's north face that jutted out from the previous angle of repose a full 400 feet—and growing five to seven feet a day—still did not deter some from playing

Russian roulette with the mountain. Others simply got fooled by the blue Sunday sky into going for a hike. The most documented and studied eruption in history pivoted around vulcanologist David Johnston's last words, called out to his headquarters in Vancouver, Washington. At 8:32 A.M., May 18, 1980, "Vancouver! Vancouver! This is it!" reverberated over the air waves as a 5.1 earthquake triggered the largest landslide in recorded history. Thirteen hundred feet of mountaintop, snow, glaciers, and anything else that got in its way hurled to the Toutle River valley floor with enough momentum that it ramped over the ridge where Johnston manned an observation post, peeling back the topography to the scalp of bedrock. It displaced a lake and created several new ones. Spirit Lake, hot as stew, was clogged with timber in spiral or herringbone patterns that shattered all sense of scale and proportion.

Millions focused on the small recreational area in Washington one hour north of Portland, Oregon, as film clips showed a chiaroscuro column of tephra and ash shoot ten miles into the heavens. Barrier-breaking sound waves felled four billion board feet of timber like sheaves of straw. Then, an unearthly silence enshrouded Mount Saint Helens—mud-muted rivers, ash turning day to night, a black-and-white landscape where no bird sang.

Today, Mount Saint Helens is a National Volcanic Monument, and hundreds of individual research plots track the succession processes. New spring grass and moss cover the ashen mesas in a veneer of green. Elk graze; pearly everlasting shoots up through the snow. The rosy finch and the violet swallow now nest inside the crater. Within the fourteen-mile blast zone, salvaged trees were volcanically flash kiln dried. Outside the zone, noble fir reach twenty to forty feet. The old dowager is incubating a growing composite dome that is already over one square mile within her 8,365-foot crater—wizened craters beget fresh mountains.

Crater Lake National Park, Oregon

Crater Lake's reputation as the roundest, bluest lens ever to reflect the sky is so famous that even on rainy days when the sky is as dense as cotton batting, visitors to the lake can be heard exclaiming, "It's so blue!" Even beneath such a sky, the lake turns from stony black to indigo and lapis, then to opaline and pewter. A sixteenth-century saying, "Blue is not merely a color, it is a mystery," could have been written about Crater Lake.

Seven thousand years ago the Makalak, ancestors to the Klamath and Modoc people, survived the destruction and collapse of Mount Mazama, the tallest mountain in their world. They described the event as a battle between two deities, Earth and Sky. Llao, the chthonic deity, occasionally ventured above ground to the mountain's summit. He became enchanted with the head chief's beautiful daughter and wanted to take her to his netherworld. She spurned Llao, and the enraged and vengeful god belched forth a devouring eruption of fire and ash. Two holy men, sensing the imminent destruction of their people, threw themselves into the inferno to appease the god. Seeing this self-less act, Squl, the spirit of the sky, took pity. He stood atop Mount Shasta, 100 miles to the south, and returned fire with fire until the mountain collapsed on top of the earthen spirit, entombing him. In time, rains and snows came, giving the people one of the deepest, purest lakes in the world.

Myths grow around a kernel of history, and this one accurately reflects the geological record. The eruption of Mount Mazama, forty-one times more powerful than Mount Saint Helens's 1980 blast, blew its guts out and the top third of the mountain collapsed in on itself, creating a six-mile-wide caldera, and showering ash in seven western states, three Canadian provinces, and far out to sea. The final extrusions of magma caulked the caldera. Over a period of approximately 800 years, it filled with pure sky water.

Crater Lake, with its vertiginous heights and enveloped in fifty-foot snow drifts and bracing winds, was regarded as a dangerous site with spirits lurking in its chilly depths. Few Indians were allowed to see the lake. On a Vision Quest an initiate would dive into the lake, praying, "I want to be a shaman. Give me power. Catch me. I need the power." Perhaps to peer into the corneal blue lake was to gaze into the eye of a god.

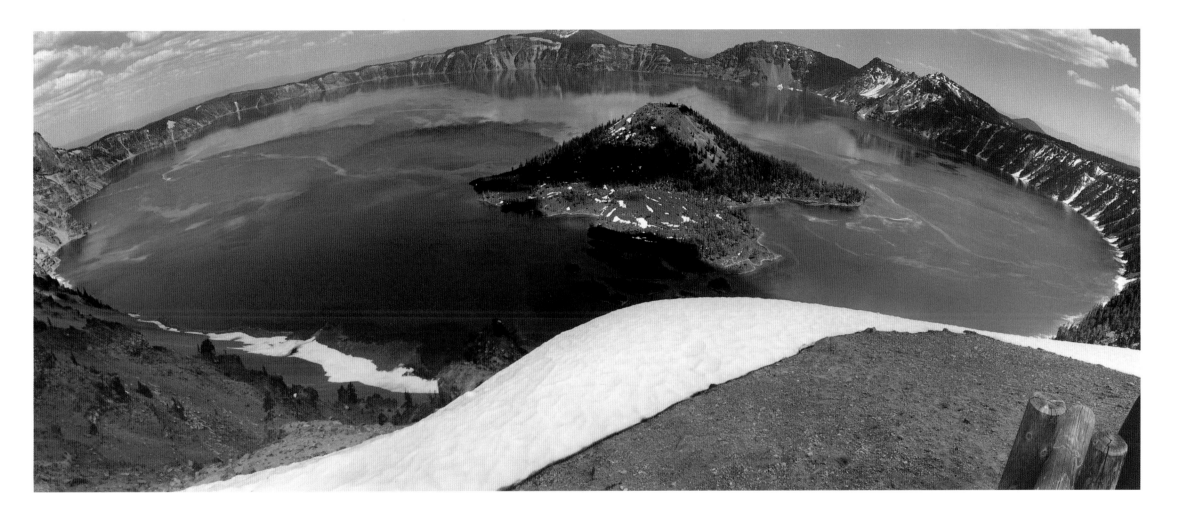

Crater Lake National Park is a neat little square with the lake standing as a bull's-eye in the center. Two volcanic cones rise up from within the grand crater of the lake, but only one by the west rim breaks the surface. Named for its conical shape like a sorcerer's hat, Wizard Island is the perfect counterpoint to the circular lake within the square park. The move to preserve the lake and this modest stand of conifer forest began with a serendipidous event in the life of Judge William Gladstone Steele. The sixteen-year-old boy from Kansas wrapped his lunch in newspaper that happened to contain an article about early exploration of Crater Lake. He became obsessed with the idea of its deepness, its blueness, its origin, and its mystery. His family moved to Portland, Oregon, two years later, but he did not glimpse the lake until 1885, when he was thirty-one years old.

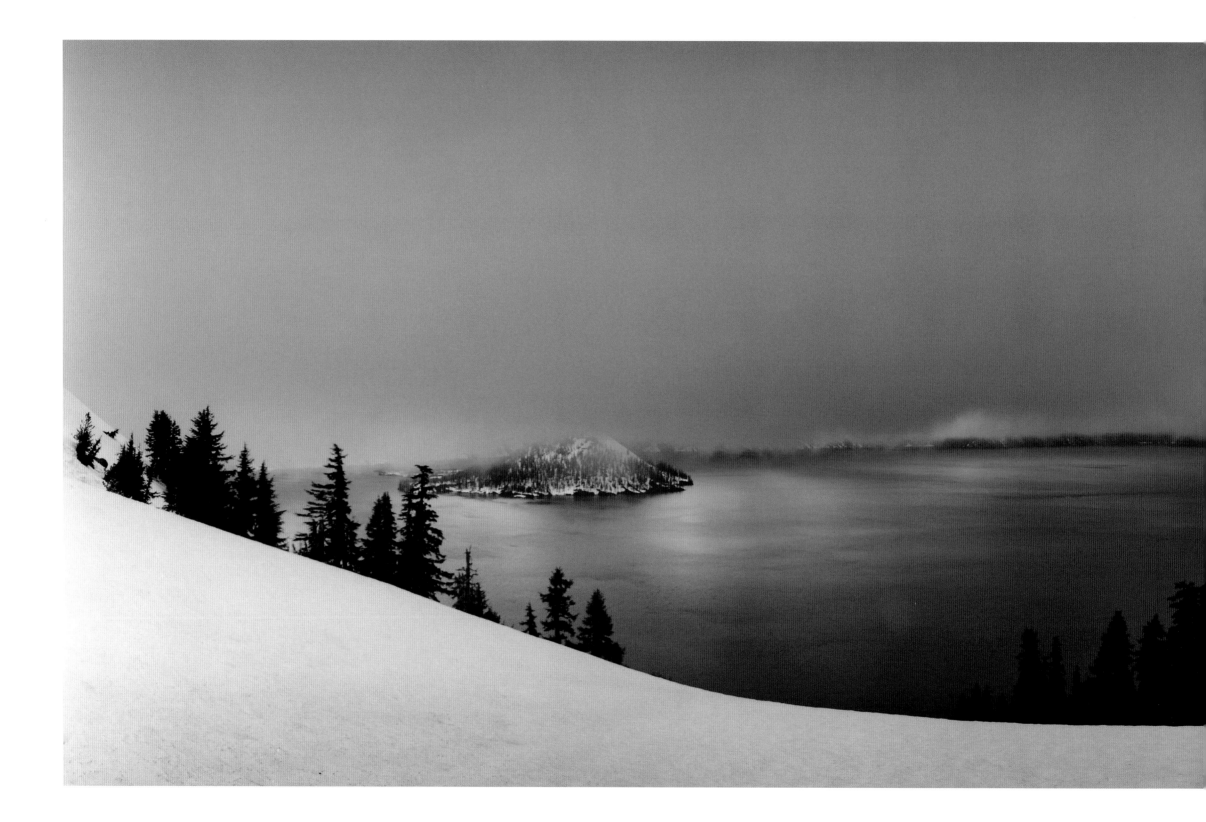

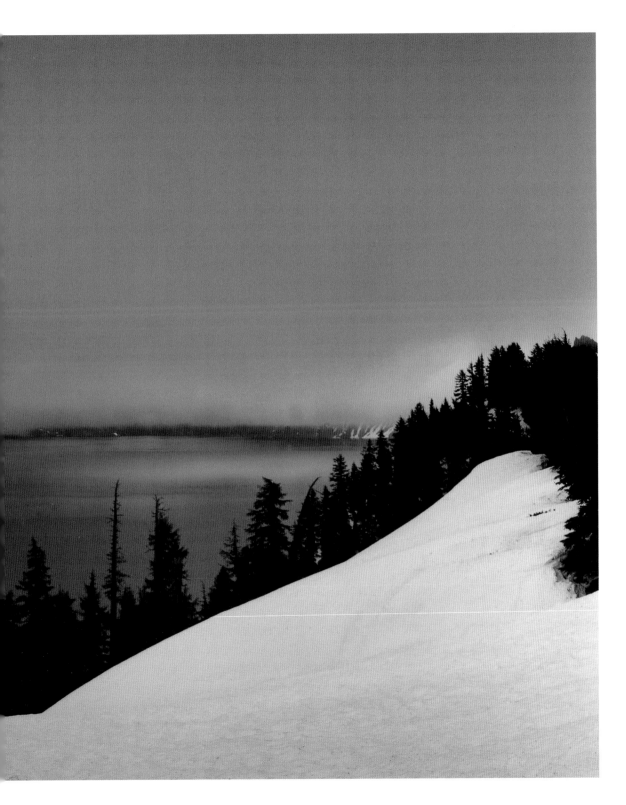

At that time Steele joined geologist Joseph LeConte and Captain Clarence E. Dutton's survey team, who were studying the volcanic features of the Pacific coast. They measured the depth of the lake via soundings made with piano wire spooled on timber. Later, more accurate readings have measured the depth at 1,932 feet—the lake is the seventh deepest in the world—but the 1885 team was off by only sixty-four feet. Over the next seventeen years, Steele brought senators, poets, doctors, and naturalists to the site to convince them that it deserved protected status. He met with opposition from sheep ranchers and developers, but his lobbying efforts achieved their goal: in 1902 President Theodore Roosevelt designated Crater Lake the sixth area to be protected by the National Park System.

Mount Shasta, California

Landscape and religion have always been intertwined. In ancient religions, rock, water, animal, and tree were animate, had a voice and a soul. In the Western desert religions, Moses, Jesus, Muhammad, and their followers withdrew into the wilderness to purify themselves and to nakedly face God. In the East, Taoism taught a way of life through metaphor—the flexible bough, the water-worn rock.

Perhaps the land is the source of all religion—the cataclysms that formed mountains and oceans, the miracle of the seed— for through these elemental events we can move outside of our skin, let the heights and depths of the land give voice to the human spirit, the give and take of life. Mount Shasta, Mount Olympus, Mount Fuji, and Mount Ararat are all volcanic; they pierce the sky and issue from the deepest earth. Native American, ancient Greek, Shinto-Buddhist, and Judeo-Christian religions, respectively, have imbued these solitary peaks with a sense of the sacred.

Smooth-backed lenticular clouds frequently hover above Mount Shasta, indicating turbulent winds and moisture below. Rising from the southern end of the Cascade Range, Mount Shasta is second in height only to Mount Rainier. It catches the brunt of Pacific storms, drawing weather to itself like a magnet, churning it into snow, and in the summer, spilling millions of gallons of crystalline water down its sides. The Sacramento, McCloud, and Shasta Rivers are all born on this mountain.

A stratovolcano, built from laminations of viscous lava and rubble, Mount Shasta is comparable in volume to Mount Fuji, both with postcard-perfect figures belying hissing fumaroles and violent storms. It must have been bitter irony for the Japanese Americans interned at nearby Tule Lake War Relocation Camp to look up and see beyond the barbed-wire fencing the tracery of Fuji against the California sky.

Shasta is a beacon visible on clear days from Crater Lake, 100 miles to the north. It rests on the weathered debris of an ancestral cone, destroyed by avalanches 300,000 years ago. Viewed from a distance, its base appears hazy and dark, in contrast with its snowy peak, creating an illusion of a majestic mountain floating in space. As Macduff Everton noted in his journal, "Standing all by herself, robed in snow with skirts of Shasta red firs, with five glaciers guaranteeing her whiteness, she was regal, confident and dazzlingly beautiful."

Late afternoon light dances across the small, nippled hills in the Shasta Valley that locals call the Hershey Kisses. These are hummocks, chunks of the mountain flung across the plain millennia ago when a lateral blast, similar to the Mount Saint Helens eruption, caused an immense landslide of magma. Now black cows dot the green pasture and yellow mustard grows shoulder high. Shasta has erupted about once every 250 to 300 years—a scene of serenity with an underside.

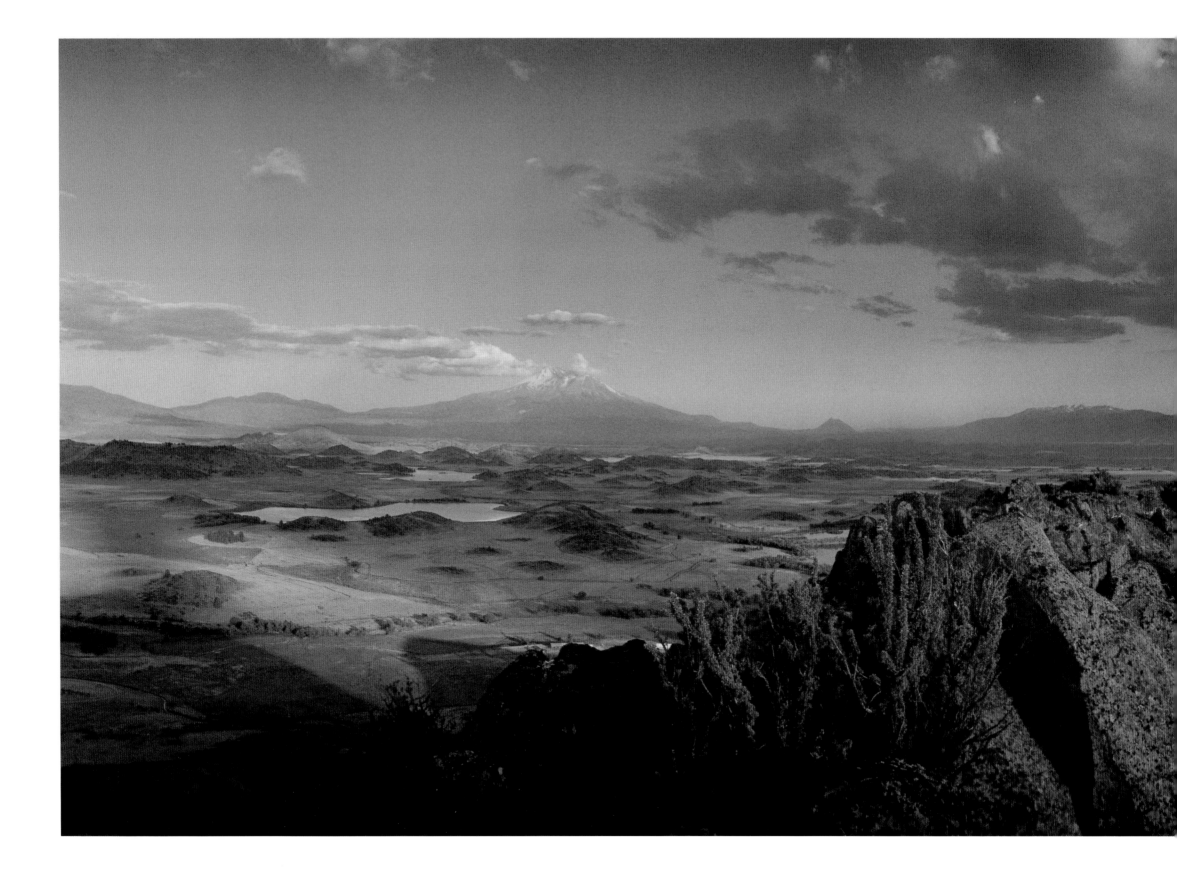

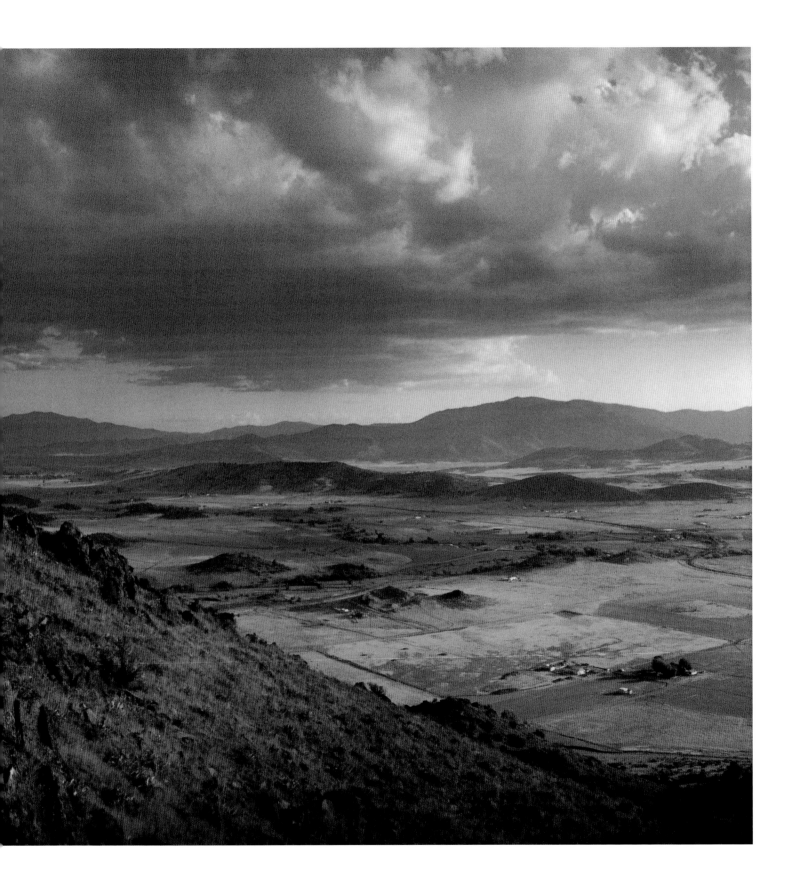

Oregon Coast

In a letter to President Jefferson of September 23, 1806, Captain Meriwether Lewis wrote, "In obedience to your orders we have penetrated the Continent . . . to the Pacific Ocean." Jefferson had commissioned a complete survey of the lands acquired from France in the Louisiana Purchase of 1803. Lewis and Clark's Corps of Discovery expedition made the first accurate maps of the western interior United States and documented more than 170 new plants and 120 animals. But the drive to find passage to the Pacific had become their bottom-line obsession. Years before, the Canadian explorer Fraser had tried and failed, as a folksong recounts, "to trace one warm line through a land so wild and savage and make a Northwest Passage to the sea." The American temperament, curious and outward-looking, hungered to possess one huge land embraced by two oceans.

The Corps of Discovery spent 6 sunny days and 112 cold, sick, rained-on days wintering near the mouth of the Columbia River, before journeying back to St. Louis with the news of their discoveries. The Clatsop Indians helped them build a fort on their land—a complex of buildings that Oregon weather subsequently rotted in less than fifty years. Occasionally, the heaviness of the Expedition's immense journey may have lifted as they set their focus outward to where earth meets sky.

Bigness defines the Pacific Northwest: big trees, big mountains, big rivers, big beaches. It is nearly impossible to imagine the wealth—an inexhaustible paradise of fish, timber, water. It seemed facetious to girdle the desire to make unbounded use of resources in a landscape of such apparent plenty. The West was being resettled by new waves of immigrants seeking sanctuary and opportunity. Their independent spirit was tenacious, and although the bounty was there, the small gains of homesteaders, miners, and ranchers eking out a living were hard-won. However, almost as soon as the nation became bicoastal, friction developed between conservationists and local economies over how to manage its resources. Today, a good deal of the Oregon coast has been preserved as state parks, accessible to the public and protected from overdevelopment.

This is the land of the spotted owl, shut-down lumber mills that have challenged people to develop new jobs, recycling, entrepreneurs in mariculture, and environmentalists talking about animals losing and recovering habitat. It is land that has been folded, abraded, and blasted into being. It is the land of the legendary Great Water that sixteen-year-old Sacajawea, the Indian girl who accompanied the Lewis and Clark Expedition, traveled so far to see.

Oregon's continental shelf extends twenty to thirty miles beyond the shoreline, quite unlike the Big Sur coast of California, which plummets almost immediately to deep ocean and a wallop of waves pounding the shore. Oregon waves roll in, long and slow, enveloping everything in a sostenuto field of sound. The ample shelf encourages gargantuan tidal flows, bathing oyster beds in estuarial waters eight miles inland. Bleached white shells in front of commercial oyster farms recall the Indian peoples' midden mounds of centuries past.

The Oregon coast drastically changed 17 million years ago when a boiling sea of lava coursed the ancient Columbia riverbed, laying down thick deposits of basalt and coating them onto the continental shelf. This basaltic floodplain might have created the hot spot atop which Yellowstone now sits. For millions of years, mud and sand carried by the strong currents of the Pacific Ocean coated over the basalt. Through subduction the Pacific plate continues to underplate the ancient shoreline of western America, and the long-buried basalt formations are jacked up above the water's surface.

Massive headlands arose with water-drilled sea caves, including Sea Lion Caves, the only place on the mainland where Steller sea lions still rook. Spires of basalt emerged from their sandstone cocoons after millennia of elemental abrasion. These sea mounts stand with a presence and poise to which monumental sculpture can only aspire. They dwarf beachcombers and draw the eye outward toward the measureless sea.

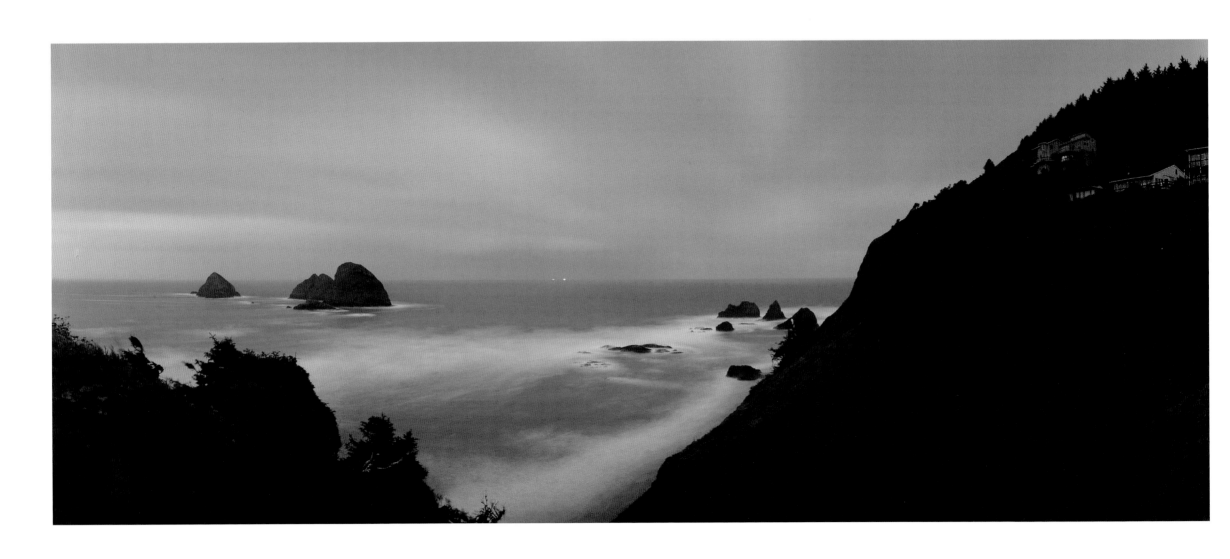

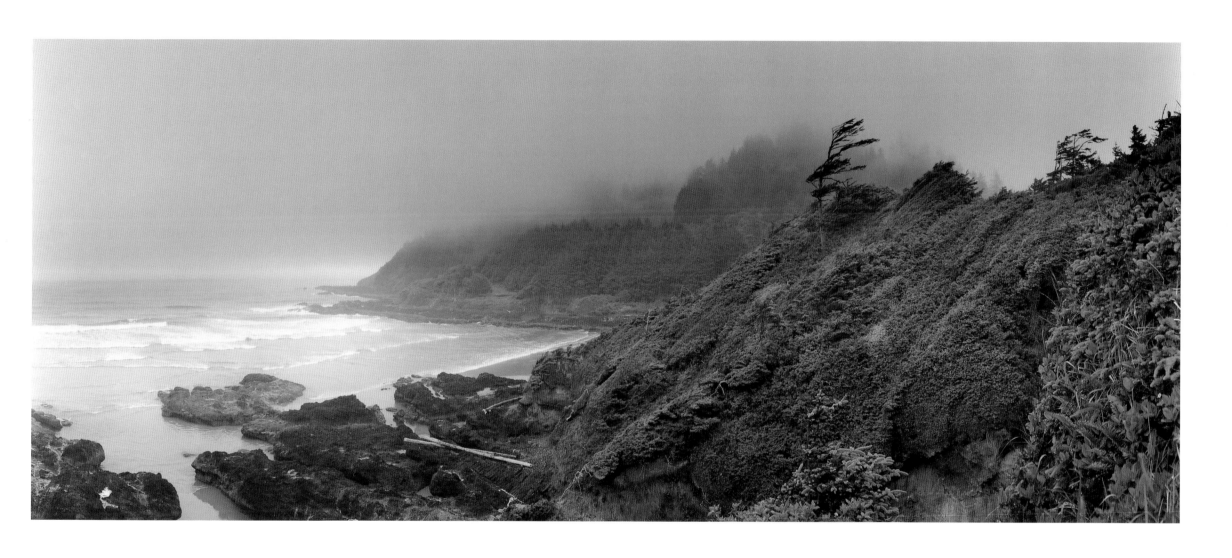

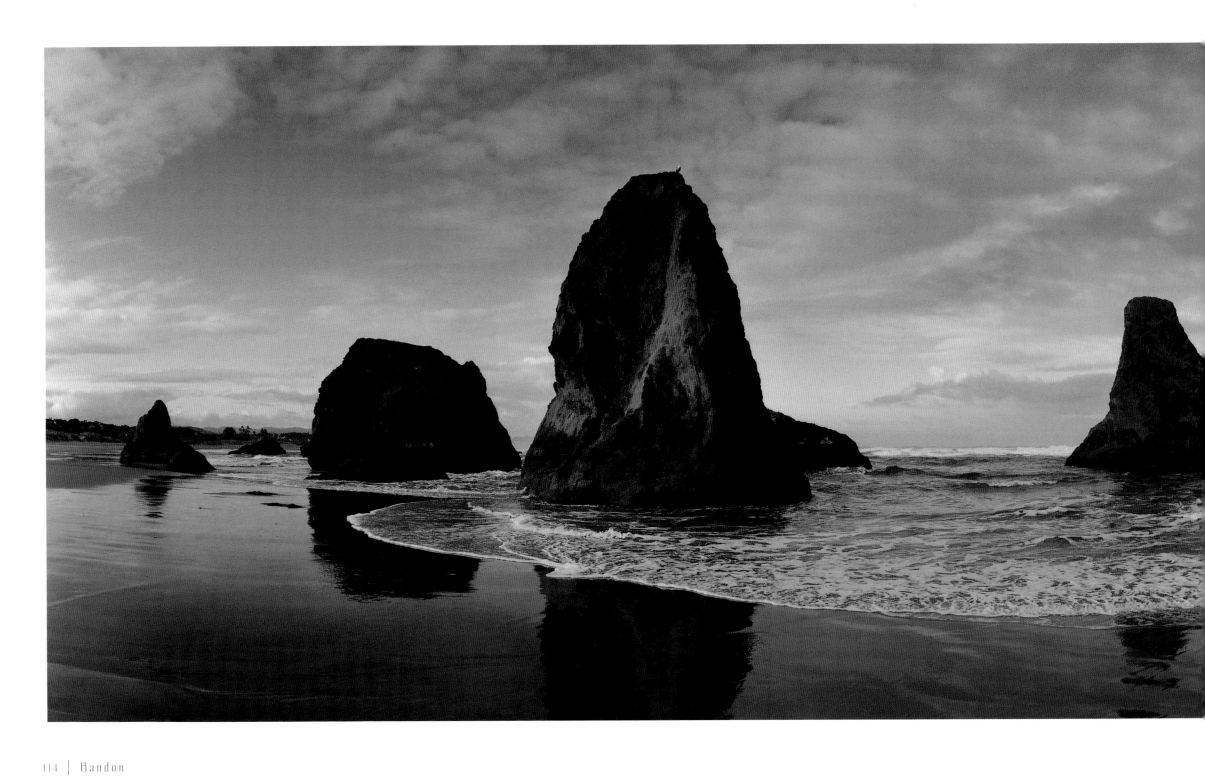

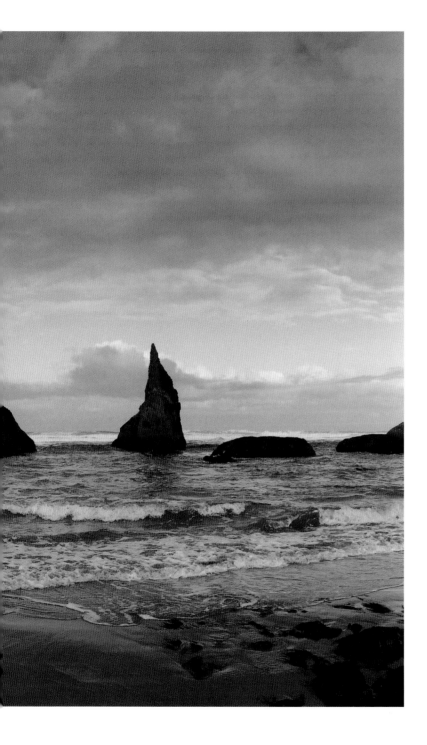

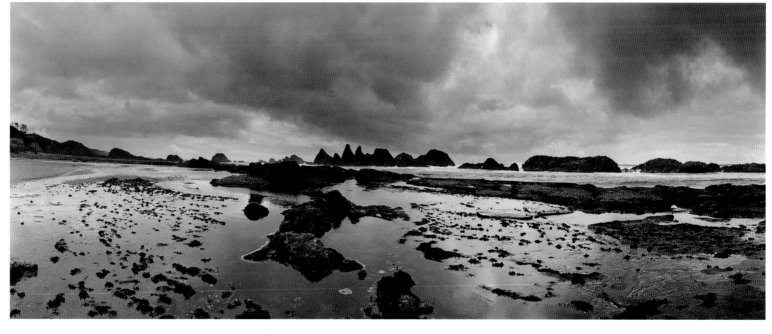

California

Big Sur

Queen Califia, a mighty black Amazonian, ruled a utopian island rich in gold called California. Such was the stuff of sixteenth-century Spanish romances, such as *Las Sergas de Esplanadián* by Luis Galvéz de Montalvo, which milked the Old World penchant for *fantasias* of exotic places for all the honey it was worth. As it turned out, however, the tale was not entirely fantasy. California is in part an amalgamation of oceanic islands compacted together. About 250 million years ago, part of the Pacific plate, an island arc of exotic terrain that geologists refer to as Sonomia, thrust up against the western edge of ancestral North America. It sutured itself to the mainland from the Sierra foothills to the Sonoma Range in central Nevada, partially through the heat and pressure of volcanic eruption.

California's igneous spine, the volcanic Sierra Nevada Range, slopes toward a lush central valley. The valley's western edge at the San Andreas Fault cuts a hard, straight line parallel to the Coastal Range, running from above San Francisco down to the Carrizo Plain, where it veers east. The state's central coast is carved, worn, and battered by tides and storms. The Pacific Ocean looms up like a dome of marbled green stone, and waves arch their massive backs, heaving themselves against the granite rocks. Because the continental shelf here drops abruptly to deep ocean, the waves' thunder is penetrating and sudden. As the tide rakes back over the shore you can hear the sea breathe. Simple gravity, in a terrain defined as pure landslide, or the pressure waves of an earthquake roll across the land and Big Sur shakes off a chunk of cliff into the sea.

Fog embraces the coast, linking the land and the ocean. Within this fog belt that extends from Big Sur north to the Oregon border, towering old-growth forests of California coastal redwoods used to thrive, shielded from the bright California sun. Dwindling groves of redwoods, the state tree, are protected in state and federal parks. In January 2000 President Bill Clinton signed into law the California Coastal National Monument, further protecting the Big Sur area.

Big Sur seems at the continent's edge, where the Pacific bends at the horizon line, vast and restless. Along this stretch of land, Highway 1 is a ninety-six-mile undulation of asphalt that hugs the sheer coastline so closely that it defines bird's-eye view. Big Sur extends from San Simeon to Carmel, beginning as a swelling of the Santa Lucia mountains, rising to precipitous cliffs, and winding down to headlands fretted by canyons with countless creek drainages. In spring the hills wear bright green splattered with suncups and blue lupine; by September, summer's golden suede-covered hills turn as silvery as the backs of donkeys.

No harbors exist between Monterey and San Simeon, but the almost inaccessible coastline—which the Spanish called *el pais grande al sur*—was a killing field for otter and seal by the Russian and Spanish traders. Thought to be extinct, otter were sighted in 1938 off the Big Sur coast, which today is a refuge protected by law. Pelicans, hawks, and eagles circle and dive, and bleating gulls scavenge the littoral.

Even in pre-Contact times, California was the most populous state in the nation, but Big Sur has never been crowded. The Esselen people survived for some 3,000 years in Big Sur until the Spanish established a rosary of fort-mission systems along the coast in the mid- to late 1700s. But the land demanded a rugged tenacity that attracted few ranchers and homesteaders. In the 1920s poet Robinson Jeffers focused his monastic gaze on this place, which spoke to his soul far more than humankind; here he composed *Californians* and *The Woman at Point Sur*. Then, after World War II, bohemia discovered Big Sur. Jaime de Angulo, a Spanish poet who had received his medical degree in France, "dropped out" to live with the Indians and learn their languages, and he rode about Big Sur naked on a horse. Henry Miller's sybaritic writing and gorgeous watercolors immortalized the counterculture's Dionysian life in the area, in books such as *Big Sur and the Oranges of Hieronymus Bosch*.

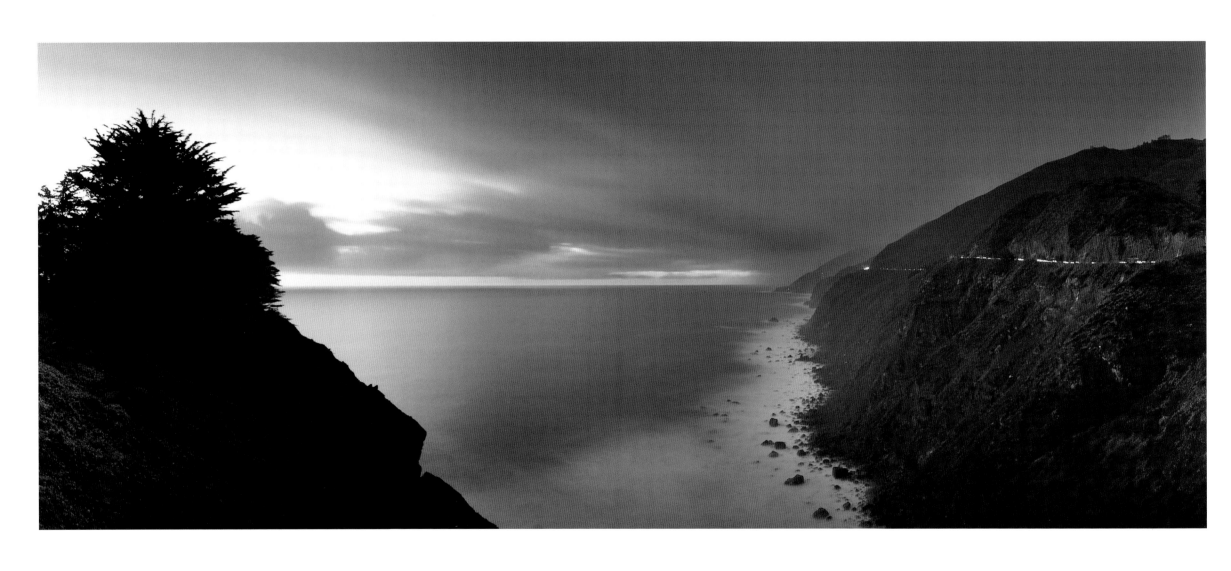

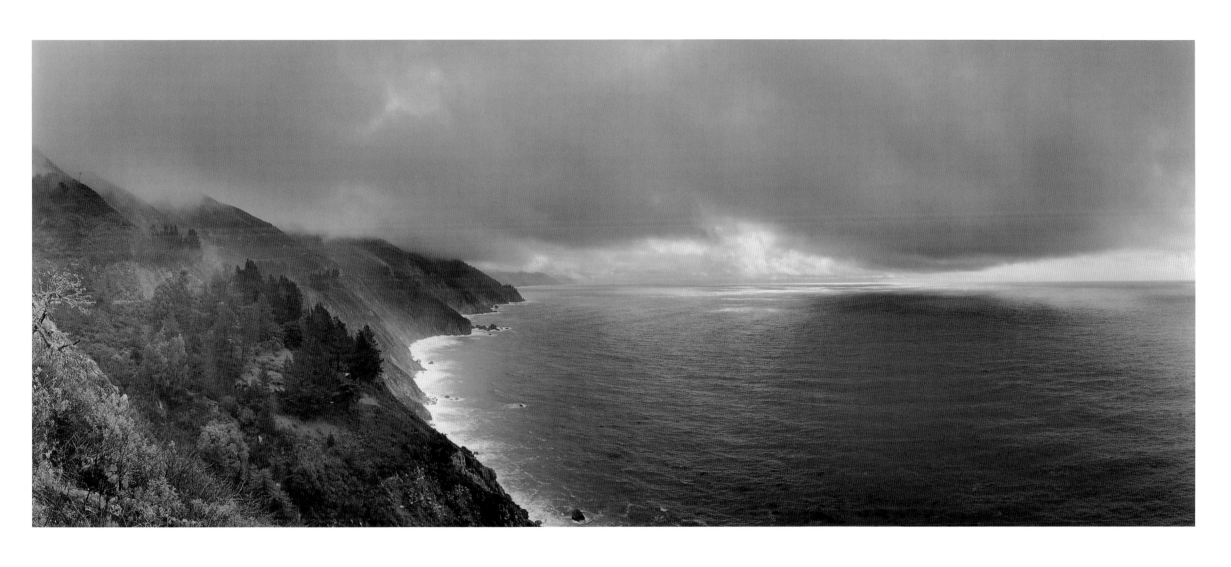

Santa Catalina Island

"Twenty-six miles across the sea, Santa Catalina is waitin' for me, Santa Catalina, the island of romance," sang the Four Preps in a popular song from the 1950s. The town of Avalon on this seventy-six-square-mile island is small and quiet, reminiscent of an older country—the little old lady walking her dogs along the malecon, the rummy bar, the vivid warmth of the painted tiles. But the adventurous sea-plane rides and the Great White Steamship, which once cruised from Long Beach to Avalon with stylishly dressed guests for an evening of dinner and dancing, are gone.

In 1919 William Wrigley, Jr., of chewing-gum fame and fortune, acquired controlling interest in the Santa Catalina Island Company, which owned the island. Going backward in time, the island was previously claimed by various ranching families; before then it was part of Mexico, since 1820 and until California was invaded by the United States in 1850; and prior to that, in 1602, it was claimed and named by Sebastian Viscaino for the king of Spain. However, for about seven thousand years, before the concept of land ownership even existed, Santa Catalina was the home of seafaring traders and hunter-gatherers that called their island Pimu. In the 300 years between European contact and California statehood, disease and the mission system caused dramatic decreases in the population of Pimungans, destroyed most of the island's wooded forests, and ruptured a trade and social network that had existed for thousands of years.

The Channel Islands Sanctuary imparts a sense of what California was like when its coast was still an undeveloped contour line of cove, cliff, rookery, and bay. Santa Catalina, San Clemente, Santa Barbara, and San Nicolas make up the southern Channel Islands; Anacapa, Santa Cruz, Santa Rosa, and San Miguel constitute the northern unit, which, with Santa Barbara Island, form Channel Islands National Park. The four northern islands once formed one large island, which geologists call Santarosae, before the ice sheets melted and the sea's level rose. But none of the eight Channel Islands has been part of the mainland or has been connected to it by a land bridge since the Pleistocene era. Thus, every living thing on these eight islands found its way there by air or by water. Occurrences so random and unusual that they are referred to as sweepstakes dispersal are what gave the Channel Islands their first plants and animals. Prior to European contact, mice, skunks, squirrels, and foxes were the only mammals on the island. Perhaps a Chumash trader from Santa Cruz Island brought a pet fox

along in his tomol-canoe and traded it to a Pimungan for some highly valued steatite to carve, and perhaps a pregnant mouse hitchhiked from the mainland on a log and survived the crossing—the luck of the draw of sweepstakes dispersal.

The ante was raised when newcomers from Europe shipped cattle, goats, and deer onto the island to ensure a food supply. Until then, island plants had not experienced grazing pressure from large herbivores, and thus they had not developed any of the herbivore deterrents, like spines or bitterness, that keep animals from eating them. Introduced herbivores were like kids in a candy shop, and they shaved the sweet-tasting, tender island plants down to a nubbin in less than a century.

The one-half-mile-wide isthmus that pinches Catalina at the neck is the Two Harbors region, with Catalina (Cat) Harbor on the windward side and Isthmus Cove on the lee. The Two Harbors area has a long ranching history, which has left large swaths of the island denuded by overgrazing. A costly program is now under way to fence part of the island from goats and bison. How did bison end up on Catalina? They were extras in one of the dozens of movies filmed on the island between the 1920s and early 1940s, such as *Mutiny on the Bounty, The Ten Commandments, Treasure Island,* and *Captain Blood.* The bison are not the only inheritance that Hollywood left: at low tide, the hull of one of the sunken prop ships pokes out of the sand at Cat Harbor.

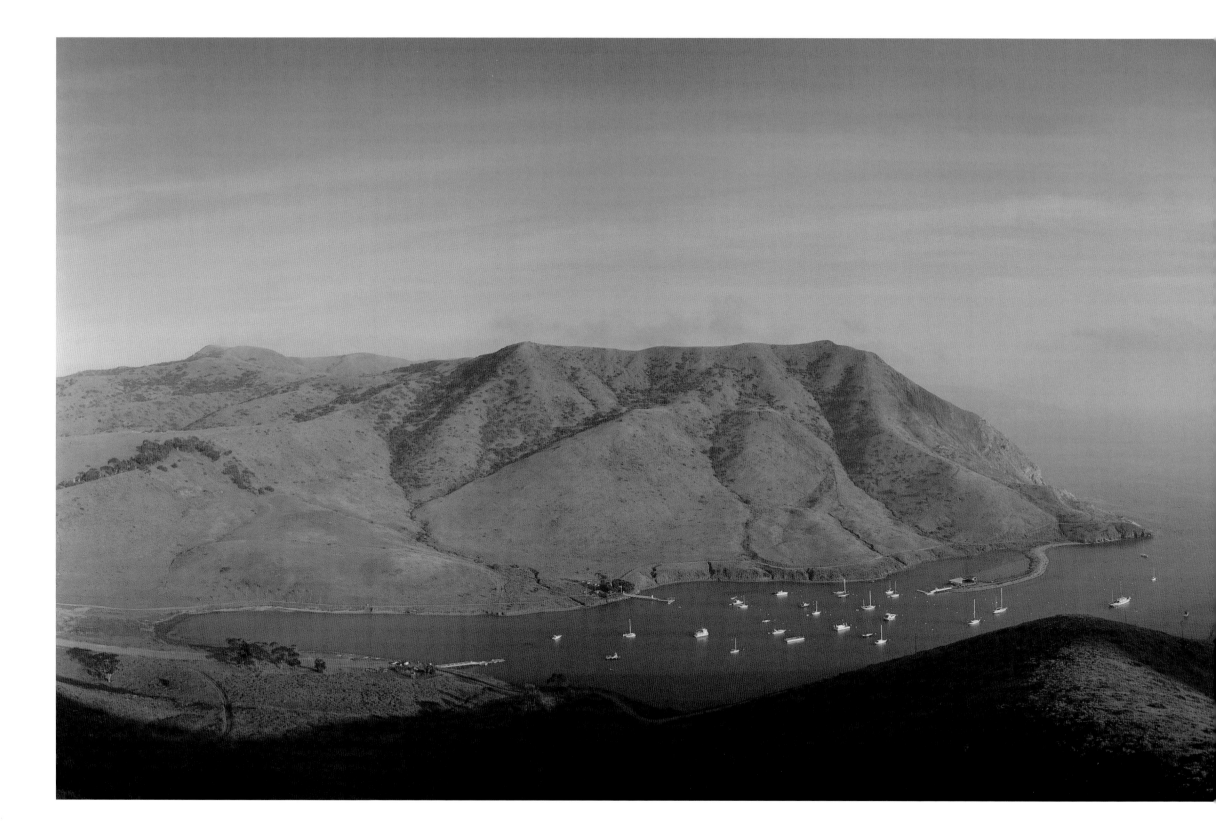

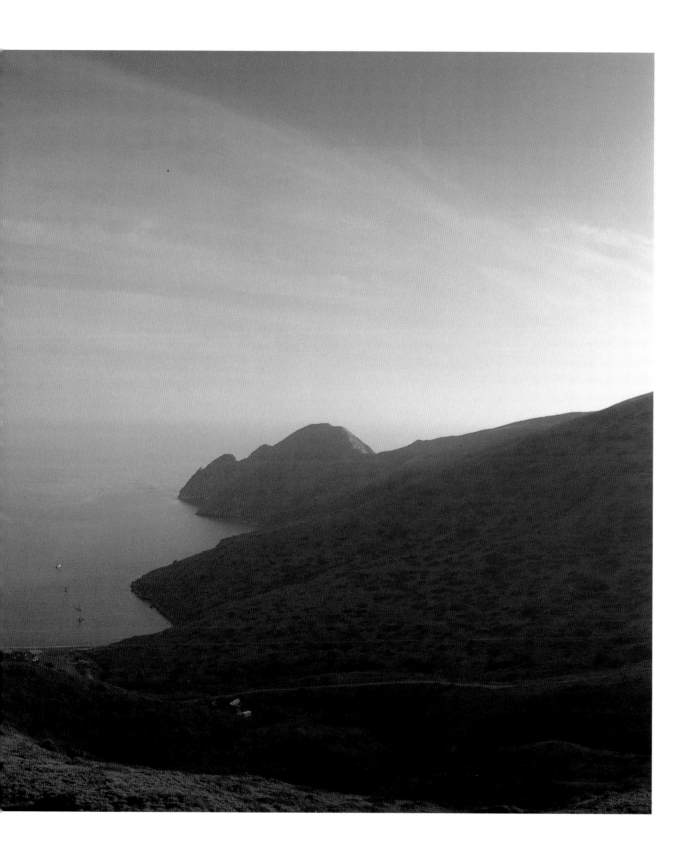

Yosemite National Park

Dr. Lafayette Bunnell, a member of the Mariposa Battalion that routed the Yosemite Indians from their home in 1851, wrote in his journals of the capture of their venerable chief, Tenieya. He told the old man that he had named the lake, by which their village stood, after him. "It already has a name," replied the old chief, and according to Bunnell, "his expression as he left us indicated that he thought the naming of the lake no equivalent for the loss of the territory."

John Muir, whose poetic lobbying led to the creation of Yosemite National Park in 1890, described the Sierra Nevada as a "Range of Light," "furrowed with cañons two thousand to five thousand feet deep, in which once flowed majestic glaciers, and in which now flow and sing the bright rejoicing rivers." One of the younger canyon valleys is Yosemite, situated in the Merced River basin at 4,000 feet above sea level and hewn nearly a mile deep into the solid granite range. Glaciers carved Yosemite Valley out of fire-born rock as if it were butter. The topography created by glaciers is distinct and heart-stoppingly beautiful, a landscape of monumentally steep mountaintops and bowl-shaped valleys. John Muir realized the unique gentleness of glacial cutting, which, unlike rivers that drill V-shaped gorges, scoop the rock so it can hold lakewater and, over time, can become sensual meadowland.

The awesome evidence of sheer fluid force can be both frightening and deeply beautiful. On New Year's Day in 1997, the unseasonably warm rains of El Niño pummeled an early snow pack, and the Merced River swelled to a width of over two thousand feet, spreading across the floodplain of Yosemite Valley at a volume reaching 25,000 cubic feet per second. The processes that shape the earth never sleep.

Originally the West was regarded as an infinite wealth of resources begging to be exploited. Later, as national parks were set aside to preserve land in its natural state, the dilemma between preservation and tourism arose. Limiting the numbers of visitors to the parks seemed contrary to the whole idea of providing the public with a wilderness experience. Each year this one-by-seven-mile valley floor, roughly half the size of Manhattan, hosts the equivalent of the entire 1991 population of Calcutta—about 4.5 million. Often a cowl of smog conceals much of the park's splendor as people come to dine, shop, get stuck in traffic, haggle for parking spots, dodge buses, and glimpse the scenery. Yosemite is a city. But step off the main road and onto one of the eight hundred miles of marked trails, and the park yields its unspoilt beauty. This is land that prompted John Muir to write, "No temple made with hands can compare with Yosemite," and it endures.

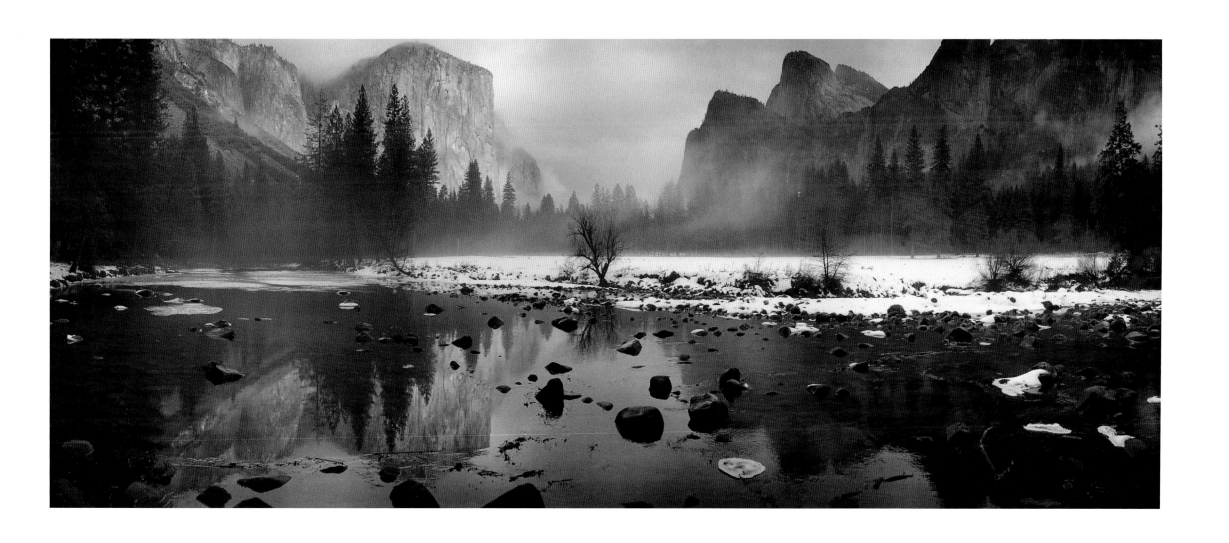

Mono Lake

Mono Lake was born of fire and ice. It was carved by volcanic eruptions that exterminated all sign of life, spewing ash over the entire Great Basin—Nevada, portions of Idaho, Utah, California, and Oregon—and was filled by glacial melt at the end of the Ice Age, approximately 700,000 years ago. Mono Lake is one of the few extant ancient lakes in North America. More than fifty other lakes from the Pleistocene epoch, including six that were connected by the ancient Owens River from Mono Lake to Death Valley, are now dry lakebeds pressed into the California desert beneath the rain shadow of the Sierra Nevada.

Mono Lake's mystery lies in the fact that it is both alluring and repelling. It is salty and alkaline, making its water silky to touch and pukish to taste. The lake combusts with life, but no fish swim in this water that chemically resembles salt and baking soda. The viscous, waxy water looks as if the sky were lacquered onto its surface. In winter the water turns celadon green from algae, but in spring the alkali flies and brine shrimp hatch and eat the lake blue. In fall so many duck, grebe, geese, gulls, phalaropes, and other migratory birds fly above that the lake mirrors a wing-blackened sky.

Two islands rise from the middle of the lake. Negit was created by a series of small eruptions beginning in A.D. 300. Its heat-absorbing blackness makes an ideal nesting ground for gulls: eighty-five percent of all California gulls are born in Negit's environs. Then, only 300 years ago, Paoha emerged. The Paiute recalled this event as a time when spirits with coiling, vaporous hair burst from the middle of the lake. Mono Lake Paiutes were called *Kuzedika'a*, fly eaters, because like the birds they fed on the protein-rich pupae of the alkali fly.

Tufa, a porous rock, is formed around the lips of underwater springs whose calcium-rich water percolates up through lake water rich in carbonates, combining chemically to form a calcium carbonate ooze that becomes limestone. Tufa only grows underwater, and the Mono Lake bed, perforated with springs, is a mother lode of it. Between the 1940s and 1990s Mono Lake's water level dropped drastically. Eerie pillars of tufa resembling the drowned ruins of a lost city emerged, exposed as grotesque parodies of their subaqueous selves. Lined up like sentries marking former spring locations, some of the formations—after centuries of growth—had reached a height of thirty feet, dramatic

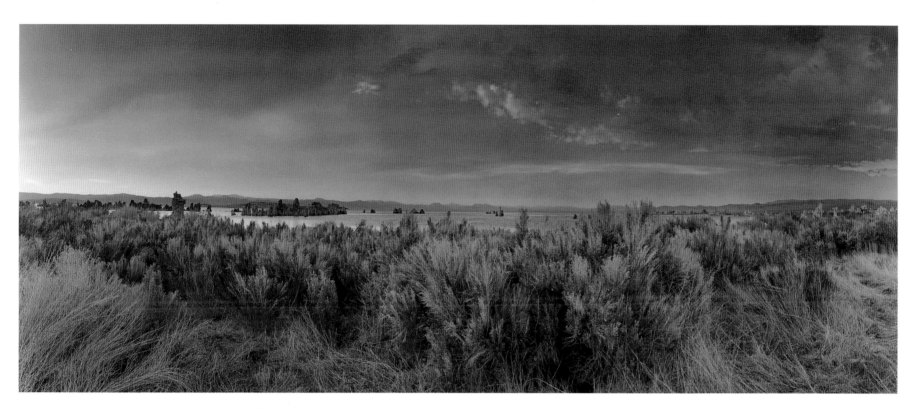

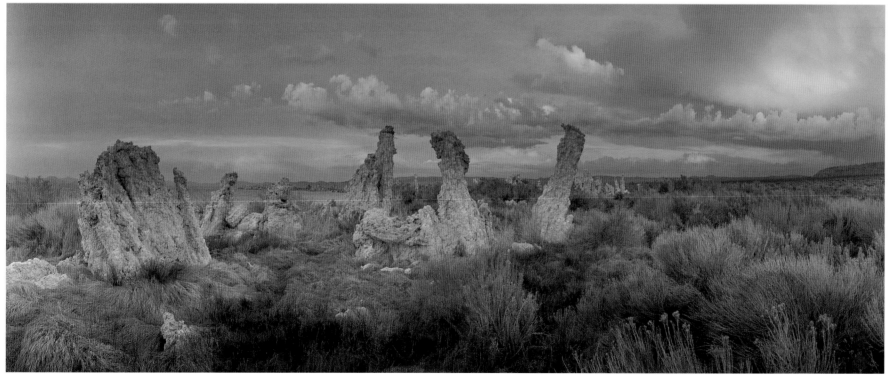

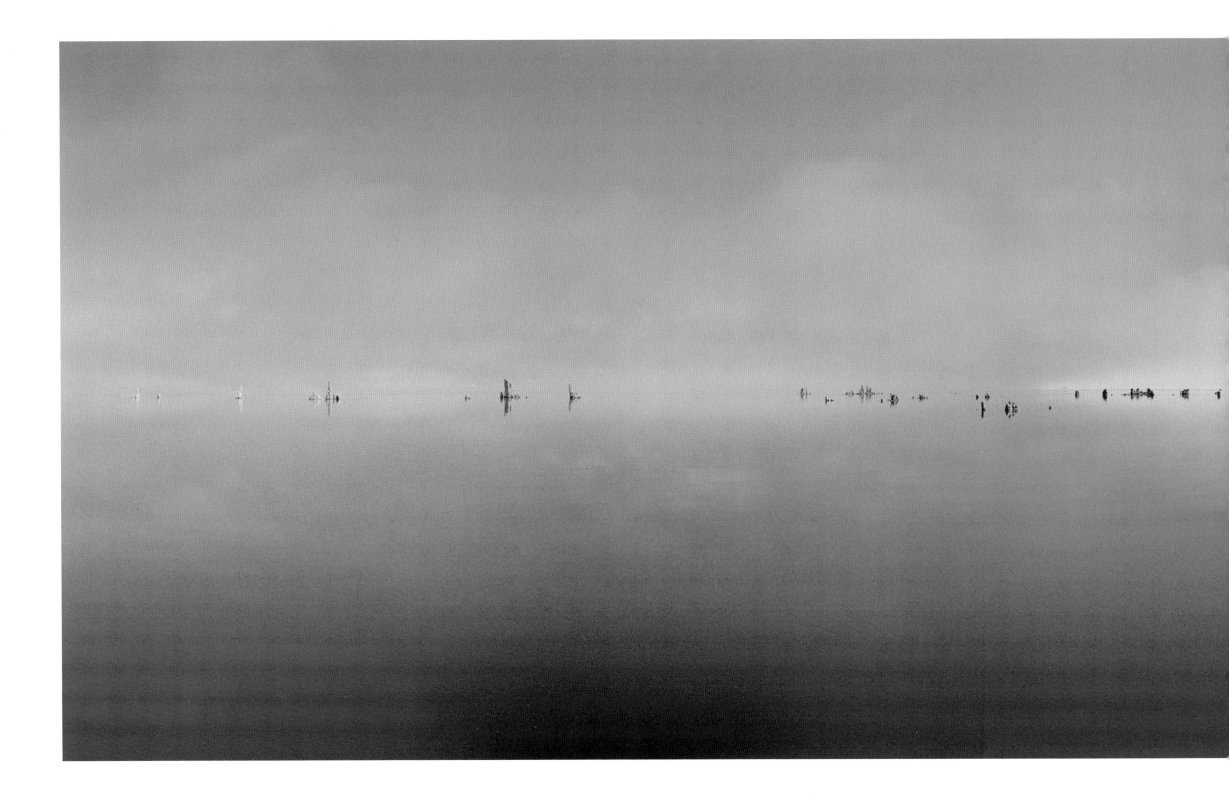

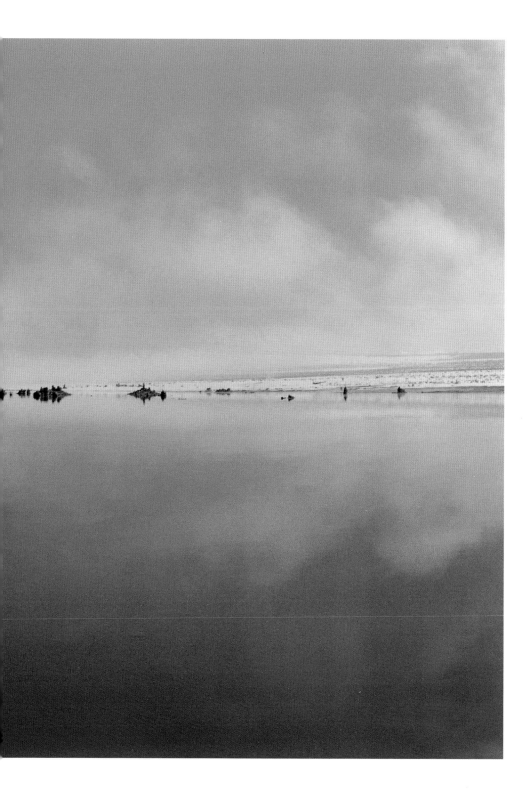

evidence of the lake's former depth. During the Ice Age the lake was seven times deeper and covered five times its current surface area of sixty-six square miles.

Most of the numinous tufa formations that today define Mono Lake were submersed until recently. In 1905, through a combination of surreptitious acquisition and outright bribery, the city of Los Angeles obtained aquifer-rich land along the Owens River. Suddenly, the people of Owens Valley saw their agriculturally fertile region turn into a desert. William Mulholland, the director of Los Angeles's waterworks, built the largest drinking straw on the continent, a 238-mile aqueduct costing 23 million dollars, to sate the thirst of a metropolis that had grown from 11,000 in 1880 to 100,000 by 1900. The water also irrigated the nearby San Fernando Valley, where Mulholland's friends and political allies had bought land with the assurance that its value would greatly increase. The film *Chinatown* revels in the ruthlessness of this cornerstone of Angelino history. In 1941 the city began diverting stream water out of the Mono Lake basin; the completion of a second aqueduct in 1970 accelerated this process.

Mono Lake's level fell over forty feet as more than half of its feeder springs were diverted. On the fringe of the Great Basin with no outlet to the sea, this loss increased the water's salinity to dangerous levels, threatening the living food chain—algae to alkali flies to trillions of brine shrimp to millions of birds. In the 1990s, after more than twenty years of grassroots efforts to save Mono Lake, a Los Angeles judge proclaimed it an endangered ecological and scenic treasure and ordered the Department of Water and Power to stop diverting freshwater from the tributary streams and to restore their riparian habitat. The tufa formations have been a favorite subject for photographers and painters for decades. Now, as the lake level rises and the tufa slowly retreats beneath the water, those compositions take on a historic value as well.

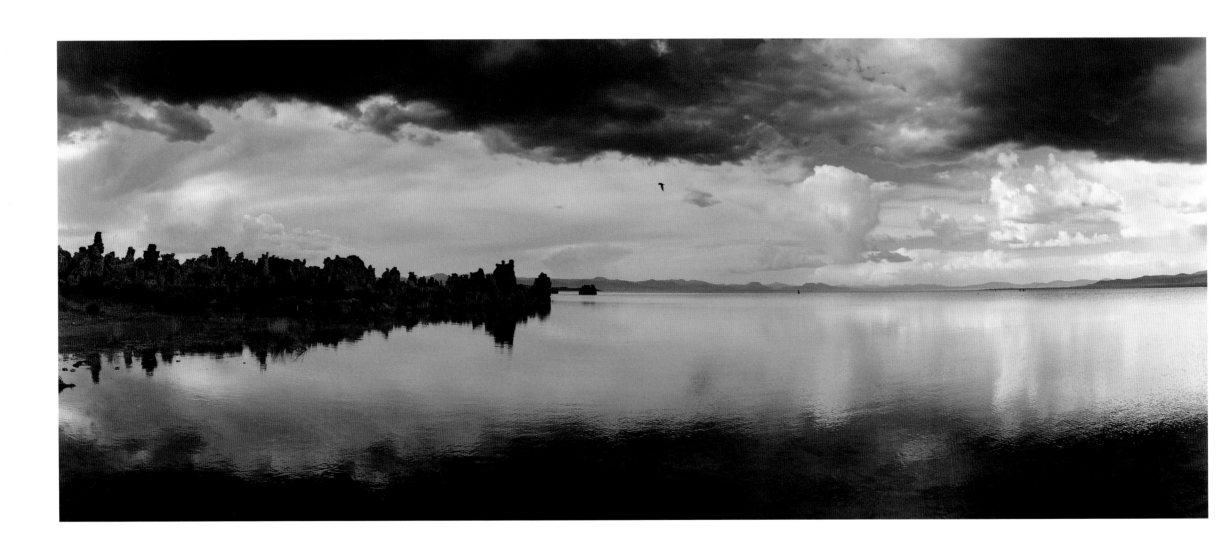

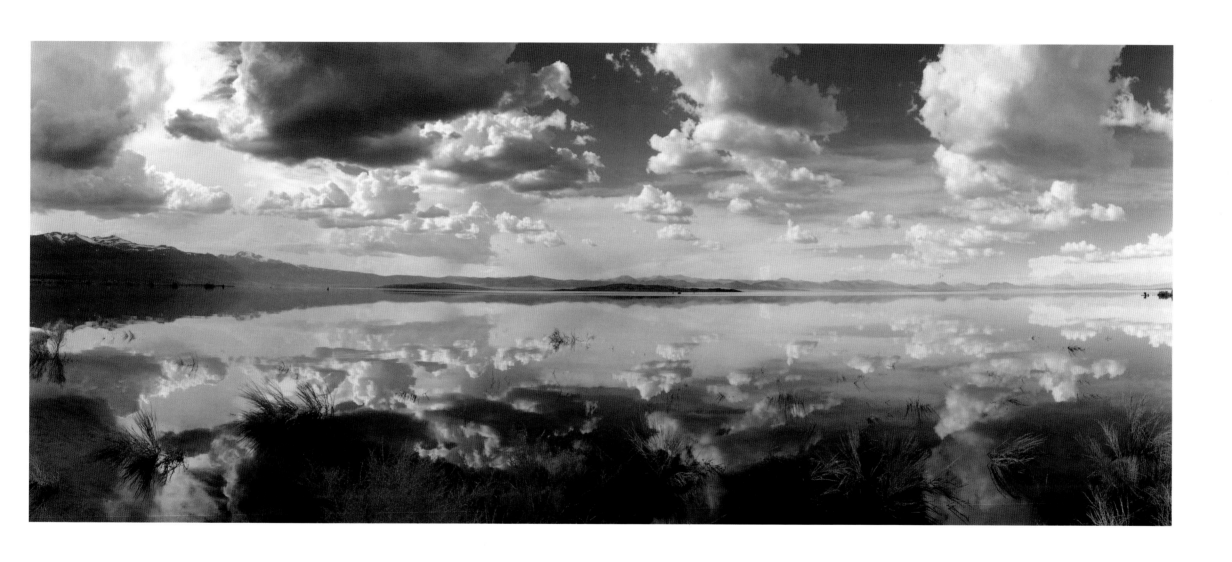

Joshua Tree National Park

Joshua Tree National Park, 140 miles east of downtown Los Angeles, is where the northern boundary of the Colorado Desert meets the southern boundary of the Mojave Desert. The transition is notable: red blossoms on the spindly limbs of the ocotillo and the light-catching cholla of the Colorado segue to contorted fields of Joshua trees in the Mojave. Throughout the park, the acrid, medicinal creosote bush perfumes the warm air.

In the high desert, the earth is fully exposed, skinned alive. On the parched flanks of its mountains the graceful arc of alluvial fans fall like trailing velvet gowns—but this is a visual trick of the desert, for this is hard land. You can see for miles, because the park is mostly treeless except for the ungainly, punkish Joshua tree. Lieutenant John Frémont, who crossed the Mojave in 1844 with Kit Karson, called it "the most repulsive tree in the vegetable kingdom"; and yet it is cousin to the lily. How—in a leap of imagination akin to sailors mistaking manatees for mermaids—a group of Mormons came to see this tree as the outstretched arms of Joshua, leading his children through the wilderness and into the promised land of Canaan, is another desert mystery. People saw things, lost faith, found faith, as they made their way along the Old Spanish Trail into California. Perhaps in the luteous, sundowner light, the trees seemed to glow.

Joshua trees can grow to be twenty to forty feet tall, their branches home to more than twenty species of birds. The clusters of swordlike leaves resemble an estrellated, undersea urchin. In fact, the torqued limbs mimic the brachiated tree coral that thrive beneath the sky-blue waters of the tropics. In flusher times much of the Pinto Basin was underwater, and rivers and riparian vegetation prevailed. Today, *Yucca brevifolia* is the largest living thing to survive on desert flatlands. Its thin water-seeking rootlets finger the soil, gripping against the winds.

Joshua Tree National Park is a natural jungle gym and a rockclimber's Nirvana. The elephantine stone clusters in this sprawling 630,800-acre park are monzonitic granite, formed when molten magma intruded into an overlaying deposit of softer gneiss, cleaving and fissuring as it cooled and shrank. These are the same granites as the Sierras, the roots of ancient volcanoes. Groundwater percolated through the fissures, eventually weathering away the gneiss, exposing the harder granite. These rocks were then dished out and socketed by water into shapes like

breaching whales, sunken ships, praying hands, burst-open fruits, and skulls—the last vestiges of a wetter time in this land. Erosion from storms and wind continues to slowly whittle the rocks.

People seek out variety, anomaly; sameness bores us. Driving for miles through repetitive desert landscape on a strip of asphalt that seems headed for nowhere can be boredom incarnate. But the pith of nature is repetition. Redundancy equals success, survival, regeneration. The patterns are subtle, the rhythms slowed. The desert obeys vaster, less frantic orbits of time.

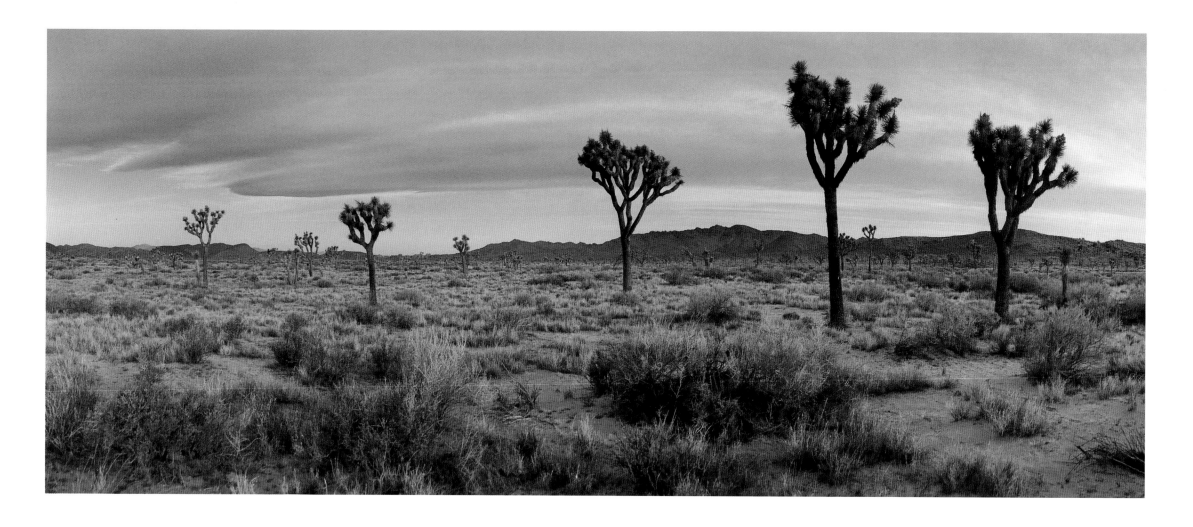

Death Valley

The Great Basin region is defined hydrologically—a basin is an area in which not a single river makes its way out to the sea. The Basin and Range province was formed when the land expanded and stretched, cracking its crusty surface as its underlayer oozed and stretched like brie cheese under a picnic sun. These cracks define the hundreds of parallel mountain ranges, riven with faults and furrowed by intervening basins, from Oregon down to northern Mexico. The Mojave Desert lies within this province, straddling the California–Nevada border at about the same latitude as the Salt Deserts of Iran.

ZABRISKIE POINT

During World War II every branch of the military bought up million-acre tracts of land here, which are still used as weapons testing sites and training bases. Mojave also contains the luxe of Las Vegas; the tumbled rock of Joshua Tree; and Death Valley, the hottest, driest, godforsaken place in the Western Hemisphere. These last two places were upgraded to National Parks when Congress passed the much-contended California Desert Protection Act in 1994. Death Valley has hosted miners who sought gold but instead found the white gold of Borax, ranchers, outlaws such as the Manson family, misfits, nudists, movie producers, and now European and Asian tourists who are boggled by its heat and unequivocal vastness.

More than fifty movies and television episodes have been filmed in Death Valley, including the silent classic *Greed* by Eric von Stroheim, George Lucas's *Star Wars*, Michelangelo Antonioni's *Zabriskie Point*, and Stanley Kubrick's *Spartacus*. Ronald Reagan, host of the television show *Death Valley Days,* dished up a serving of the Wild West to 1950s households with such authority that he won his audience long before running for office. The commercial sponsor for the show was, of course, a company called Twenty Mule Team Borax.

In the landscape of Death Valley viewed from Zabriskie Point, yellow hills fall away like an ancient sheet of parchment that has been burnished by relentless erosion, folded and refolded along bone-white creases. The serpentine imprint of a dry flood channel coils deep within the canyon. Shadows butterfly across the nude, sedimentary hills, which seem to proliferate in the heat until distance itself is a place.

Approximately three million years ago the Panamint and the Amargosa Ranges began to torque in north-south directions along strike-slip faults, creating this valley. The earth's crust was stretched ten miles thinner than the average twenty-five-mile thickness beneath continents, and it is still pulling apart. Subterranean heat meets the irradiated surface of sand and salt pans, making Death Valley hot as hell. There is nothing but bare rock to catch the heat—desert plants are spread far apart, and few clouds interrupt the expanse of sky. Most of the heat is thrown off each night, re-reflected into the sky, leaving the desert cold as a spent star.

A nimbus sky means nothing here. The ragged fringes of rain in the sky are dry rain, or virga—only 1.7 inches per year actually touch the valley floor. Water hisses away instantly, evaporating at an annual rate of 150 inches, but it is enough to sustain over 900 species of plants and 250 species of bird. And even fish: at the nadir of the Western Hemisphere, 282 feet below sea level, eight species of minnowlike pupfish fiercely mate, fight, and grab at life, within a dwindling salty spithole called Badwater. For miles beyond, the shimmering salt flats cruelly tease the eye into seeing a vast body of water, but it is only water's ghost, a skim on thick mineral and salt deposits from an ancient lake with no outlet.

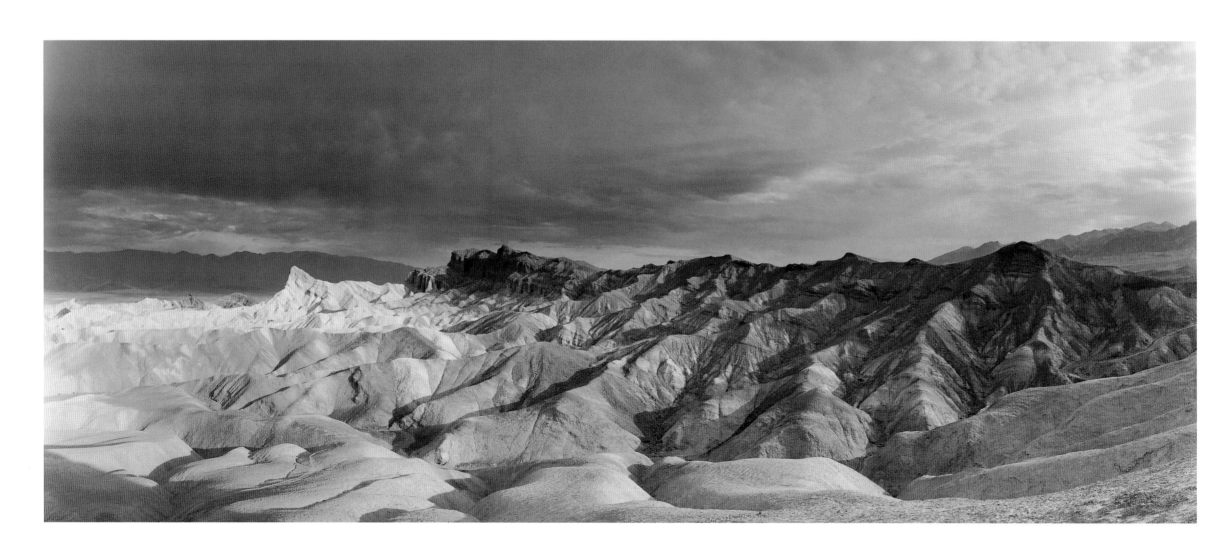

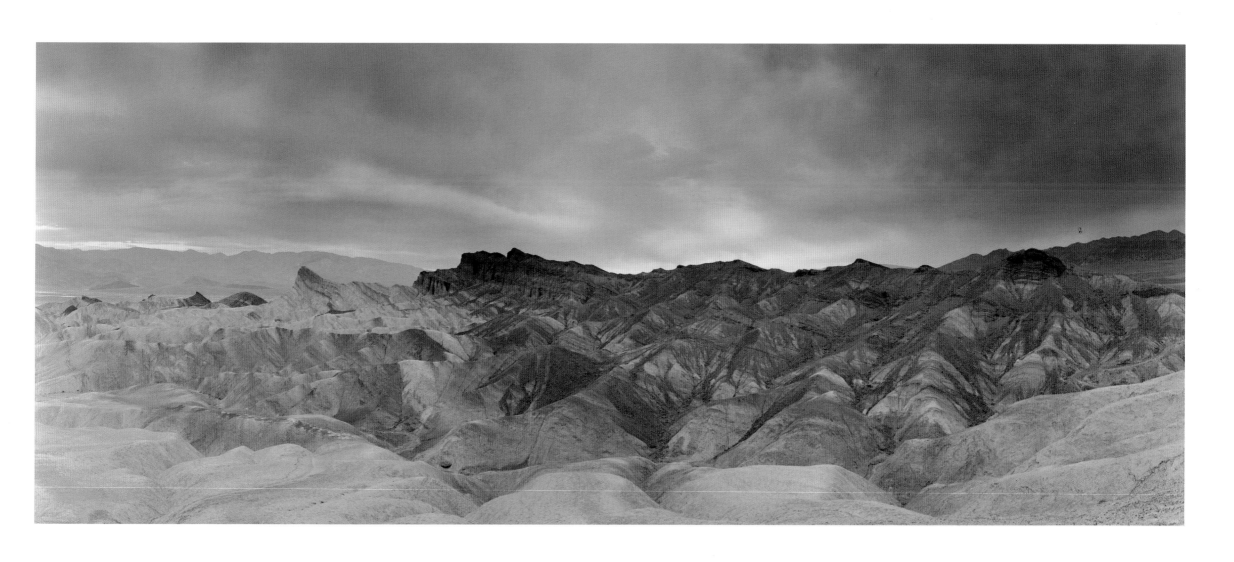

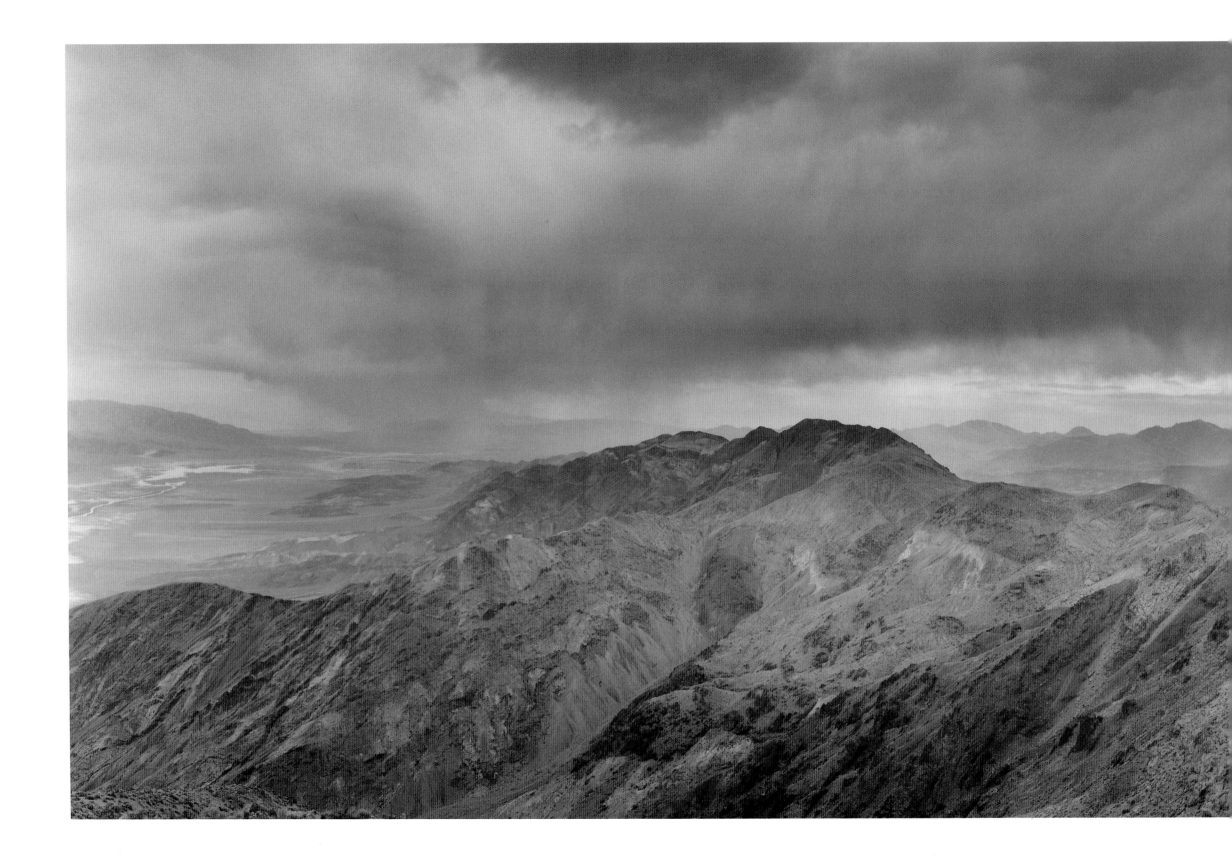

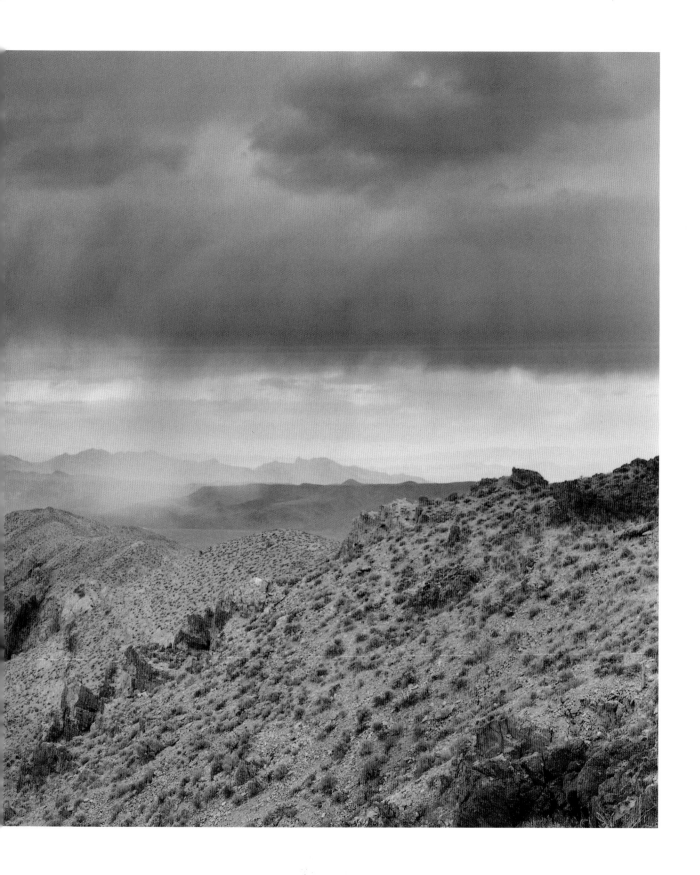

List of Sources

A number of individuals aided me greatly in my research. The knowledge I gained from my conversations with them can be found in almost every essay in this book. Many of these people served as sources for more than one essay, and so I will list them all here at the top: Dr. Tanya Atwater, geologist, University of California, Santa Barbara; Ray Clary, National Park Service ranger, Theodore Roosevelt National Park; Allison Morely, editor, *Life* magazine; Lynn Murdock, naturalist, Waterton/Glacier International Peace Park; Clare Landry, Ranger Naturalist, Waterton/Glacier International Peace Park; Mary Carroll, botanist; Hallie Larsen, Ranger Naturalist, Petrified Forest National Park; Margaret Hiroko Eejima, artist and film historian; National Park Service ranger, McCloud and Mount Shasta Ranger District; Max Claussen, Claussen Oyster Farms; Edwina Leggett, owner of Califia Press, San Francisco; Dotty Patrick, boat owner; and John Storrer, biologist.

Many of the following sources were used for more than one section. I have repeated all of the bibliographic information at each mention, in order to make full references easy to find.

THE GREAT PLAINS

SAND HILLS

Gibbs-Smith, Dan Dagget. *Beyond the Rangeland Conflict: Toward a West that Works.*
 Flagstaff, Arizona: Grand Canyon Trust, 1995.

Huntington, Collis B. "Race to the Last Spike." In *Eyewitness to the American West*,
 edited by David Colbert. New York: Viking, 1998.

Stubbendieck, James. "Range Management." In *An Atlas of the Sandhills*, edited by Ann
 Bleed and Charles Flowerday. Omaha, Nebraska: World-Herald Foundation, 1998.

BADLANDS NATIONAL PARK

Crow Dog, Mary, and Richard Erdoes. "The Ghost Dance" and "Siege at Wounded Knee."
 In *Eyewitness to the American West*, edited by David Colbert. New York: Viking, 1998.

Gibbs-Smith, Dan Dagget. *Beyond the Rangeland Conflict: Toward a West that Works.*
 Flagstaff, Arizona: Grand Canyon Trust, 1995.

Lame Deer, John Fire, and Richard Erdoes. *Lame Deer: Seeker of Visions*. New York:
 Washington Square Press, 1994.

Schoumatoff, Alex. *Legends of the American Desert*. New York: Alfred A. Knopf, 1997.

Schuler, Jay. *A Revelation Called the Badlands*. Interior, South Dakota: Badlands
 Natural History Association, 1989.

THEODORE ROOSEVELT NATIONAL PARK

Frazier, Ian. *The Great Plains*. New York: Farrar, Strauss & Giroux, 1989.

Lame Deer, John Fire, and Richard Erdoes. *Lame Deer: Seeker of Visions*.
 New York: Washington Square Press, 1994.

Morris, Edmund. *The Rise of Theodore Roosevelt*. New York: Ballantine Books, 1975.

Theodore Roosevelt National Park, North Dakota, Visitor Center display

MONTANA PRAIRIE

Goddard, Donald. *American Painting*. New York: Hugh Lauter Levin Associates, 1990.

BREAKS OF THE MISSOURI

Ambrose, Stephen. *Undaunted Courage*. New York: Simon and Schuster, 1996.

Eliot, T. S. *Four Quartets: Dry Salvages*. New York: Alfred A. Knopf, 1943.

Kesselheim, Alan. "An Obsession and a Map: Beyond Lewis and Clark."
 Big Sky Journal (Summer 1999): 92–102.

Lavender, David. *The Way to the Western Sea*. New York: Doubleday, 1988.

ROCKY MOUNTAINS

YELLOWSTONE NATIONAL PARK

Reese, Rick. *Greater Yellowstone*. Helena, Montana: Montana Magazine
 American and World Geographic Publishing, 1991.

Theroux, Alexander. *The Primary Colors*. New York: Henry Holt & Company, 1994.

Tilden, Freeman. *The National Parks*. New York: Alfred A. Knopf, 1960.

Vogel, Shawna. *Naked Earth*. New York: Dutton Books, 1995.

WATERTON/GLACIER INTERNATIONAL PEACE PARK

Websites:
 http://vulcan.wr.usgs.gov/Glossary/Glaciers/glacier-terminology.html
 http://www.nps.gov/glac/resources/geology.html

LEMHI PASS

Ambrose, Stephen. *Undaunted Courage*. New York: Simon and Schuster, 1996.

Lavender, David. *The Way to the Western Sea*. New York: Doubleday, 1988.

ASPEN

Sierra Club Guide to the National Parks: Desert Southwest.
 New York: Stewart, Tabori & Chang, 1984.

GREAT SAND DUNES NATIONAL MONUMENT

Tilden, Freeman. *The National Parks*. New York: Alfred A. Knopf, 1960.

Trimble, Stephen. *Great Sand Dunes: The Shape of the Wind*. Great Sand Dunes National
 Monument, Colorado: Southwest Parks and Monuments Association, 1978.

COLORADO PLATEAU

GRAND CANYON

Fishbein, Seymour. *Grand Canyon Country: Its Majesty and Its Lore.*
 Washington, D.C.: National Geographic Society, 1991.

Thybony, Scott. *Canyon Country Parklands: Treasures of the Great Plateau.*
 Washington, D.C.: National Geographic Society, 1993.

GRAND STAIRCASE–ESCALANTE NATIONAL MONUMENT

Grand Staircase–Escalante National Monument, American Custom Maps.
 Bureau of Land Management. Text by Stephen Maurer and Mary Beath.
 Albuquerque: University of New Mexico, 1977.

Calf Creek Falls Trail Guide. U.S. Department of the Interior, Bureau of Land Management.

GHOST RANCH

Website: http://www.newmexico-ghostranch.org/foundation.html

PAINTED DESERT AND PETRIFIED FOREST

Houk, Rose. *The Painted Desert: Land of Light and Shadow*. Petrified Forest
National Park, Arizona: Petrified Forest Museum Association, 1990.

MONUMENT VALLEY NAVAJO TRIBAL PARK

Cody, William F. "Buffalo Bill Takes the Stage." In *Eyewitness to the American West*,
edited by David Colbert. New York: Viking, 1998.

DenDooven, K. C. *Monument Valley: The Story Behind the Scenery*. Las Vegas: KC
Publications, 1992.

Dwan, Allan. "On the Run." *Eyewitness to the American West*, edited by David Colbert.
New York: Viking, 1998.

Hart, William S. "A Cowboy Star is Born." *Eyewitness to the American West*,
edited by David Colbert. New York: Viking, 1998.

Website: http://www.swlink.net/-southwest/utah/mval/mvalley.html

WUPATKI NATIONAL MONUMENT

Ferguson, William, and Arthur Rohn. *Anasazi Ruins of the Southwest*.
Albuquerque: University of New Mexico Press, 1987.

Preston, Douglas. "Cannibals of the Canyon: Has American Archaeology's
Great Mystery Been Solved?" *The New Yorker* (November 30, 1998): 76–89.

Thybony, Scott. *A Guide to Sunset Crater and Wupatki*. Tuscon, Arizona: Southwest
Parks and Monuments Association, 1987.

Turner, Christy, and Jacqueline Turner. *Man Corn: Cannibalism and Violence in the
Prehistoric American Southwest*. Salt Lake City: University of Utah Press, 1999.

CASCADE RANGE AND PACIFIC NORTHWEST

MOUNT SAINT HELENS

Boly, William. *Fire Mountain: The Eruptions of Mount St. Helens*.
Portland, Oregon: Cathco Publishing, 1980. Quotation from Paul Kane.

U.S. Department of the Interior. *Eruptions of Mount St. Helens: Past, Present, and Future*.
U.S. Geological Survey. Washington, D.C.: Tilling, Topinka and Swanson, 1984.

Websites:
http://magic.geol.ucsb.edu/-fisher/pliny.htm
http://vulcan.wr.usgs.gov/Glossary/framework.html

CRATER LAKE NATIONAL PARK

Tilden, Freeman. *The National Parks*. New York: Alfred A. Knopf, 1960.

Websites:
http://www.nps.gov/crla/lakemyth.htm
http://www.nps.gov/crla/steel.htm

MOUNT SHASTA

Teale, Edwin Way, ed. *The Wilderness World of John Muir*. Boston: Houghton Mifflin, 1954.

Wood, Charles, and Jurgen Kienle, eds. *Volcanoes of North America: United States and
Canada*. Cambridge, England: Cambridge University Press, 1990.

OREGON COAST

Bannan, Jan. *Oregon State Parks*. Seattle: The Mountaineers, 1993.

Douglas, William O. *My Wilderness: The Pacific West*. Garden City, New
York: Doubleday and Company, 1960.

Fort Clatsop National Memorial, Astoria, Oregon, Information Center display.

"Northwest Passage" by Stan Rogers © Fogarty's Cove Music, Inc.

CALIFORNIA

BIG SUR

Brother Antoninus. *Robinson Jeffers: Fragments of an Older Fury*.
Berkeley, California: Oyez Books, 1968.

Fradkin, Philip. *The Seven States of California*. New York: Henry Holt & Company, 1995.

Jeffers, Robinson. *The Selected Poetry of Robinson Jeffers*. New York: Random House, 1959.

Lussier, Tomi Kay. *Big Sur: A Complete History and Guide*. Big Sur, California: Big Sur
Publications, 1993.

McPhee, John. *Assembling California*. New York: Noonday Press, 1993.

Miller, Henry. *Big Sur and the Oranges of Hieronymus Bosch*. New York: New Directions, 1957.

Rothenberg, Jerome, and George Quasha, eds. *America a Prophecy*. Introduction by Gary
Snyder to "Coyote Shaman Songs" by Jaime de Angulo. New York: Vintage Books, 1974.

Website: http://bayareabackroads.com

SANTA CATALINA ISLAND

Websites:
http://www.catalinaconservancy.org/history/cat_hist.htm
http://www.aqd.nps.gov/grd/parks/chis/index.htm

YOSEMITE NATIONAL PARK

Bunnell, Lafayette Houghton. "American Names." In *Eyewitness to the American West*,
edited by David Colbert. New York: Viking, 1998.

Muir, John. "The Wonders of Yosemite." In *Eyewitness to the American West*,
edited by David Colbert. New York: Viking, 1998.

Teale, Edwin Way, ed. *The Wilderness World of John Muir*. Boston: Houghton Mifflin, 1954.

MONO LAKE

Fradkin, Philip. *The Seven States of California*. New York: Henry Holt & Company, 1995.

Irwin, Sue. *California's Eastern Sierra*. Los Olivos, California: Cachuma Press, 1991.

Yongue, W. Gerald, and Audrey Harris Lee. *Mysterious Mono Basin*.
Vining, California: published by the authors, 1975.

Website: http://www.monolake.org

JOSHUA TREE NATIONAL PARK

Darlington, David. *The Mojave: A Portrait of the Definitive American Desert*.
Henry Holt & Company, New York, 1997.

MacMahon, James. *Deserts (National Audubon Society Nature Guides)*.
New York: Alfred A. Knopf, 1997.

DEATH VALLEY

Collier, Michael. *An Introduction to the Geology of Death Valley*.
Death Valley, California: Death Valley Natural History Association, 1990.

Darlington, David. *The Mojave: A Portrait of the Definitive American Desert*.
New York: Henry Holt & Company, 1997.

Furnace Creek Inn and Ranch Resort, Death Valley: self-published press packet.

MacMahon, James. *Deserts*. National Audubon Society Nature Guides.
New York: Alfred A. Knopf, 1997.

Whitten, D. G. A. *A Dictionary of Geology*. Middlesex, England: Penguin Books, 1972.

Acknowledgments

Working together on this book has been a summer of delight. We feel incredibly lucky to be able to collaborate, proving that business and pleasure do mix—especially when the light is good—knowing that our greatest supporter is right next to us.

Eric Himmel is a helpful, kind editor, with a genuine enthusiasm for this project. Bob McKee's design skills give the book its beauty and continuity, and his love of the craft of bookmaking is evident in every project he undertakes. Wendy Burton-Brouws, our agent, is also a fabulous photographer. It is a compliment that she likes and supports our work. We are honored to have Edmund Morris contribute the introduction to the book.

We want to thank our parents for taking us camping, and thank our children, Sienna and Robert, for letting us continue the tradition. We also want to thank the rangers and staff at all the county parks, state parks, and especially the national parks and national monuments. They are understaffed, underpaid, and it is a disgrace that Congress continues to underfund them.

MACDUFF EVERTON:

Many thanks to Janet and Kornelius Schorle, wonderful friends who provide encouragement and keep my cameras clean and working. Kornelius designed the Noblex, the panoramic camera that I use. He is currently working on a new panoramic camera, and I can't wait to buy one.

I buy my film at Samy's Camera in Santa Barbara, and across the parking lot is Armstrong Photo Lab, perhaps the best lab in the West. Richard Armstrong develops all my film, and I make my prints in his rental darkrooms. Richard has been phenomenally helpful on this project.

Emily Hart Roberts runs my office so efficiently it is often better if I'm in the field. She knows where I am even if I don't.

Some of the photographs in the book were originally shot on editorial assignments. I would like to thank editors at several magazines in particular—Kathleen Klech, Dana Nelson, Lucy Gilmour, Cynthia van Roden, and Sabine Meyer at *Condé Nast Traveler*; Carol Enquist,

Linda Meyerriecks, Dan Westergren, and Win Scudder at *National Geographic Traveler*; Lisa Passmore, Heidi Yockey, Stephanie Syrop, and Bill Black at *Travel Holiday*; as well as Pamela Hassell at *Connoisseur*, Amy Osburn at *Los Angeles Magazine*, Tom Heine at *Endless Vacation*, and Bill Swan at *Town & Country*.

Janet Borden represented me even before she opened her gallery in Soho. She has become so much a part of our life that when the light is grand and I know I've gotten a good shot, I'll refer to it as a "JB." She and Matthew Whitworth have encouraged us in their inimitable way. Rose Shoshona of Rose Gallery in Santa Monica has also supported this project. Greg Fitch and Stephen and Mus White provided early help and encouragement.

Karen Sinsheimer, who curated the traveling show, worked with us on the selection of photographs for the book. When Mary and I were dizzy with images and words, Karen would help us focus.

Fred and Carol Kenyon, who always find time to look at more photographs and provide cogent comments.

Vermeer, Turner, Constable, Monet, van Gogh, Millet, Homer, Whistler, Diebenkorn, Innes, Hopper, Beckmann, Heebner, Goya, and all the other painters who inspire me and from whom I learned how to see the light.

Most of all, I want to thank Mary who agreed to collaborate on this book as well as our life together, and for her trust when I suggest we go just a little bit farther. Mary provides sunshine even when there are dark clouds. Perhaps the greatest pleasure is being able to share something with someone you love.

MARY HEEBNER:

When Eric Himmel at Abrams asked Macduff Everton whether he had a writer in mind for his proposed book of panoramic photographs of the American West, he said he had. Mary Heebner—she's a fine writer who happens also to be my wife. Many editors would balk, but Eric was open to his idea and agreed that such a collaboration would make a beautiful book. So began an intense immersion in the lore, geology, history, and most of all, firsthand experience traveling, mentally and physically, through the American West. We would be out photographing and sketching until "can't see," and then I would hammer on the laptop in our motel room, knowing that dawn, and a new opportunity to photograph, came only too soon.

I am humbly indebted to the many researchers and writers who have devoted lifetimes to understanding single aspects of this complex and fascinating subject. As an amateur, I have been inspired by their work, which has made me want to learn more. In researching, reading, and writing the commentary, several people were invaluable. Thanks to our daughter Sienna Craig and her husband Ken Bauer for editorial help, geologist Tanya Atwater, botanist Mary Carroll, biologist John Storrer, readers Mercedes Eichholz, Gail and Barry Berkus, Carol and Fred Kenyon, Claire and Walter Heebner, Frances and Clyde Everton, Robert Everton, Laurie Ryavec, and Rosemary Fitzgerald. Thanks to M. Hiroko Eejima, Sam Masson, Steve Craig, and Emily Potts for their research assistance. I also wish to thank my astute and gracious editor, Nicole Columbus. Working with her has been a delight. Above all I wish to thank Macduff for suggesting that we collaborate on this book, for his inquisitive eye, tender heart, and unquenchable love of the natural world.

MAKING **HISTORY**

ANCIENT EGYPT

Fiona Macdonald and Sue Nicholson

W
FRANKLIN WATTS
LONDON • SYDNEY

First published in 2008 by Franklin Watts

Copyright © Franklin Watts 2008

Franklin Watts
338 Euston Road
London NW1 3BH

Franklin Watts Australia
Level 17/207 Kent Street
Sydney, NSW 2000

A CIP catalogue record for this book is available
from the British Library.

Created by Q2AMedia
Series Editor: Jean Coppendale
Editor: Katie Dicker
Creative Director: Simmi Sikka
Sr. Art Director: Ashita Murgai
Designer: Dibakar Acharjee
Senior Project Manager: Kavita Lad
Project Manager: Gaurav Seth
Picture Researcher: Jyoti Sachdeva
Art, Craft & Photography: Tarang Saggar
Illustrators: Amit Tayal, Rajesh Das
Models: Lea Lortal, Madhav Murgai, Ruchi Sharma (Hands)

Dewey number: 932

ISBN 978 0 7496 7848 7

Website information is correct at time of going to press. However, the publishers cannot
accept liability for any information or links found on third-party websites.

Note to parents and teachers:
Every effort has been made by the Publishers to ensure that the websites in this book are suitable for children, that they
are of the highest educational value, and that they contain no inappropriate or offensive material. However, because of the nature
of the Internet, it is impossible to guarantee that the contents of these sites will not be altered. We strongly advise that Internet
access is supervised by a responsible adult.

Many projects in this book require adult supervision, especially those which involve the use
of scissors and craft knives. Some projects suggest the use of wallpaper paste. It is advised that a fungicide-free
paste (cellulose paste) is used. If in doubt, consult the manufacturer's contents list and instructions. Many projects suggest
the use of paint. It is advised that non-toxic paint is used. If in doubt, consult the manufacturer's contents list and instructions.

Picture credits:
t: top, b: bottom, m: middle, c: centre, l: left, r: right

4t : Sandro Vannini/Corbis, 4b : Steven Allan/Istockphoto, 7b :The Print Collector/Alamy,
10bl :THE BRIDGEMAN ART LIBRARY/Photolibrary, 10br :The Trustees of the British Museum, 12bl :Tor Eigeland/Alamy,
14t :THE BRIDGEMAN ART LIBRARY/Photolibrary, 14b :The Print Collector/Imagestate Ltd/Photolibrary,
16b :THE BRIDGEMAN ART LIBRARY/Photolibrary, 18t : David Keith Jones/Images of Africa Photobank/Alamy,
18b :The Trustees of the British Museum, 19t :Visual Arts Library (London)/Alamy, 22t : Andrejs Pidjass/Shutterstock,
23br :The Print Collector/Imagestate Ltd/Photolibrary,24bl : ancientnile/Alamy,
26t :THE BRIDGEMAN ART LIBRARY/Photolibrary, 26b :The Trustees of the British Museum,
27t : Gianni Dagli Orti/CORBIS, 28bl : Upperhall Ltd/Robert Harding Picture Library Ltd/Photolibrary.

Printed in China

Franklin Watts is a division of Hachette Children's Books, an Hachette Livre UK company.

www.hachettelivre.co.uk

Contents

River kingdom

The Ancient Egyptians lived in North Africa, beside the River Nile. They settled there around 10,000 years ago, when climate change turned the rest of Egypt into a hot, dry desert.

The early Egyptians

The first settlers survived by hunting and fishing. Around 5500 BC, they began to grow crops and raise animals. They built villages, and traded goods they had made. Around 3100 BC, the settlers joined together to create a rich, powerful kingdom.

Egypt stayed proud and strong for thousands of years, until Roman armies invaded in 30 BC. But there are many remains of its splendid past that still survive today, for us to admire.

▲ Many fine portraits, such as this gold mummy mask, show us what the Ancient Egyptian people looked like.

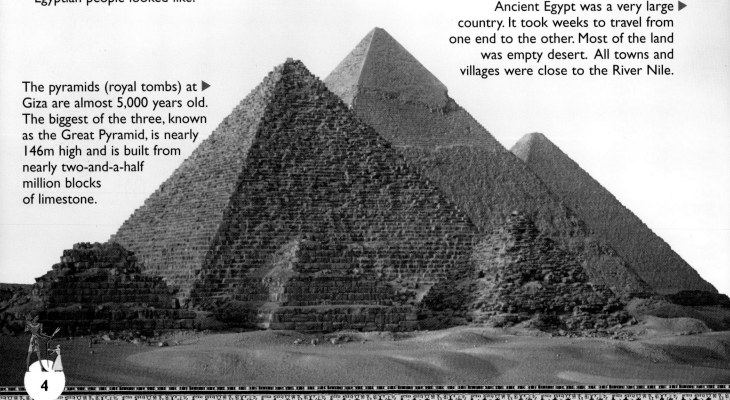

Ancient Egypt was a very large ▶ country. It took weeks to travel from one end to the other. Most of the land was empty desert. All towns and villages were close to the River Nile.

The pyramids (royal tombs) at ▶ Giza are almost 5,000 years old. The biggest of the three, known as the Great Pyramid, is nearly 146m high and is built from nearly two-and-a-half million blocks of limestone.

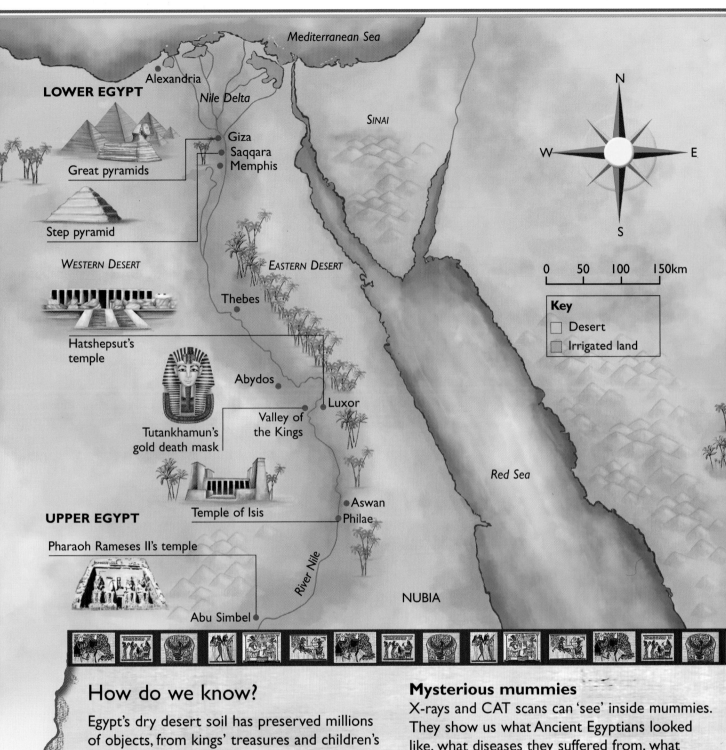

LOWER EGYPT

Mediterranean Sea

Alexandria

Nile Delta

SINAI

Great pyramids

Giza
Saqqara
Memphis

Step pyramid

N
W — E
S

0 50 100 150km

WESTERN DESERT

EASTERN DESERT

Key
Desert
Irrigated land

Hatshepsut's temple

Thebes

Tutankhamun's gold death mask

Abydos

Luxor

Valley of the Kings

Red Sea

UPPER EGYPT

Temple of Isis

Aswan
Philae

Pharaoh Rameses II's temple

River Nile

NUBIA

Abu Simbel

How do we know?

Egypt's dry desert soil has preserved millions of objects, from kings' treasures and children's toys to books of magic spells.

Magnificent monuments

We can still see Ancient Egyptian temples and tombs, and marvel at the skills of the workers who made them. Statues, carvings and wall-paintings provide pictures of Egyptian life.

Mysterious mummies

X-rays and CAT scans can 'see' inside mummies. They show us what Ancient Egyptians looked like, what diseases they suffered from, what they ate and how they died.

Written records

The Egyptians' own writings let us discover their private thoughts, hopes and fears. Past travellers to Egypt, from 500 BC to the 20th century, have also left detailed descriptions.

Pharaohs and priests

Powerful kings, called pharaohs, ruled Ancient Egypt. Egyptians believed that pharaohs were the sons of gods, who went to live among the stars when they died.

The power of the pharaohs

The pharaoh was the most important person in Ancient Egypt. He was the law-maker, army commander and chief priest. Pharaohs also controlled trade, taxes, mining, irrigation and food supplies. They made war, or peace, with foreign rulers, and paid for massive temples and tombs so that everyone would remember them.

Golden shrine – holy house for the god

Priest holds sweet-smelling incense

Pillars hold up the temple roof. They are decorated with carvings showing gods, pharaohs and hieroglyphics (picture-writing)

Statue of Horus, hawk-headed sky-god who protected pharaohs

Offerings to please the gods, and to ask for help and protection in return

Pharaoh prays to the god Horus

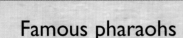

Famous pharaohs

Narmer (c. 3100 BC) First pharaoh of the united kingdom of Egypt.

Khufu (2589–2566 BC) Pharaoh who built the Great Pyramid.

Amenhotep I (1525–1504 BC) Pharaoh who conquered Nubia.

Hatshepsut (1498–1483 BC) Queen who sent traders and explorers to East Africa.

Thutmose III (1479–1425 BC) Famous warrior pharaoh who defeated the Syrians at the battle of Megiddo (Armageddon).

Akenhaten (1379–1334 BC) Pharaoh who tried to change Egyptian religion. He built a new capital city and wrote hymns.

Tutankhamun (1334–1325 BC) Died aged 18. Famous for his treasure-filled tomb in the Valley of the Kings.

Rameses II (1279–1213 BC) Defeated invaders from Turkey. Died aged 92!

Cleopatra VII (51–30 BC) Clever, charming queen who tried to stop the Roman invaders. Killed herself when she failed.

▼ Pharaohs were the living link between the Egyptian people and the gods. Pharaohs prayed to the gods and gave them offerings of food. In return, they hoped the gods would protect them.

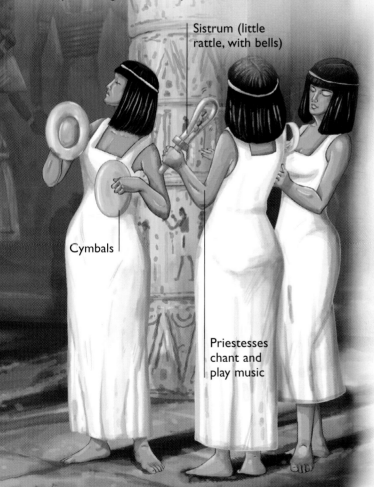

Sistrum (little rattle, with bells)

Cymbals

Priestesses chant and play music

What they wore

This wall-painting (below) shows the pharaoh Amenemhet (with beard) with his family. Most Egyptians wore white linen clothes but the pharaoh's clothes would have been made from a finer linen. Some priests wore lion or leopard skins, magic signs of life and death, past and future.

▲ The pharaoh (with beard) and his son are wearing short, pleated kilts. The women are wearing long, straight dresses with shoulder-straps.

Dress like an Egyptian

All Ancient Egyptians, both rich and poor, wore clothes made of linen to keep cool in Egypt's hot climate. Men wore a knee-length 'kilt', knotted at the waist. Women wore long dresses, often with pleats. People mostly went barefoot, or wore sandals woven from reeds.

Tie a strip of white or gold fabric, or a ribbon, around your wig to make a headband

Vulture collar, made in the same way as the collar on page 16

Plait cords or ribbons of gold, turquoise and blue to make a belt

Turn to page 16 to find out how to make the bracelets

Make a kilt from a rectangular strip of fabric, knotted at the waist

Tunic

1

Lay the fabric flat and smooth out any wrinkles. Cut out a piece measuring 60cm wide and about 200–220cm long.

Wig

1

Loop about 200, 60cm lengths of black wool on a table top, to keep them flat. If possible, keep the strands of wool the same length.

◄ Ancient Egyptians paid great attention to their appearance. Both men and women wore jewellery and used make-up, especially dramatic green or black eye paint. Rich men and women wore wigs, which were held in place with beeswax.

2

Fold the cloth in half lengthways. Measure and mark 15cm in from each edge of the fold, then cut a curved slit between the marks to make a neck hole.

3

Trim the outer edges of the fabric with pinking shears to stop it fraying. Glue the long edges of the cloth together with fabric glue, leaving 25–30cm open at the top edges for armholes.

Tie the tunic at the waist with a belt of plaited cord, or ribbon.

2

Tie a piece of wool round the centre of the looped strands and knot tightly. Cut the looped ends with scissors.

You will need

For the tunic:
- A large piece of white fabric
- Tape measure • Scissors
- Pinking shears • Fabric glue
- Cord or ribbon

For the wig:
- A ball of thick black wool
- Scissors
- Strip of white or gold fabric, or ribbon

3

Fan out the wool into a circle. Cut some strands shorter to make a fringe, about 15cm long.

On the banks of the Nile

In Egypt, it hardly ever rains. So how did people survive? By making good use of the River Nile.

The river of life

The land beside the Nile was rich and fertile; farmers grew wheat and barley to make bread, and many fruits and vegetables. They raised cattle, sheep, goats, pigs, geese and ducks, for meat, milk and eggs.

Egyptians also dug mud to shape into bricks, and cut reeds to make paper, mats, baskets, sandals and boats. They washed and went swimming in the Nile, and enjoyed picnics beside it. Sailing down the river was the easiest way to travel, as there were no proper roads.

Donkeys carry loads

Houses built from bricks made from Nile mud

Goatherd and goats

▲ Most Ancient Egyptians were farmers who lived along the banks of the River Nile.

▲ This wall-painting from an Egyptian tomb shows a family hunting wild birds among tall papyrus reeds beside the River Nile. Their pet cat is enjoying the hunt, as well!

▲ A wooden sickle (big curved knife) with sharp stone blades was used to cut ripe crops, such as barley, wheat and flax.

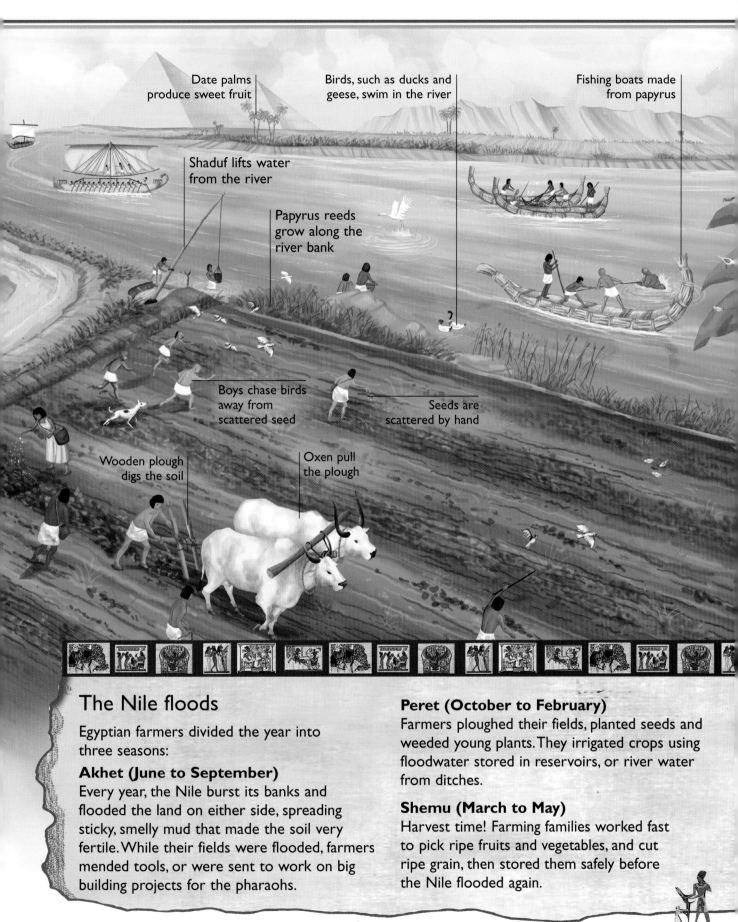

Date palms produce sweet fruit

Birds, such as ducks and geese, swim in the river

Fishing boats made from papyrus

Shaduf lifts water from the river

Papyrus reeds grow along the river bank

Boys chase birds away from scattered seed

Seeds are scattered by hand

Wooden plough digs the soil

Oxen pull the plough

The Nile floods

Egyptian farmers divided the year into three seasons:

Akhet (June to September)
Every year, the Nile burst its banks and flooded the land on either side, spreading sticky, smelly mud that made the soil very fertile. While their fields were flooded, farmers mended tools, or were sent to work on big building projects for the pharaohs.

Peret (October to February)
Farmers ploughed their fields, planted seeds and weeded young plants. They irrigated crops using floodwater stored in reservoirs, or river water from ditches.

Shemu (March to May)
Harvest time! Farming families worked fast to pick ripe fruits and vegetables, and cut ripe grain, then stored them safely before the Nile flooded again.

Make a shaduf

Once the waters of the Nile went down each year, the rich, black mud started to dry out in the sun. The farmers tried to trap as much of the floodwater as possible in mud-brick reservoirs and irrigation canals. They then lifted the water from the canals to the fields using a device called a shaduf. Each shaduf could be operated by just one person. This project shows you how to make a model shaduf.

1

Find two strong, forked twigs, each around 10cm long. Press them into a ball of clay around 5–10cm apart. Leave the clay to harden overnight.

How a shaduf worked

A shaduf was a long pole balanced on a cross beam with a bucket and rope at one end and a heavy counterweight at the other. The farmer would pull the rope to lower the bucket into the canal, then raise the bucket by pushing on the weight. The pole could be swung around, so that the bucket of water could be emptied over the fields.

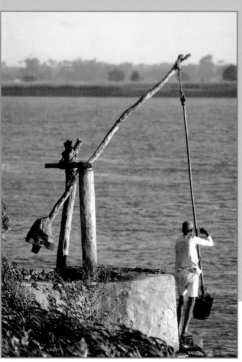

◄ Some Egyptian farmers still use a shaduf to water their fields.

4

Press a ball of plasticine on to the other end of the long stick.

2 Place the long stick across the short stick, at right angles. Wrap the string around the two sticks to keep them in position, but not too tight, so the long stick can swivel easily.

3 Ask an adult to help you make holes in either side of a yoghurt pot, near the rim. Thread string through the holes and knot it. Then tie the string to one end of the long stick.

5 Test your shaduf to see how it works. Pull on the string to dip the yoghurt pot into a bowl of water. Press down on the plasticine ball to raise it. (You may need to add or remove some of the plasticine to make your shaduf balance.)

You will need

- Self-hardening modelling clay
- Two strong, forked twigs
- A long stick; a strong, straight twig or a thick, garden cane
- A short, straight stick
- String
- A small container, such as an empty yoghurt pot
- Plasticine

Living in a town

Most Egyptians lived in small country villages. But Egypt also had many big, busy towns, with crowded streets guarded by wooden gates and mud-brick walls.

Fishing boat

Small window-openings are secure, but make houses dark inside

Flat roofs of houses used as extra living rooms

▲ Egyptian craft-workers had workshops in towns. It took many years to learn how to carve stone into statues, or how to make jewellery, pottery, glass and metal containers or fine linen cloth.

All towns had markets selling food and ▲ drink, and useful goods that ordinary Egyptians could not make themselves, such as sandals or pottery.

Busy centres

Some towns were holy places, where people came to pray to their favourite gods. Others were government centres; the pharaoh's officials and tax collectors lived there. A few towns were purpose-built to house workers making and decorating royal tombs.

Craftsmen and women worked in ▶ the open air, or in crowded workshops behind houses in towns. This model shows carpenters hard at work in their shop.

Rich family's house
has two storeys

Woven papyrus mat
provides some shade

Market stalls. Traders
sell food, fabric,
shoes and baskets

Fabric awning
protects people
from hot sun

Street
sweeper

Pottery
storage jars

Flat roofs also
used as bedrooms.
Mat woven from
papyrus reeds

Food and drink

Egyptian families ate food that they had grown and cooked themselves. They had just one main meal a day, at noon, with a snack at breakfast and supper time.

Poor people ate coarse brown bread and vegetables – usually onions, garlic, lettuces, cucumbers and beans – washed down with thick, sweet beer. For a treat, they enjoyed fish and fruit, especially dates, grapes and melons.

At the market

Pharaohs and rich people liked to give lavish feasts and entertain honoured guests. Their food was cooked by servants or bought at markets.

All Egyptians liked buying and wearing jewellery. Wealthy men and women would buy elaborate collars, rings and bracelets or have them made. Poorer people wore simple pieces of jewellery bought from market stalls.

Make Egyptian jewellery

This project shows you how to make an Egyptian collar and some bracelets to complete your Ancient Egyptian outfit (see pages 8–9). The Egyptians loved gold, and used it in all sorts of jewellery, from earrings and belts to necklaces and hair ornaments.

Stylish designs

This pendant is from the tomb of the pharaoh Tutankhamun. It shows a vulture and is made of gold inlaid with blue and red semi-precious stones – lapis lazuli and cornelian. The gold to make jewellery came from mines between the River Nile and the Red Sea. Semi-precious stones were found in the deserts, or were imported.

The king ▶ would often give people a gift of jewellery, if they had served the state well.

Collar

1 Draw a collar shape on some thick, white card, as shown above. The collar should be big enough to fit around your neck. Cut it out.

Bracelets

1 Cut out strips of card about 8cm deep and long enough to fit comfortably around your wrist, with an extra 2cm overlap. Draw designs on the card with PVA glue squeezed through a tube.

2 Draw some Egyptian designs on the card.

3

Using a tube of PVA glue with a small nozzle, squeeze out the glue to make a pattern of raised lines. Leave it to dry for several hours, then paint the whole collar with gold paint. When dry, paint the raised pattern with bright colours.

4 Ask an adult to make holes at each end, using a hole punch. Thread some cord through the holes so you can fasten the collar around your neck.

2

Copy some Egyptian designs, such as this 'wedjet' eye symbol

When dry, paint in gold. Add touches of paint in other colours, such as blue, red and turquoise. Glue the edges of the card together, to make a bracelet.

You will need

- Thick, white card
- Scissors
- PVA glue (in a tube with a nozzle)
- Metallic paints
- Fine-tipped paintbrush
- Hole punch
- Cord

Friends and family

Egyptians were lively, sociable people. They enjoyed family life, and sharing work or leisure-time with friends. They celebrated weddings and religious festivals with parties, singing and dancing.

▲ This family statue of Ka-em-heset shows him with his wife and son. Ka-em-heset was the chief sculptor and royal architect around 2300 BC. Families paid for carved and painted stone statues like this to be placed in their tombs, so that their spirits could all be together in the Afterlife.

Family life

Families were partnerships. Each member had a job to do, and a duty to help all the others. Men worked in the fields, in workshops or on building sites. Women cooked, cleaned, cared for babies, brewed beer, spun thread and wove fabric. Children learned from their parents, and worked for them.

Boys and girls could marry for love, though some marriages were arranged by parents. Divorce was allowed for cruelty. A typical couple might wed at 12 years of age – and be dead soon after 30! Many women died in childbirth; men in accidents or war. Disease killed many children; only the strongest survived.

▼ Adults and children loved sports, such as ball-games, leapfrog and tug-of-war. Children played with dolls and model animals, such as this wooden lion. Families also played board games, such as Senet and Snake.

▲ Dressed in their best, men and women guests sit chatting at a feast. Boy servants and young women offer them food and drink.

Party dress made of fine, lightweight, pleated linen

Guest sniffs a scented flower. The Egyptians loved perfumes

Servant girl hands a drinking-cup to a guest. Wine was for rich people or special occasions only

Family pets and other animals

Egyptians lived close to animals, on their farms and beside the Nile. Farm animals and pets were useful and beautiful, but wild creatures were dangerous and feared.

Children playing in the fields were often killed by scorpion stings and snakebites, or infected by disease-carrying flies. People washing in the river had their legs bitten off by hippos and crocodiles.

Cats (called 'miw') killed the rats and mice that ate farmers' grain. Egyptians were the first to tame cats; they also worshipped a cat-goddess called Bastet.

Dogs (called 'iwiw') were used for hunting, tracking criminals and guarding homes. Tombstones for pet dogs still survive, inscribed with names such as 'Brave One' and 'Trusty'.

Play 'Snake'

Board games were popular with lots of Egyptian families. One of the oldest so far discovered is called 'Snake' because the stone board it is played on looks like a coiled snake. This project shows you how to make a board and counters so you can play a game of Snake.

How to play Snake

No one knows for sure how the Ancient Egyptians played Snake. However, you can play a game for two players using these simple rules:

- **Each player has four balls, or counters, which should be placed on the snake's tail.**
- **Each player throws the dice to decide who starts. The person throwing the highest score begins.**
- **Take turns to throw the dice. Each player must throw a six before they can move a ball from the tail on to the snake's body.**
- **The balls must be moved one by one around the spiral towards the head, according to the number on the dice.**
- **Whoever throws a six gets another turn.**
- **If a player lands on a square occupied by another player, the other player's ball goes back to the tail and the player must throw a six to bring it back into play.**
- **The winner is the first person to get all their four balls on to the snake's head.**

Roll out a large piece of modelling clay, 3cm thick and more than 30cm wide. Place a dinner plate or bowl upside-down on the clay and ask an adult to cut around it with a blunt knife.

Model a snake's head and fix it on to the centre of the clay circle with some water. You could give the snake two glass bead eyes. Lightly trace out the snake's spiral body with the tip of a blunt knife.

3

Using a small piece of wood, a pebble, a cork or even your thumb, make grooves in the clay in the shape of a spiral. Each groove should be big enough to hold a clay ball the size of a marble. Shape a piece of clay to make the tip of the snake's tail, then leave the clay board to harden.

4

Roll eight marble-sized balls out of clay, four in one colour and four in another. Flatten the bases a little, so they don't roll off the board. Leave to dry, then paint Egyptian designs on them in gold metallic paint.

Writing, counting and discovering

The Ancient Egyptians were some of the first people to invent writing, yet few could read or write. Ordinary people memorized useful knowledge, family history, jokes, stories and songs, and passed them on by word of mouth.

▲ Hieroglyphs carved on smooth stone, at a temple. Egyptians believed that each sign had the power to do good or ill, like the person, object or thought it stood for.

◄ Schools for scribes belonged to temples. They were known as 'Houses of Life'. Boys learned to read and write in groups by copying and reciting texts. They started to train as scribes when they were 12 years old.

Scribe

Hieroglyph (picture symbol)

Students, all boys

Stone palette to hold black and red ink

Students practised writing on broken bits of stone called ostaca

Egyptian children's hairstyle. Boys have shaven heads, except for one lock of hair

Pen, made from reed stalk

Egyptian science

Medicine

Egyptians did not understand how many body parts worked, or what caused diseases. They treated patients with herbal medicines, prayers, amulets (charms) and magic spells.

Maths and engineering

Massive monuments, such as the pyramids, show the Egyptians' skills at surveying and calculating. They used a decimal system of numbering, and discovered how to work out the area of squares, circles and triangles.

Astronomy and prediction

Priests observed the stars and planets very closely, and used them to invent a calendar. This helped them work out when the Nile was likely to flood. They also invented the Nilometer to measure the depth of the Nile floodwaters. About 6 or 7 metres of floodwater were needed to be sure of a good harvest.

Reading and writing

Only boys from rich families learned to read and write. They needed these skills for a high-ranking career. Trained scribes (writers) also copied out royal commands, religious texts, laws, letters, poems and books about magic, medicine and science.

Egyptians used three scripts. Hieroglyphics (picture-writing) was for carving royal or religious texts in stone; each symbol stood for an object or idea. Hieratic (simplified hieroglyphs, with flowing shapes) was for writing with pen and ink. Demotic (even simpler, and quick) was used for letters and business documents.

Scrolls of papyrus, covered with writing

Painted plaster statue of a scribe. Scribes usually ▲ sat cross-legged on the ground like this. Egyptians did not use desks or tables for writing.

Make a lucky pendant

The Ancient Egyptians sometimes wrote protective spells in hieroglyphs on papyrus, to keep them safe. The papyrus was then rolled up and carried in a pendant worn around the neck. Here's how to make your own lucky pendant.

1

Cut out a piece of cardboard 6cm x 6cm. Fold the card in half lengthways and glue the sides together. Then glue along one short side to make a pocket.

Egyptian amulets

An amulet was a charm to ward off evil. The 'wedjet' eye charm represented the eye of the sun-god Amun-Re and the god Horus. The scarab beetle represented the sun-god Khepri. Only kings and queens were allowed to carry the ankh, the Egyptian symbol of life.

Eye of Horus

Ankh

Scarab

▲ Symbols of Ancient Egypt.

3

Cut out a small rectangle of card measuring 4cm x 1cm for the hanging loop. Cover it in gold foil, then fold it in half and glue it to the back of the pendant, at the top (see picture below). Cover the rest of the pendant in gold foil and smooth it down.

2

Cut out two wedge-shaped pieces of card as above, each measuring 3cm along the short edge, with an overlap of 0.5cm. Glue the pieces on to the front of the pocket, one at the top and one at the bottom.

You will need

- Cardboard
- Scissors
- Cotton wool
- Pencil or pen top
- Black poster paint
- Pencil
- Glue
- Gold foil

Thread a ribbon or cord through the folded card so you can wear the pendant around your neck.

4

Make a pattern on the foil with the top of a pen or the end of a pencil. Gently rub some black poster paint over the foil to make the pattern stand out. Rub away any excess paint with a piece of cotton wool.

Don't forget to slip a lucky message or charm into the pocket at the back of your pendant! This message shows the Egyptian symbols for the English words GOOD LUCK!

GOOD

LUCK

Everlasting life

The Egyptians feared death, and hoped to live for ever. They believed this would happen if their bodies were preserved as a shelter for their 'ka' (spirit) in the Afterlife.

Death and burial

At first, bodies were preserved by burying them in the desert. The dry sand stopped them rotting away. Later, pharaohs and rich people paid to have their bodies made into mummies, then safely buried in strong or secret tombs.

Mummy-makers removed a body's inner organs, dried its flesh with natron, injected it with plant oils and wrapped it in layers of bandages, often with amulets placed between the layers. Finally, the mummy was sealed in a coffin decorated with the dead person's portrait and pictures of guardian gods.

The mummy of ▲ Pharaoh Rameses II (ruled 1279–1213 BC), which has survived for over 3,000 years. It was unwrapped a long time ago.

◀ Family members taking part in an 'Opening of the Mouth' ceremony for a dead relative. They gently touch the mummy with special holy knives. They believe this will let the mummy's 'ka' (spirit) enter its body, and let the dead person live again.

Priestess kneeling and saying prayers. Rich people paid for crowds of mourners to weep and pray at their funerals

Mummy is coated in black resin (plant gum or oil) to preserve it. For the Egyptians, black was a symbol of rebirth, like the rich, dark Nile mud

▲ Priests carry newly made mummies, wrapped in cloth and bandages. Next, each mummy will be carried to its tomb, accompanied by mourners and musicians chanting prayers, and laid to rest in a wooden coffin or stone sarcophagus.

Gods and goddesses

Magical, mysterious, beyond their control – that's how Egyptians saw the world. So they asked gods and goddesses for help:

Amun (king or ram) creator god

Anubis (jackal) god of dead bodies

Bastet (cat) household goddess

Bes (dwarf) god of children

Hathor (cow) goddess of music and love

Horus (hawk) god of the sky

Isis (mother) goddess of healing

Maat (woman or feather) goddess of truth and justice

Osiris (king) god of the Afterlife

Ra (man with hawk's or ram's head) god of the sun

Thoth (bird) god of scribes

Make a mummy mask

Before a mummified body was sealed in a coffin and laid in a tomb, its face was often covered with a beautiful, lifelike mask. This was to make sure the dead person would be recognised in the Afterlife. The simplest masks were made of plaster. Others were painted wood. The finest were made of gleaming gold, decorated with semi-precious stones. This project shows you how to make a papier-mâché mummy mask.

Tutankhamun's mask

Tutankhamun became pharaoh when he was just nine years old. When he died at the age of 18, his body was made into a mummy then put into three coffins that fitted one inside the other. This famous gold death mask was found in his tomb.

▲ This life-size mask protected Tutankhamun's mummy. It was made of gold and inlaid with semi-precious stones.

1 Blow up a balloon until it is the same size as your head. Mix wallpaper paste and cover half the balloon with five layers of torn newspaper strips, dipped in the paste. Leave to dry for two days. Ask an adult to pop the balloon and trim the mask with scissors.

3 When dry, cut out the headdress shape (this is like a horseshoe) from thick card and glue it in place behind the mask. When dry, cover the mask and headdress in two or three layers of white emulsion.

2

Then ask an adult to cut out two round eyeholes. Build up the nose and mouth from pieces of card and paper. Make a nose from a triangular piece of shaped card. Fix it in place with glue and tape. Cover the whole mask with two more layers of paper strips.

Mouth built up from card and bits of paper

4

When completely dry, paint your mask and headdress with bright metallic paints.

Eye shape made from pieces of thick string, painted black

False beard made from a roll of card, which can be decorated with string

Timeline

c. **10000–8000 BC** Climate change turns 90 per cent of Egypt into desert.

c. **5500 BC** Egyptian farmers plant crops, raise animals, build villages beside Nile.

c. **3500 BC** The first Egyptian walled towns.

c. **3100 BC** Upper (southern) and Lower (northern) Egypt unite. The new kingdom is ruled by pharaohs from capital city, Memphis.

2686–2181 BC Old Kingdom. Pyramids built as tombs for pharaohs.

2181–2055 BC Wars in Egypt between rival leaders.

2055–1650 BC Middle Kingdom. Pharaohs conquer Nubia, and pay for splendid temples and statues. Capital city moved to Thebes. Egypt trades with Middle East.

1650–1550 BC Hyksos (people from Palestine) settle in Egypt and grow powerful.

1550–1069 BC New Kingdom. Pharaohs conquer and rule a great empire, and defeat invaders. Tutankhamun's tomb and other royal burials in the Valley of the Kings. Egypt trades with Africa and Mediterranean lands.

1069–747 BC Pharaohs rule northern Egypt; kings from Nubia rule southern Egypt.

747–332 BC Egypt is rich, but losing power. It is invaded by Assyrians (from Syria and Iraq) and Persians (from Iran).

332–30 BC Egypt is conquered by King Alexander the Great of Macedonia (north of Greece), and ruled by Macedonians, including Queen Cleopatra VII.

30 BC–AD 395 Egypt is conquered by Rome, and becomes part of the Roman Empire.

AD 324 Christianity becomes the official religion of Egypt.

AD 641 Arab invaders bring Islam and the Arabic language to Egypt.

Glossary

Amulet Lucky charm. Small object or image believed to have protective powers.

Fertile (soil) Containing all that is needed to grow strong, healthy plants.

Inner organs All parts of the body that are not skin, muscle, bone or hair. Egyptians removed the brain, lungs, liver, stomach and intestines when making mummies, but left the heart in place. They thought it contained the dead person's mind.

Inscription Writing carved on stone.

Irrigation Bringing water to dry land, to help crops grow.

Ka Spirit. The Egyptians believed that a person was made of five things: body, ka (spirit), ba (personality), name, shadow.

Natron Salty chemical, found in Egyptian deserts. Mummy-makers used it to absorb moisture from dead bodies.

Nubia Land to the south of Ancient Egypt; today, it is part of Egypt and Sudan.

Papyrus A type of reed (tall, grass-like plant) that grew beside the River Nile. The Ancient Egyptians flattened and pressed its stalks to make paper.

Pharaoh The Ancient Egyptians' name for their king.

Reservoir Artificial, man-made lake, used to store water.

Scribes Professional writers. In Egypt, most scribes worked as government officials.

Shrine Holy place, usually inside a temple, where the statue of a god or goddess was kept.

Index

Webfinder

http://www.ancientegypt.co.uk
The British Museum gives information on Egyptian life, gods and goddesses, mummification, pharaohs, pyramids, temples and lots more.

http://www.bbc.co.uk/history/ancient/egyptians/
Pyramid challenge, Be a mummy maker, Explore the treasures of Tutankhamun, Health hazards cures in Ancient Egypt, Hieroglyphics – write your name in the ancient script.

http://www.historyforkids.org/learn/egypt/
Crafts, projects and lots of information about Ancient Egypt.

http://www.iwebquest.com/egypt/ancientegypt.htm
Information about daily life in Ancient Egypt, plus activities and missions.